THE MINOR ARTS OF ISLAM

ERNST KÜHNEL

THE MINOR ARTS
OF ISLAM

Translated from the German
by Katherine Watson

CORNELL UNIVERSITY PRESS
ITHACA, NEW YORK

First published 1971

Standard Book Number 8014-0563-7
Library of Congress Catalog Card Number 75-110331
Printed in Germany

First published 1963; © by Klinkhardt & Biermann, Braunschweig
English translation © G. Bell & Sons 1970

CONTENTS

PREFACE

This book is addressed in the first instance to museum men, collectors, and art dealers, to help them lay the foundations of expertise on a subject that has been rather remote but has recently been awakening livelier interest. There is of course no other way to acquire this expertise than by years of intensive study of the problems raised here, and, even more important, of the objects themselves.

The author has left out all the decorative techniques directly connected with architecture in the hope of giving the most concise and comprehensive review possible of Islamic minor arts in the narrower sense. The more recent utility wares like the folk art and bazaar production which have started up in every country of the Near East since the decline of the old techniques are outside the subject of this book.

Special attention has been paid to the problem of forgeries and in the introduction and appendix the writer has brought together all the general considerations and practical advice that may be of use in the study of Muslim art. The transcription of names and technical expressions has been kept as simple as possible.

The author and publishers thank museums and private collectors for their kind permission to reproduce the objects in their possession, and especially those institutes with whose agreement the colour plates could be made. Figures 5–7, 23, 24a, 25f, 29, 41, 43, 45, 70, 85, 88, 116, 124, 131, 135f, 153–155, 158, 160, 164, 193f. are prepared from photographs by F. Bruckmann, Munich, figs 187 and 196 from those by Archiv Más, Barcelona.

E. Kühnel

GENERAL INTRODUCTION

ISLAMIC FURNITURE AND OBJECTS

Anyone with more than a very superficial interest in the applied arts of Islam must start with an understanding of the general context in which they arose and of the specific motives for the manufacture of the different objects. To gain a true appreciation of their significance the student will have to discard many of the prejudices he has held, perhaps treasured, since his youth; and first of all he will have to learn a large chunk of world history that he never encountered at school. This done, he will be able to visualise the milieu whence oriental art arose, and the art itself will present much less difficulty than is generally assumed; in fact in many respects it is considerably simpler to understand than, for example, the problems raised by the study of Christian art.

One decisive factor needs to be stressed at the start: Islamic art knows no distinction between the religious and the profane. Divine service consists essentially in prayer and needs no sacral or liturgical objects for its celebration. Even ceremonial vestments are unknown, and since those officiating recite the Koran from memory, there is, strictly speaking, no need even for a copy of Holy Writ for cult purposes. In fact, of course, copies of the Holy Koran abound everywhere, in varying degrees of splendour, with boxes to keep them in and folding lecterns for spreading them on, but these are no more than luxuries that have been piously donated to the mosques and mausolea in the same way as the lamps, candlesticks and carpets that furnish the holy places. The form and decoration of these objects is no different from those used in private houses, though the choice of format and the motifs would naturally be guided by the particular purpose they had to fulfil.

In private houses, too, much that seems indispensable to us in Europe is absent: first and foremost, there is none of the larger space-filling fur-

1

niture: tables, chairs, sofas, chests of drawers, cupboards, bedsteads and so forth. None of this was needed by the Muslim, accustomed as he was to squatting on the floor and depending for his comfort entirely on cushions and pillows without frames and supports; the only solid furniture was chests to hold clothes and household linen. Recesses in the wall, often as large as cupboards and closed by wooden doors, held the household utensils, and if he wanted to display some luxury pieces or other treasures he divided up a wall surface into ornamental niches, each one containing a single object, and sometimes even shaped to fit it (Fig. 1). To Islamic taste the ideal room is animated only on the surfaces that contain it: the floor by a carpet, the wall by niches over a tiled dado, the ceiling by coffering or stalactite moulding. Clearly, painting and sculpture here receive short shrift, and this circumstance again considerably simplifies the function of applied art. It has been able to develop much more freely and more independently than in our civilization, since it has never been constrained by the "fine" arts into accepting dictates for its themes and its forms. Dependent on nothing but itself, it has pursued the most diverse techniques to their extreme elaborations, yet has always maintained a strict self discipline in preserving the limits set.

In choice of motifs the Muslim was bound by certain religious and aesthetic restrictions which never concerned Western artists, and this makes the study of Islamic art exceptionally easy when it comes to the problem of representation. It is true that the extent of the prohibition on the representation of living creatures has been exaggerated; it does not appear in the Koran, but in the Hadith (the Sayings of the Prophet) and for this reason alone was not dogmatically binding on all Muslims. Even so, religious discretion has always kept figure subjects within narrow bounds. For furnishing holy places they were rigorously forbidden, even in Persia where such things were always regarded more leniently; and in the countries of the orthodox tradition (Sunna) they were tolerated even in profane decoration only at certain periods and with considerable reservations: in Spain only in the tenth and eleventh centuries, in Egypt under the Fatimids (tenth to twelfth centuries), in the Near East in the time of the first Caliphs, in the twelfth and thirteenth centuries in the Seljuk states and again under the Mongols. In the modern period, since the fifteenth century, Persia and India, and at times the Ottoman Empire, have enjoyed complete tolerance.

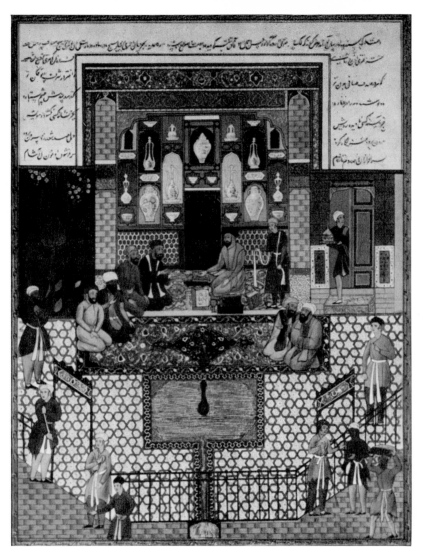

Fig. 1. Interior of the house of a person of quality. Indian Miniature, late 16th century.
H. R. d'Allemagne, Paris.

Extreme moderation prevails in the representations themselves, even where there were no confessional considerations: it often amounts to no more than enlivening trees and bushes with birds of different kinds, or to the portrayal of single beasts or animal combats or hunts, or to fabulous

3

creatures of ancient oriental or Mongol derivation. The human form only appeared as a rule in a few pictorial motifs, rarely containing many figures, with a preference for scenes of court life: a prince enthroned and surrounded by his servants, holding a glass in his hand, and entertained by musicians or acrobats, or hawking with his retinue, playing polo or in the heat of battle[1].

Such scenes were probably often drawn from life, but on the whole they are subject to a conventional formula and adapted to whatever decorative purpose they are intended to fulfil.

Historical episodes relating to particular events or personalities were rarely handled except in later miniature painting, which of course had a special status in all these matters; nor were portraits common, but the legendary themes, whose popularity had been spread by the great Iranian poets far beyond the borders of Persia, were often chosen: Chosrau discovering the Shirin, Bahram Gur performing his master shot, Leila visiting the Majnun in the desert and so on. Quite often Christian subjects were treated, usually based on Byzantine models, for works intended as donations to the Christian communities which existed throughout the East, or as gifts to European potentates; they were never used on ordinary export wares.

Every luxury article would be influenced primarily by the patron; he often decided on the choice and arrangement of the motifs, on the text of the inscriptions and so forth. The main patrons were the princes; not only were they anxious to adorn their own palaces with masterpieces of their native art industry but they aspired to put foreign courts under an obligation by presenting them with rich gifts. Again, holders of high office and rich merchants would hope to win or retain the favour of an art-loving prince by offerings of this kind. The personal interest of the patrons naturally kindled the ambition of the craftsmen who furthermore might expect a rich reward if they could justify the expectations of the client. The splendid oriental habit of blind generosity, so conscientiously followed in Islam, not infrequently rewarded outstandingly successful work literally with its weight in gold.

[1] The disc nimbus that appears so frequently with personages in miniatures and on pottery and bronzes is not to be interpreted as a sign of holiness. It either expresses authority of some kind or else is simply used decoratively to make the head stand out from the background.

The guilds were strictly organized and provided a happy combination of technical and aesthetic training which ensured that quality was both maintained and improved. In every branch of craft function and fitness to material were regarded as the essential foundation, and general changes in style or individual expression could only take effect within this framework. It could never happen that an artist used his talent equally in pottery and metalwork, or that if he were successful in designing end papers he might gaily try his hand at textile or carpet patterns; professional discipline saw to it that the cobbler stuck to his last by forbidding such infringements of craft loyalty. The market police (*hisba*) played an essential and often beneficial role in regulating trade relations; it worked under a court official of high standing who wielded considerable authority (*muhtasib*). He was empowered to intervene directly against abuses of every kind, and especially to ensure that materials of inferior quality were never used. Within the sphere of their craft the artists extended themselves to exploit every manual and decorative resource, and they managed to develop their techniques to the furthest extremes in innumerable fields.

It was always a principle that the original use and function of the object must be apparent in the form, even if the piece in question would never be required to fulfil it in practice and was destined from the beginning solely for display. Thus when, as often happened, a potter or a bronze caster modelled the figure of an animal it could not be conceived as a "free" sculpture, but had to be unambiguously recognizable as a vessel for pouring or for incense, a lid, ink pot, bath scraper or such like (Fig. 66, 67). Again, at certain periods there would be a universal turn to a new ornamental style, but each translation into a different material would involve a different adaptation to suit it. The training in draughtsmanship for the potter was different from that of an engraver or a weaver; a motif which the first could only render in broad strokes and strong contrasts would be delicately detailed by the second to suit a more small-scale effect, while the third would metamorphose it into a symmetrical textile design. But never – and this must be expressly emphasised for the reader who has been born and bred to the Western aesthetic tradition – never at any time was there any purely naturalistic intention in the representation, and the appearance of reality, whether in the wider or narrower sense of the word, was always used with conscious subjectivity for purely ornamental purposes. It is no primitive attitude that prevents the Muslim artists from

5

representing objects "as they are", but the most extreme fidelity and responsibility towards their craft, together with their sense of impotence towards the Almighty Creator whose works it would be childish frivolity and presumption to attempt to imitate.

All this needs to be borne in mind by anyone who wishes to understand the spirit of Islamic art, or who hopes to attain to that relationship with its inner values which alone makes the true connoisseur and successful collector.

THE HISTORICAL BACKGROUND

As in other and older civilizations, art in Islam was closely bound up with the political destiny of the various states, and it was often directly controlled by the active encouragement that it could expect from the princely courts. Its most flourishing periods coincide with the strengthening of one or another centre of power, while decline set in wherever the protective arm of the ruler weakened; once a country had played out its political role, its art, too, was no more. Thus all artistic activity stagnates in Morocco after the fifteenth century, in Egypt and Syria after the sixteenth, in Turkey, Persia and India after the eighteenth. For the periods of vigorous activity in the various regions a summary of the most important historical dates is provided below.[1]

The Caliphate. When the Prophet died in 632 his followers elected a successor (literally "representative") to hold spiritual and worldly authority, and thereby established the caliphate. This institution only lasted about two centuries as the real centre of power, though it continued until recent times as a kind of fictitious papacy.

632–661: The Four Great Caliphs (Abu Bakr, Umar, Uthman, Ali; capita al Madinah). Extension of Islam to Syria, Mesopotamia, Persia and Egypt.

661–750: The Umayyad caliphs (capital Damascus). The caliphate becomes hereditary. Extension of Islam into North Africa, Spain and Turkestan.

750–1258: The Abbasid caliphs (capital Baghdad); Anti-caliphate of the Umayyads in Córdoba (see below) and permanent division into Western and Eastern Islam, tenth to twelfth centuries. Anticaliphate of the Fatimids in North Africa and Egypt, tenth to twelfth centuries (see below). Dissemination of Islam in India.

1258–1517: Nominal caliphate of the Abbasids at the court of Cairo under the guardianship of the Mamluk sultans (see below).

[1] More detailed lists of the rulers of the different countries in every period will be found in the important works of reference by S. Lane-Poole: "The Mohammadan Dynasties" (Westminster 1894, reprinted 1925) and, more comprehensive, in E. v. Zambaur: "Manuel de généalogie et de chronologie pour l'histoire de l'Islam" (Hanover 1927, also a reprint).

1517–1924: Titular caliphate of the Ottoman sultans in Constantinople (see below), recognized in the Turkish sphere of influence and to some extent in India.

Spain. The victory of General Taria over the Visigoths at Jerez de la Frontera in 711 began the conquest of Spain for Islam, completed by Musa. Remnants of the Goths held out in the Asturian mountains and later formed the nucleus of the *reconquista*.

713–750: Governors for the Damascus Umayyads.

755–1031: Emirate and caliphate (in 929) of the Córdoba Umayyads.

Abd-ar-Rahman I, 755–788: beginnings of a Spanish-Arab art style.

Abd-ar-Rahman II, 822–852: flourishing activity in building and crafts.

Abd-ar-Rahman III, 912–961: Córdoba at its height as cultural centre.

Hisham II, 976–1009: Government in the hands of the chancellor al-Mansur; spread of the Umayyad style throughout Spain and North Africa.

The eleventh century saw the decline of the caliphate.

1031–1087: the Taifa kings (regional Arab or Berber dynasties in Seville, Granada, Málaga, Murcia, Valencia, Saragossa, Toledo, Badajoz and elsewhere) Lively artistic activity in decadent Umayyad style at the individual courts.

1087–1147: Sultanate of the Almoravids (a Berber dynasty; capital Marrakesh; governor's seat at Seville). Political association with Morocco; the Abbasids recognized as caliphs. Little artistic activity, religious reforms.

1147–1235: Rule of the Almohads (a Berber dynasty in Spain and North Africa; Seville seat of the governor and at times his residence). Loss of much territory to the Christians and great defeat at Las Navas de Tolosa 1212.

Abd-al-Mumin, 1130–1163; active cultural policy

Yaqub al-Mansur, 1184–1199: lively encouragement of the arts; first flowering of the new Moorish style.

1232–1492: Sultanate of the Nasrids until 1237 in Jaén, then in Granada; the rest of Spain conquered by the Christians.

Ibn al-Ahmar Muhammad I, 1232–1273: founding of the Granada style.

Yusuf I, 1333–1354, and Muhammad V, 1354–1391: peak of the Alhambra style and its spread to Seville, Fez, Tlemcen and elsewhere.

After the occupation of Granada by the Catholic kings (1492), Moorish

craftsmen under Christian rule perpetuated Islamic elements into the sixteenth century in the so-called Mudéjar style.

North Africa is not considered in this survey, as it was of little importance in the field of the applied arts.

Sicily. Part of the island was occupied in 827 from Qairawan, the first capital of North Africa, and the rest in the following decades; in 909 it was taken by the Fatimids (see below) from whom it was seized by the Normans in 1071. Muslim art continued to flourish under them and was then given special encouragement by the Emperor Frederick II (1215–1250) who favoured Arabic art.

Egypt. Conquered by Amr ibn al-As after a successful war against the Byzantines.

641–868: Umayyad and Abbasid governors (seat of the governor at Fostat). First artistic activity dependent on the techniques evolved by the Coptic Christians.

868–905: Emirate of the Tulunids (of Turkish descent, nominated by the Abbasids but virtually independent; residence al-Qatai near Fostat). Much artistic activity in the Abbasid style.

935–969: Emirate of the Ikhshids (also Turks, and equally independent).

969–1171: Fatimid caliphate (a Berber dynasty of the Shi'ite confession, ruling in North Africa since 909; capital moved in 969 from Mahdiya to the new foundation of Cairo near old Fostat).

Hakim, 996–1020: first flowering of the Fatimid style, which shows a predilection for figure motifs, partly in imitation of Persia.

Mustansir, 1035–1094: all arts flourish.

1169–1250: Ayyubid sultanate (Kurdish descent; the Abbasids recognized as caliphs; capital Cairo).

Salah al-din (Saladin), 1169–1193: formation of a new ornamental style.

1250–1517: Mamluk sultanate (slaves and pretorians, mostly of Turkish descent; two successive series of rulers: Bahrids and Borjids). The following were special patrons of the arts:

Baybars (1260–1277); Qalaun (1279–1290); Barquq (1382–1398); Qait Bey (1468–1495). The distinctive feature of this period was the introduction of large scale inscriptions, emblems and similar motifs.

1517–1805: Governors of the sultans of Constantinople (Turkish provincial art).

Syria. Conquered in 638; lively artistic activity under the Umayyad

caliphs (see above), especially in Damascus, Jerusalem and the desert castles, at first closely linked with hellenistic Syrian style.

750–877: Abbasid governors.

877–1094: United with Egypt (see above) under the Tulunids, Ikhshids and Fatimids (but Aleppo under small Arab dynasties after 944).

1094–1174: Seljuk princes and atabegs (but Jerusalem and most of the coast in the hands of crusaders after 1099).

1174–1260: Ayyubid emirate (branches of Saladin's family in Aleppo, Hama, Homs and Damascus; the latter frequently united to Egypt; Jerusalem reconquered 1187–1229 and finally in 1244). Lively artistic activity at the princely courts.

1260–1517: United with Egypt under the Mamluks (victorious resistance to the Mongols and in 1291 the last crusaders expelled).

1517–1918: united with Turkey (provincial flowering of national Turkish style with a regional character).

Mesopotamia. The geographical division into Iraq, Jazira and Diyarbakr (south, central and north Mesopotamia) was a determining factor in the political history of the three regions. They were never closely associated for any length of time. The conquest of the whole area with the Sasanid residence at Ctesiphon was completed in 637.

661–750: Umayyad governors. Early Islamic culture blossoms in the cities of Hira, Kufa and Basra.

750–945 (1256): rule of the Abbasids (residence Baghdad, except for the years 836–883 at Samarra).

Harun al-Rashid, 786–809: lively encouragement of the arts in Baghdad; Raqqa founded on the Euphrates as a second residence.

Mamun, 813–833: Baghdad at its peak.

Mutawakkil, 847–861: Abbasid ornamental style develops in Samarra and spreads throughout the empire.

945–1055: Emirates of the imperial princes (at times until the end of the eleventh century there were Arab, Persian and Kurdish dynasties in Mosul, Diyarbakr and Baghdad; finally the Iranian Buyids became dominant, and the Caliphs lost all executive power in secular affairs).

1055–1256: Seljuk princes and atabegs (various local dynasties in Mosul, the Jazira, Diyarbakr, Kurdistan and Iraq). Arts flourish, especially at the northern courts (Zengids, Ortokids) and in Raqqa.

1256–1336: united with Persia under the Ilkhans (a Mongol dynasty under

the sovereignty of the Great Khans; the caliphs expelled). Baghdad became their seat and underwent a renaissance.

Hulagu, 1256–1265: strong Mongol influence on art forms.

Ghazan, 1295–1304.

1336–1502: united with Azerbaijan under the Jalairids and Turcomans (1393: Baghdad taken by Timur and held for some years).

1502–1638: united with Persia under the Safavids (see below, Diyarbakr already surrendered to the Ottomans in 1515). Shi'ite pilgrimage centres flourish.

1638–1918: united with Turkey (divided into different vilayets).

Iran and West Turkestan. Rapidly conquered for Islam after the destruction of the Sasanid empire in 642. Persia was permeated by the Shi'ite dogma (which disputes the legitimacy of the first three caliphs) and thus now isolated both confessionally and politically from orthodox Islam.

661–820: Umayyad and Abbasid governors. Art in the decadent Sasanid style.

820–1037: emirates of the imperial princes (national dynasties in Kurdistan, Azerbaijan, Khorasan, Tabaristan, Jurjan and other regions, generally recognizing the Abbasid caliphs but virtually independent. In the tenth century dominance of the Samanids of Bokhara, and later, in the west, of the Buyids). Islamization of Sasanid forms. Lively artistic activity.

1037–1231: Seljuk sultans and atabegs (local dynasties in Kirman, Azerbaijan, Fars, Luristan and elsewhere). Artistic activity in Herat, Rayy, Nishapur, Hamadan and elsewhere.

1227–1336: Mongol emperors and Ilkhans of Persia (Hulagu and his successors). Tabriz the summer residence. All arts permeated by Mongol elements.

1336–1387: National dynasties (Muzaffarids in central and south Persia, Jalairids in the west).

1387–1502: united with Turkestan in the Timurid Turkish-Mongol empire (capital Samarkand: Azerbaijan under Turcoman princes). Blossoming of the Persian-Mongol art style, especially in Samarkand and Herat.

Timur, 1387–1405. Shah Rukh, 1405–1447.

1500–1599: Shaybanids in West Turkestan.

1502–1736: Safavid Shahs in Persia (all parts of the country united).

Renewed flowering of Iranian culture; development of a national art style and perfection of all techniques.

Shah Ismail I, 1502–1524: residence Tabriz.

Shah Tahmasp I, 1524–1576: residence Qazvin after 1549.

Shah Abbas I, 1587–1629: residence Isfahan. Increase in artistic production; relations with China and Europe.

After 1736: various dynasties. Decline of all arts and onset of mass production.

Fath Ali Shah, 1797–1834: attempt to revitalize crafts.

Asia Minor and Turkey. Asia Minor was firmly held by Byzantium until the Seljuk invasion wrested it from the Greeks. 1077–1300: sultanate of the Rum Seljuks (capital Konya). Lively artistic activity, often in close association with Persia.

Ala al-din Kai Kobad I, 1219–1236: peak of Seljuk art in Konya and elsewhere.

1300–1924: sultanate and caliphate of the Ottomans (at first there were small emirates in various centres of Asia Minor which were gradually absorbed by the Ottomans; simultaneous expansion of power in Europe). Orkhan, 1326–1360: residence Brussa. Beginnings of a new Turkish style.

Murad I, 1360–1389: conquest of Adrianople – residence after 1365 – and penetration into Balkans.

Mehmed I, 1402–1421: defence of the conquests imperilled by Timur's victories. Brussa at its peak.

Mehmed II, "Fatih", 1451–1481: Constantinople taken in 1453 – thenceforward the residence – and penetration into Crimea and Adriatic.

Selim I, 1512–1520: conquest of Kurdistan and Diyarbakr, Syria, Egypt and Arabia; assumption of the caliphate.

Suleyman I, 1520–1566: heigh of Turkish power: occupation of Hungary and siege of Vienna 1529; victories at sea and foundation of the pirate states of Algiers and Tunis under Turkish sovereignty. Richest development of Ottoman art style, based on Persian.

Murad IV, 1623–1640: annexation of Iraq, but losses beginning in Europe. Art spreading into the provinces.

Ahmed III, 1703–1730: Hungary and other regions lost.

The introduction of baroque elements lays the foundation of the "Turkish rococo" in Constantinople.

India and Afghanistan. The conquest of Hindustan for Islam began in 712 with the Arab expedition to Sindh in the Indus valley. It was successful, but of only local significance.

Later undertakings all began in the Afghan highlands, whose history until the mid-eighteenth century remained tied to that of India. In about 900, Kabul was in the possession of the Samanids (see below) whose Turkish vassal Alptigin made himself independent.

962–1186: emirate and sultanate of the Ghaznevids (capital Ghazna. Abbasids recognized).

Mahmud, 998–1030: extension of the empire from the Punjab into Hindustan and Gujarat, later also into West Turkestan and part of Persia. Flowering of Persian culture and much artistic activity at the court of Ghazna; Firdausi active.

1186–1206: Sultan Muhammad of the Ghorids (in Ghazna the Ghorids after 1161, in Lahore as well after 1186).

1206–1526: Sultanate of Delhi (various dynasties, nominally until 1554; after the mid-14th century some parts of Hindustan are independent, Afghanistan united with West Turkestan).

Altmysh, 1210–1235: first great blossoming of Delhi.

Firuz Shah III, 1351–1388: much building.

1526–1857: empire of the Great Moghuls (Timurid dynasty in the whole of Hindustan and other regions of India, until 1738 also in Afghanistan).

Babur, 1526–1530: in Kabul from 1504, Agra the residence after 1526.

Humayun, 1530–1556: driven out by rebellions, 1540–1555 a fugitive at the Persian court.

Akbar, 1556–1605: unification and expansion of the empire; residence from 1569–1585 at Fatihpur Sikri, later at Lahore; encouragement of literature and learning. Religious toleration. Relation with the Jesuits of Goa. Foundation of an Indian national court art.

Jehangir, 1605–1627: heightened artistic activity; residence Lahore; Persian and European influences.

Shah Jehan, 1628–1659: Mughal court at its most brilliant; residence Delhi.

Aurangzeb, 1659–1707: religious reaction at the imperial court; spread of art in the residences of the rajahs and rise of popularizing tendencies.

LANGUAGE AND SCRIPT

The immense territory subjugated by Islam contained the most varied peoples, each working out their different national ideals and cultural destinies within the common framework of their faith according to the talents bestowed on them by race and earlier traditions. Yet when we consider what has survived from the great periods of art we find that this legacy speaks to us in only two languages. The extent of each certainly varied several times during the centuries, but always one of them, the Arabic, maintained supremacy over the other, the Persian. The conviction that the Koran is a revelation sent direct from God resulted in its dissemination being tolerated only in the original language, leaving no more than explanations and commentaries to the local idiom. For this reason inscriptions of a religious nature are never found in any language other than Arabic throughout the whole Muslim world; and likewise, almost every text that required some degree of ceremonial formulation (eulogies of the reigning prince, good wishes or blessings invoked on the owner, tomb inscriptions, records of benefactions, signatures of artists and so on) remain in Arabic. The Arabic language played for centuries the same role in all the Islamic countries that Latin played in mediaeval Europe, and Persian only gradually asserted itself in the East alongside it. Confined within the straitjacket of Arabic script, it had first to return to the inspiration of its earlier national literature before it could arrive at the new and unsuspected riches of its ultimate flowering. Then the fame of her great writers carried the language of Iran far beyond her frontiers, and we soon find it current among the more educated upper classes in nearly every Turkish state. In the sixteenth century it was as prevalent in Constantinople as at the Mughal court, and in Muslim India in fact it maintained its pre-eminence right into the nineteenth century. Persian texts are more frequent in the eastern zone on objets d'art, usually in the form of verses, either quoted from one of the well-known poets or invented specially for the work in question. Turkish epigraphy is unknown on the kind of works that concern us here; was hardly ever used in earlier periods, and is only found to any extent in the modern period.

The phrases important for art history are with few exceptions always and everywhere in Arabic, mostly in more or less stereotyped formulae; they do not require any deep knowledge of the language to understand them. For those quite unacquainted with such things it may be added that the kind of dialectal differences that occur in the vulgar idiom of the various Arabic-speaking lands had no place in the pure literary written language common to all. On the other hand in the course of time the form of the script produced manifold variants, a number of them clearly with a provincial colouring, which we shall need to examine in more detail.

In the first four centuries of the *hijra* all epigraphy was executed in an angular vertical script, named Kufic after the early Islamic cultural centre of Kufa in Mesopotamia. The earliest examples show the undecorated letters in a broad heavy hand, and there are no pointing or other diacritic signs. These latter do not become at all common until after the ninth century and at the same time the lettering becomes more gracile, finally evolving into a distinctive ornamental style. By branching and intertwining the shafts and linking them closely with the leaf scrollery of the background the calligraphers about the turn of the millenium arrived at the so-called *Kufic fleuri* which marked the end of the decorative possibilities of the old lapidary script, and which was universally adopted. Meanwhile the round cursive *naskh* hand which had always been in ordinary use was developing as a calligraphic form, and appears from the twelfth century alongside the older vertical script for inscriptions on objects; the stark contrast between the two hands was skilfully exploited for decorative effect, thus ensuring a lengthy survival for the older script. It is however not difficult for anyone to distinguish between the archaic and the later purely archaistic Kufic, once he has learnt how to recognize the few significant changes in the evolution of the Arabic script.

Naskh was written in Egypt and the Near East according to prescribed rules in several sizes and various styles; there were many variants besides the usual curving *thuluth* (i.e. third). Characteristics which might facilitate local attributions are however very difficult to establish; even the large format of the *tumar* which is held to be diagnostic of the Mamluk style seems to have been practised earlier outside the Egyptian-Syrian artistic sphere. On the other hand the varieties of *naskh* that developed decorative significance in Spain and North Africa are easier to recognize by their provincial peculiarities, though they too must be distinguished from the

Maghribi. This hand, characteristic of the Islamic west as the name implies, has remained in general use right until the present day, and even led to the creation of special face types for printing. It can be regarded in some measure as a connecting link between the later delicate Kufic and the round hand, and it assumes in Arabic typography the same special place occupied by the Gothic script in European book production. It does not occur in epigraphy.

Persia first achieved her own style with Mir Ali of Tabriz at the time of her renaissance round 1400. This is *nast'aliq*; it remained cursive but distinguished strictly between thick and thin strokes and differed in other ways as well from *naskh*. It was carried to India and Turkey with the spread of the language and developed there for decorative purposes as well. There were several other calligraphic variants in special favour in the eastern zone but they were never used to decorate works of art and do not concern us here.

As to the meaning and content of the calligraphic friezes round vessels and utensils, whether standing alone or in combination with other decoration, it should be noted that over the whole of the Arab-speaking world, from Andalusia to Mesopotamia, they are almost always limited, even on purely secular objects, to quotations from the Koran or religious tags, general good wishes or eulogies of the ruler, and sometimes statements about the patron or artist. Only very exceptionally do we find, for example in Spain, an inscription with profane Arabic verses. On the other hand in the Persian cultural zone in addition to the types just enumerated we often find Persian poems: in Iran itself from the thirteenth century and on Indian and – more rarely – on Turkish work from the sixteenth. After the introduction of *nast'aliq* they are of course always in this script, which indeed was often used for pious quotations as well, for the sake of variety.

The eulogies of princes can be exceedingly important for deciding the date and provenance of an object. They vary very little and were more or less identical in all periods and countries, drawn up according to formula and only differing in the number, not in the kind of wishes and attributes. One of the lengthier texts would run something as follows:

"Fame and power and prosperity and long rule and health and blessing to our lord, the sultan, the king, the just, the wise, the noble, the warlike, the victorious...; may his rule endure."

Sometimes the eulogy is even more explicit and carefully chosen in expression, but more usually it is abbreviated. Objects not made for a particular ruler and intentionally kept anonymous were often inscribed with a vague stereotyped makeshift formula like "Praise the name of our lord the sultan" or with general good wishes, as: "Praise and blessing and prosperity to the owner".

The identification of the names mentioned in inscriptions with historical personalities is often extremely difficult because so little information is given about them. Arabic first names are customary in all Muslim countries, and generally patronymics, not family names are given with them, with at most a reference to rank or origin (*nisba*) in addition: "Ali ibn Umar ibn Abdullah al-Mausili" thus does not mean that this Ali resides in Mosul but that he, or perhaps his grandfather 'Abdullah, came from there. References of this kind generally only appear with the artist's signature, however.

The Fatimids and Almohads adopted the custom, widespread among the Arabs and Berbers, of calling themselves after their favorite sons, even in court ceremony: Abu Yaqub Yusuf (Joseph, father of Jacob) must not be confused with Abu Yusuf Yaqub (the reverse). Furthermore rulers frequently suppressed their own names on accession or at least set them aside in favour of another expressing their devotion to God, or they were immediately endowed with an honorific which carried symbolic significance; often both at once. The Abbasid caliphs for instance are almost all known by their pontifical names: al-Mutamid (bi'llah), the Man Supported (by God), al-Muti (bi'llah), the Man Obedient (to God) etc. The Mamluks almost always have three names, the first a decorative epithet, the second a function of the Faith, the last the original first name: e.g. al-Kamil Saif ad din Shaban (Shaban the Perfect, Sword of the Faith); others are called Rukn-ad-din, Nur-ad-din (Pillar of the Faith, Light of the Faith) and so on. Many other dynasties also used similar formulations, and in an analogous way many epithets refer to services to the country: Rukn-ad-daula (Pillar of the Empire) and such like. Turkish and Mongol rulers often have their native names, exotic-sounding in the Arabic, attached to the official title, and are then easier to identify.

Artists' Signatures. The fundamental religious attitude of Islam, which was decidedly inclined to disdain the deeds of the individual, is partly to blame for the fact that the historical sources, in other ways so anecdotal,

make no mention of the leading artists who at different times helped forward the development of styles and techniques; only calligraphy and later miniature painting can be linked with specific personalities. Even so the names of artists have survived in large numbers, mainly on Mosul bronzes, sword blades and Spanish ivory boxes, but hardly ever on glass or faience, except for a few isolated examples, especially in a particular Syrio-Egyptian group; biographical data are only available for calligraphers and painters, and then only very few. Signatures are almost always added very modestly in a discreet corner, though sometimes they also come at the end of a longish dedicatory inscription; they are mostly introduced by the Arabic *fecit* عمل, a word whose shape is not hard to recognize. Usually the home of the maker is given more importance than his name: it is often followed by the date, sometimes, from the fourteenth century, in numerals, but usually written out.

BOOKS

There are many examples surviving from the great periods of Islamic book production, in many different forms; they have only recently been assembled and studied in a systematic manner. There are on the one hand whole manuscripts, or fragments of them, sometimes in their original bindings, on the other collectors' albums or single pages from such. In the manuscripts there is at once a distinction to be drawn between those with and those without notable calligraphy or some kind of illumination. No art lover will be tempted to acquire a book simply for the text, or because it is a few hundred years old, nor should he be interested in books with rough and tasteless illustrations; criteria in this field are far removed from the attractions of primitive exoticism, being based on the standards of a highly refined and cultivated art.

As a general rule works written by a master hand are carefully illuminated as well, and the orientals themselves rate calligraphy considerably higher than we do: the names of all the great calligraphers of Islam are known, and authentic works from their brushes have always been highly prized and changed hands for large sums of money. The European collector is unlikely to aspire to the arduous study needed for real connoisseurship in this field, and is likely to rest content with a superficial acquaintanceship with the most important forms of the script, such as we have given in the preceding chapter and will complete more fully below.

The Arabic script has no capital letters and ornamental illumination possesses none of the decorative initials so important in our European mediaeval manuscripts. The task of the illuminators was thus confined to decorating title pages, chapter headings, border medallions and so on. They found their greatest scope in working on copies of the Koran, and the developments carried out there were then transferred to the ornamentation of other texts; so that there is a certain uniformity throughout Islam.

Religious, juridical and philosophical books have never had real pictorial illustration, and of the remaining Arabic literature the only works to receive occasional illustration were scientific treatises, collections of fables, cosmographies and two or three other prose works (and these only until the end of the Middle Ages). Miniature painting as such evolved almost entirely in works of Persian literature, and it was in this field that it reached independent pictorial compositions; they were closely associated with the text and were to some extent subordinated to it.

The single leaf did not become fashionable before the fifteenth century. At that time people in the courts of West Turkestan, Persia and Istanbul began to take an interest in separate miniatures of every kind (portraits, genre, landscapes, still life) and collected them into albums in a large variety of formats called *muraqqa*, mixed with specimens of writing and unfinished drawings by well-known artists, all glued onto board. The borders of the mounts were decorated with ornamental motifs and sometimes figurative as well, not always very skilfully; and this custom continued in India into the nineteenth century. It is rarely possible to see any definite order in the contents; as a rule all the available material, ancient and modern, genuine and fake, native and foreign – including European etchings – was happily and sometimes quite tastelessly stuck together, very often with examples of calligraphy alternating with miniatures.

With complete manuscripts one never ceases to wonder at the exquisite refinement of oriental book production, achieved in the many different countries of Islam by the devoted collaboration of the numerous participants involved in each copy. The active interest of the patron himself is apparent in the careful choice of paper: often it is sprinkled with gold or colour-tinted, or it bears other marks of luxury quality: sometimes it was procured from far distant places. The layout was then carefully planned, and the number and style of title headings, border decoration, pictures etc. The calligrapher needed to take all this into account as he worked, and when he had finished it was the turn of the illuminator ("gilder") to decorate the title pages, headings, marginalia and such like with fine gold and coloured ornament; only after this did the painter, if he was required at all, add his compositions at the prescribed places. Finally the binder took over, making the cover simple or rich according to taste and to his technical skill, but never deviating from certain basic and universally accepted rules.

The edges of the pages and the binding had to coincide exactly all round, and the upper cover was never without its flap which, so to speak, held the whole volume together. This feature and the direction of the writing, causing the pagination to run from right to left, are not the only differences between oriental and western books; there are other characteristics which the collector has to look out for. For instance the title page is always double, never single, and the arrangement of the decoration of the two halves combines them into a single unit, often counterbalanced by an equally ornate pair of end pages. Even if they are omitted the text usually begins on an inner right hand page.

The name of the calligrapher, the date and place of production, if appearing at all, were recorded in a modestly worded tail colophon that follows directly on the final word of the text. Often the outer protecting pages of the volume show the seals and handwritten notes of earlier owners; these may be of interest, especially where there is no signature. Books were not infrequently rebound in quite early periods and title pages re-placed, or damaged paintings restored. Lastly we should remember that books both in private houses and in large libraries were not kept on shelves side by side in rows, but one above the other in piles of different heights in niches in the wall.

The following chapter examines the different types of manuscript likely to be of interest to the connoisseur and collector, and attempts to provide him with the most essential equipment for assessing them.

KORAN MANUSCRIPTS

It is relatively easy even for a novice to see whether or not an Arabic manuscript is a Koran. In complete examples the irregular length of the sura is a sure diagnostic; the headings are always given prominence by decoration, and these are few in the first part, becoming increasingly frequent towards the end. Furthermore the chapter headings, however varied they may otherwise be, always begin with the word سورة "sura", and once these characters have been learnt it is often possible to recognise even fragments of the holy book without difficulty. For purposes of teaching it was often divided up into larger and smaller sections (*juz'a* and *hazb*) which are indicated by border medallions or sometimes copied out separately. There are also markings for pauses and small signs at the ends of the verses interpolated into the unbroken text.

Kufic Texts. Korans of the first centuries of the *hijra* are always written in the angular vertical letters of the Kufic style that solemnly and piously sets down the holy words in a thick and ponderous hand. It is called after the town of Kufa in Iraq, one of the first cultural centres of Islam. Hardly anything but fragments has survived, but these in not inconsiderable quantities, written on parchment in horizontal format, with the title pages and headings decorated either purely in gold or with the addition of a few colours. Embellishment consists at first entirely of interlacery and similar geometric motifs, but soon a number of varieties of palmette and other adaptations of plant forms are added in the border medallions (Fig. 2). In the tenth and eleventh centuries in Cairo, Baghdad and Persia, the introduction of paper made a vertical format customary; the calligraphy loses some of its hieratic stiffness by the addition of flourishes to the verticals and by curves, and is often given a discreet background of arabesques. Korans written in the erroneously termed Karmatic Kufic (Plate 1) are especially rare and sought after, while it is still possible occasionally to find single leaves of parchment in the archaic style on the bookstalls of oriental bazaars. It is important to make sure that the letters have not been touched up with paint, as may be the case if the original writing has faded. This can be detected by the wary in the more hesitant

penmanship, and usually because the colour of the ink is fresh and pronouncedly black instead of brownish.

Maghribi Texts. The peculiarities of the western ductus which we described in the previous chapter are identifiable in Spanish and Moroccan Korans after the early twelfth century; they have remained characteristic of the whole of North Africa to the present day. This region never set such store by calligraphic training as did the East, and there are examples written

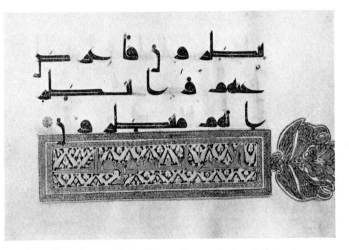

Fig. 2. Page from a Kufic Koran. Iraq or Syria, ninth century.
Museum Dahlem, Berlin.

without much artistry (though perhaps with care), but with strikingly rich illumination. The Moorish codices are unequalled for the imaginative play of the arabesque work, executed primarily in gold and blue, that surrounds the pages in never repeated variants, twining round the headings and embellishing the marginalia. Valencia, Seville and Fez vied in producing manuscripts throughout the high period of the twelfth and thirteenth centuries (Fig. 3), using remarkably long pieces of parchment; in the fourteenth and fifteenth centuries Granada came to the fore alongside the Moroccan capital with its more vivid colourings; and the Alhambra style became established for all time as the model for codex embellishment throughout the Maghreb (Fig. 4). Certain manuscripts belong to a western Islamic school whose centre has not yet been discovered; instead of the decoration being held in frames and spandrels the text is accompanied by free drawings of tree forms with some of their branches even spreading

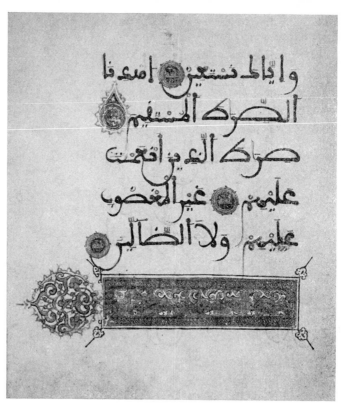

Fig. 3. Page from a Koran in Maghribi hand. Spain or Morocco, dated 1305.
Staatsbibliothek, Munich.

across the text. They have, perhaps rightly, been associated with Sicily, where the Islamic crafts still flourished in the thirteenth century and where painting on ivory especially (see below) shows very similar decorative tendencies.

Early Maghribi texts with rich illumination are extremely rare; there is little to be found in the trade except late Tunisian, Moroccan and Sudanese Korans, and a few religious tracts, most of them written hastily and painted in a rough and superficial manner. The bright colouring and use of contrasting inks often gives them a certain exotic primitive charm which should not of course serve in any way as a criterion of their value.

Korans from Baghdad and Cairo. Different variants evolved comparatively early from the ordinary cursive *naskhi* hand, the most important being the curving and elegant *thuluth*; its dimensions, swells and curves are all subject

24

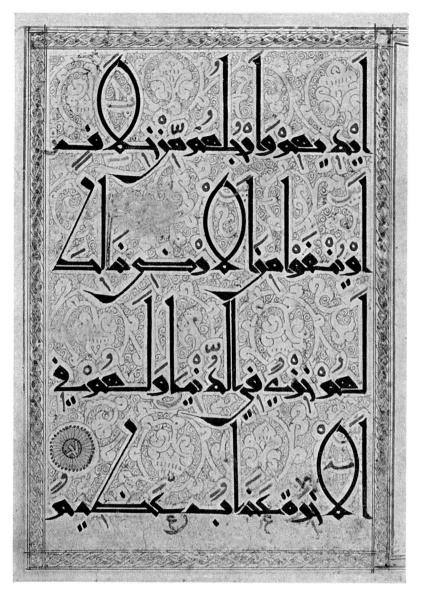

Plate I. Page of text from a Koran. Persia, eleventh century.
Museum Dahlem, Berlin.

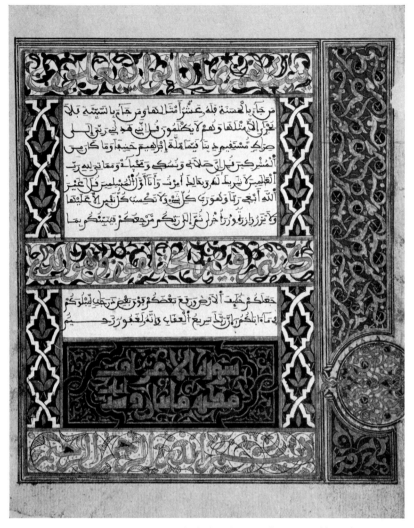

Fig. 4. Page from a Koran in Maghribi hand. Granada or Fez, fifteenth century.
Islamisches Museum, Berlin.

to a strict canon devised by extremely sensitive aesthetes; they laid down
detailed laws even on questions of space, distances between letters, the
width of margins and other such matters. Apart from the famous names
of the leaders of the Baghdad school, Ibn Muqla, Ibn Bawwab and Yaqut
al-Mustasemi, a large number of other names of artists who worked out-
standingly in *naskh* are recorded, but we have no texts identified with one

25

or another to enable us to judge how far they excelled over the anonymous examples that have survived, and survived in great quantities, since the thirteenth century at least. Many are from the Mamluk period in Egypt, illuminated in blue, brown and gold, the title pages usually without text and divided up geometrically into lattice or star shaped compartments with arabesques and palmettes; the sura headings are generally in Kufic-like letters on a ground of leaf scrolls and surrounded by a border of interlacery. From the fifteenth century the clarity of execution leaves something to be desired; it is relatively easy to recognize late copies in this way and by certain contradictions in the use of space, which loses breadth and confidence. Since the same style of writing was adopted in most of the other Islamic countries, we have to rely on variations in the ornament to decide on geographical attributions.

It is at present uncertain whether we are to credit the school of Cairo or that of Baghdad (which became more vigorous again under the Mongol Ilkhans in the thirteenth century) with the feat of transforming the lapidary style of the Kufic Korans into rounded forms, and developing its mature ornamental beauty. In any case the large and majestic *tumar* variant was used in both cities for luxury Korans. Soon it was generally current in the epigraphy of the Mamluk period but never quite so effectively as in the gigantic pages of these incomparably imposing Korans, with their few words, sometimes kept entirely to gold and black, balanced against each other with an unfailing sensitivity for harmony and rhythm (Fig. 5).

Persian and Turkish Korans. After the Mongol invasion Tabriz came to the fore as the centre of the Persian school of calligraphy and illumination. For a short time round 1400 Samarkand became the artistic focus under the great Timur; but later, when that city declined, Tabriz again began to grow in importance. Towards the end of the fifteenth century it was chosen by the new Safavid Shah as his residence and soon held undisputed sway, especially in the production of fine Korans. The emblematic scheme of dividing the title pages into star or medallion-shaped fields with borders framing them with reciprocal patterns or cartouches was invented in Tabriz. This style of decoration was then adopted by carpet designers to produce the most far-reaching revolution in Persian carpet design. The repertoire undergoes a complete change: thin flower stems cover the ground in a maze of delicate lines, upon which are laid more boldly drawn palmette flowers and cloud bands together with pure arabesques. Blue still pre-

بِسْمِ اللّٰهِ الرَّحْمٰنِ الرَّحِيمِ

يَا أَيُّهَا النَّاسُ اتَّقُوا رَبَّكُمُ

الَّذِي خَلَقَكُم مِّن نَّفْسٍ

وَاحِدَةٍ وَخَلَقَ مِنْهَا

Fig. 5. Page from a luxury Koran, Baghdad, fourteenth century.
Staatsbibliothek, Dresden.

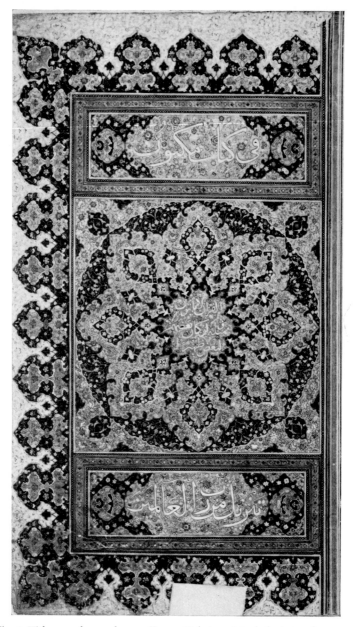

Fig. 6. Title page from a luxury Koran. Tabriz or Istanbul, sixteenth century.
Frau Maria Sarre, Ascona.

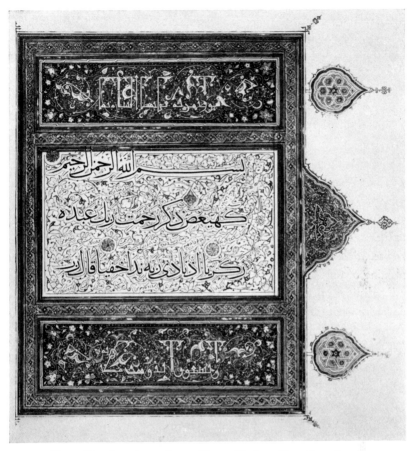

Fig. 7. Illuminated page from a Koran. Turkey, fifteenth century.
Formerly Martin collection.

dominates at first, but towards the end of the sixteenth century red becomes
more important, all combined with many other colours and several tones
of gold. These provide the background, especially in the decorative zigzag
sided medallions, for single words of the text picked out in elegant white
thuluth (Fig. 6).

The school of Constantinople grew up in the sixteenth and seventeenth
century as an offshoot of Tabriz, with the Turkish sultans summoning
thither a succession of Persian artists. Their influence on the budding craft
there was so strong that it is now in many cases quite impossible to deter-
mine whether a text was produced in one or the other centre (Fig. 7). In

29

the mosques of Constantinople especially there appeared a large number of splendid Korans, many of them firmly dated and signed by famous calligraphers, and now the pride of the Türk ve Islam Eserleri Museum. Other religious texts were copied and decorated in the same manner, and they are equally difficult to attribute definitely to one or the other city unless they themselves provide the necessary information. Some Ottoman sultans took great pride in being themselves distinguished copyists of the Koran.

In Persia the notable centres other than Tabriz were Herat and Shiraz, and later Qazvin and Isfahan as well; but here it was not primarily religious but secular texts that dominated the calligraphic development (see below, p. 40f.). In Turkey a special small pocket format of the Koran was developed in the seventeenth century, and soon adopted everywhere. Since the eighteenth century the work of both countries deteriorated, with unpleasing colours and inferior gilding and rough confused drawing; artistically distinguished examples of late date are very rare. Indian Korans developed with little originality from Persian models; finely illuminated examples of the early Mughal period are exceptional.

SINGLE LEAVES OF CALLIGRAPHY

Persian and Indian collectors' albums of the sixteenth to nineteenth century regularly contain examples of calligraphy by contemporary or older masters. Anyone with some knowledge of the history of Islamic calligraphy who has leafed through a number of these with any care will have noticed how patently erroneous is the great play made with the famous names. One may wonder whether the oriental collectors, who must after all have had adequate expertise in this subject, could really be taken in by such forgeries, or whether rather they themselves commissioned these falsely signed but often quite skilfully imitated leaves when there were no genuine ones to be had. Often indeed there is clearly no attempt at deliberate forgery, but simply true copies at third, fourth or tenth hand of long vanished originals, rather as the paintings of the great Chinese painters have only come down to us through a series of repetitions. This whole question, however, is of little import to the European collector, for he is less concerned with the authenticity of the attribution of these calligraphic pieces than with the general decorative effect, and this is perfectly achieved by the faithful copy.

It is especially the names of the great teachers of *nast'aliq*, such as Mir Ali al-Katib, Sultan Ali al-Meshhedi, Imad al-Husni, that we meet again and again. Since none of them lived before the fifteenth to seventeenth century, it may be that a large number of the signed leaves are really by them; on the other hand there are others in *thuluth*, purporting for example to be the work of Yaqut al-Mostasami, which are of course immediately suspect.

The leaves in question might either have been skilfully assembled from the remains of famous writers' manuscripts, or they may have been produced directly for the particular purpose. Sometimes they were written as teaching models, sometimes they were done to show off the skill of the calligrapher in his handling of the pen. Hence the many flourishes and elaborations that so frequently occur: examples in white or coloured ink, whole pages in the bewilderingly florid *shikeste* hand, difficult to decipher even for the initiated, or others in the minute *ghabri* that looks as though it was blown on like dust, and all kinds of figures – lions, birds, horses,

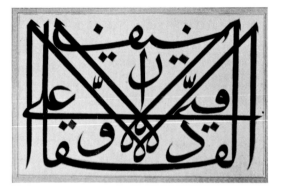

Fig. 8. Calligraphic motto. Persia, sixteenth or seventeenth century.
Islamisches Museum, Berlin.

Fig. 9. Calligraphic motto. Persia, seventeenth century.
Frau Maria Sarre, Ascona.

ships and so forth, formed from the letters of a *bismillah* or other pious
saying, often with much wit and grace, always with an extraordinary fine
sense of ornamental consistency. These leaves, glued on to board or framed,
were always much sought after and considered auspicious to hang on the
wall of a room (Figs. 8, 9).

Anyone who is interested in gaining greater understanding of the
mysteries of Islamic calligraphy and enjoying all its aesthetic possibilities

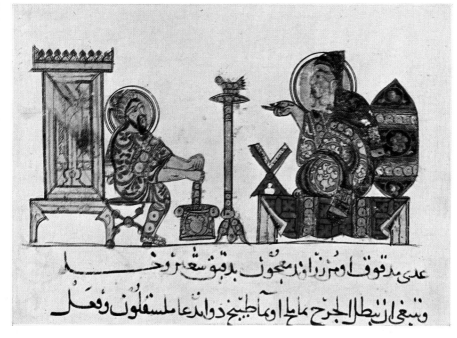

Plate II. Miniature from an edition of Dioscorides, dated 1224, Baghdad.
Freer Gallery, Washington.

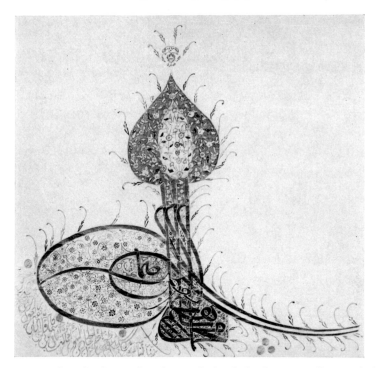

Fig. 10. Tughra of Sultan Mehmed IV at the head of a firman or edict. Istanbul,
seventeenth century.
Türk ve Islam Eserleri Müzesi, Istanbul.

will begin by searching for these leaves; they either appear on the market
assembled in collectors' albums or quite often singly. Characteristic
examples of calligraphy can often be acquired relatively cheaply; appre-
ciation of their beauty has dwindled in the East where earlier they were
very highly prized, while few people are yet aware of them in the West.

Remarkable examples of calligraphy are the decrees of nomination
(*firman*) and other document rolls, often metres long, issued by the Sublime
Porte in the *diwani* hand, a vigorous official version of *naskh*; as the head-
ing stands the *tughra*, the decorative signature of the reigning sultan, in
the most elaborate form imaginable, but always with three long uprights
and a large sweeping loop to the left. The *nishanji* or keeper of the imperial
cypher was responsible for drafting it; the illuminator then added flowery
decoration in colours heightened with gold (Fig. 10).

ARABIC ILLUMINATED MANUSCRIPTS

Scattered fragments of Arab texts with sketchy drawings, mostly found in Fostat (Old Cairo) must be regarded as the oldest attempts at pictorial art in the Islamic realm (eighth to eleventh century). They show no consistent development: there is no sign of this until the Baghdad school of painting in the twelfth century.

Fig. 11. From a manuscript of the Fables of Kalila wa Dimna.
Baghdad, thirteenth century.
Bibliothèque Nationale, Paris.

The Arab contribution to the study of the natural sciences is well known, and how they continued to build on the foundations of knowledge inherited from the classical world. All the available Greek treatises on physics, chemistry, botany, medicine, astronomy were conscientiously translated to the orders of the Abbasid caliphs, and in view of the importance of the pictorial explanations of the problems dealt with, it is not surprising that the illustrations were also copied or rendered anew in accordance with the spirit of the time. Thus there arose in Baghdad from about the tenth century a school of book illustration in which late classical

34

naturalistic, Manichaean-Uigurian and Islamic ornamental styles were all combined in a highly individual manner. This style was soon transferred to other texts that had become favourites especially the fables of Badpai (Kalila wa Dimna) and didactic bestiaries, and later to the *maqamat* (discourses) of Hariri which became so popular in the twelfth century. In recent decades many fragments of such manuscripts have been appearing, and though none is earlier than the twelfth or thirteenth century, they are sufficiently numerous to give us an adequate idea of this early Arabic miniature style (Fig. 11). It is remarkable, in spite of its occasional reminiscences of Syrian-Nestorian or Byzantine models, for the great independence and vitality of its expression, for the economy of its execution and the decorative sense of composition. A vivid colour scheme with much shading and rich gilding, the movement of folds and ornamental detail in the garments, give these pages a very individual colourful charm.

A version of the Materia Medica of Dioscorides of 1224, dispersed among a number of collections, and an especially splendid manuscript of Hariri of 1237 (Bibliothèque Nationale), have preserved for us the names of the painters Abdullah ibn al-Fadhl and Yahya al-Wasiti. The former shows how far he has outgrown his Greek models, for example where he portrays a famous doctor dictating a prescription to his amanuensis (Plate II); the latter demonstrates in many of his pictures his genius for composition. One of his most brilliant works is the miniature showing a cavalry detachment with its standards, drums and trumpets, each member singled out to the utmost effect and the legs of the horses lined up like a palisade (Fig. 12). The school seems to have flourished for a time after the Mongol invasion; works of this last phase can be recognized by the presence of Far Eastern elements, especially in the landscapes. Among the off-shoots it founded in other centres the school of Cairo rose to great heights in the Fatimid period. Only a small number of examples of this style has been preserved. There are however the ceilings of the Cappella Palatina in Palermo to give us an idea of the achievement of this school. A manuscript of Jazari of 1315 with a description of hydraulic automata already belongs in the Mamluk period. It illustrates, among others, the animated clock designed by the author with its different figures to register the dates, days and hours.

In the fourteenth century interest in Greek science waned, and the traditional schemes survived only and to a limited extent in astronomical

Fig. 12. Procession with standards from a manuscript of Hariri by Yahya al-wasiti
dated 1237, Baghdad.
Bibliothèque Nationale, Paris.

treatises which could not very well do without the figurative representation
of the constellations. There are still books of fables, and while copies of
Hariri become rarer, another Arabic text is more frequently illustrated
instead. It seems that the variety and character of its contents made it
particularly suitable to preserve the connection with the previous period.
This was the cosmography of Qazvini; it treats of plants and animals,
wonders of nature and fabulous beings, of angels and demons and many
other things. It was considered an indispensable part of any library. The
oldest example known to us, preserved in the National Library in Munich,
was produced in 1280; it shows a final flicker of the Arab style of painting,

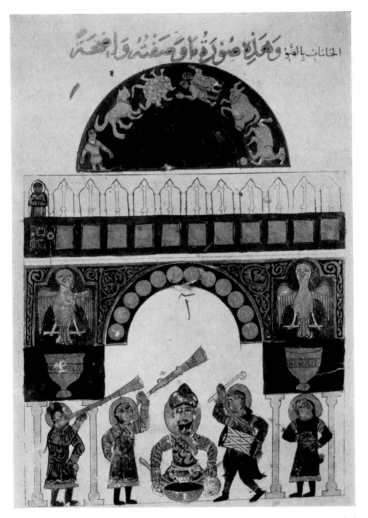

Fig. 13. Jazari's animated clock. From a manuscript dated 1315, Syria or Cairo.
Museum of Fine Arts, Boston.

while its successors already belong completely to the Persian-Mongol
miniature style. They vie with each other in fidelity to nature in the
representations of plants and animals, and the figures of archangels are
sometimes treated in a most impressive manner (Plate III).

In the fifteenth century representations of figures in Arab manuscripts
virtually cease, and they never seem to have been common in the Muslim
West.

The "Arabic primitives" being so rare, even single leaves are treasured and reach fantastic prices on the market; they are very rarely of any calligraphic distinction, but are written with indifferent care, and without any decorative intent, in the habitual *naskh*.

PERSIAN ILLUMINATED
MANUSCRIPTS

It is known that book illumination existed in Iran in the pre-Islamic Sasanid period, but nothing remains to give us an indication of what it was like. It is conceivable however that elements of the old national style survived in some regions in miniature painting, just as they did in ceramics, metalwork and textiles, encouraged by the Samanid, Buyid and subsequent dynasties. Of recent years a manuscript has suddenly appeared which is a Persian book of instruction for princes with many pictures in a very lively and quite individual style. There are Sasanid features in some of the motifs and it is superficially reminiscent of the rough pottery of Nishapur (see below). It is dated by the colophon to the end of the eleventh century and has aroused considerable interest because both the drawing and the colours are quite unusual, without any connection with the later evolution of book illumination in Persia. This first followed the Baghdad school and then created its own style under Mongol influence. One half of the manuscript was acquired by the museum in Cincinnati and the other by the Kevorkian Foundation in New York, and its authenticity has been seriously questioned by several experts, among others by prominent Iranists on textual grounds; but no conclusive proof of forgery has been produced and it is a matter for debate whether any modern painter would be able to invent this very consistent and completely original miniature style.

Forgeries of Persian miniatures are no rarity, and the collector has to be careful because even oriental dealers are easily deceived in this matter. The speculators tend to choose securely dated old manuscripts that happen to have been left unfinished with spaces left for the miniatures. When these are skilfully painted in the style of the period to which the manuscript belongs, and with some plausible reference to the text, they can easily be mistaken for genuine. But of course it is difficult to avoid every possible stylistic or iconographic solecism, and these mistakes provide the experienced connoisseur with adequate means of unmasking a forgery. In other cases a manuscript without illustrations was taken and paintings simply stuck over parts of the text, or the text was erased and a picture composed *ad hoc* in its place, in the hope that the purchaser, being ignorant of Persian,

would not notice the gaps in the text. Close examination can show remains of writing, if no whole letters, under the forged pictures.

These remarks apply to all periods of Persian book illustration; and incidentally the Persians also illustrated Arabic and even sometimes Turkish texts, so that a text in a foreign language is no indication that the paintings do not belong to one of the Persian schools. Their greatest scope was naturally in illustrating works of native poetry. Two great epics are pre-eminent, and between them provide the foundation for the whole develop-ment of the genre: the famous *Shah-Nameh* (Book of Kings) by Firdausi and the *Khamsa* (Five Poems) by Nizami, with the song of Alexander and the love stories of Chosrau and Shirin and of Majnun and Leila. Other favour-ites for illustration were certain works of less literary importance, while of the other great writers Hafiz was only rarely chosen; Saadi's *Bostan* (Orchard) and, after the late fifteenth century, Jami's *Joseph* were more frequently illustrated. Persian texts can always be recognized even by the layman because they are always written in columns – usually four, but shorter poems in two – and from the fifteenth century always in the cursive *nast'aliq*; if pure *naskh* is used they belong to an earlier period. Apart from translations from the Arabic the only prose works that were occasionally enriched with illumination were chronicles like those of Rashid al-din and al-Biruni and later the *Safa-Nameh* (History of Timur).

The ornamentation of title and decorative pages in Persian manuscripts naturally developed somewhat differently from that of Koran illumination, even though the same decorative elements were used. In the first place the gilders in the Timurid period evolved a line of their own, either in larger areas of artistic interlacery of arabesques and palmettes in regular repeats (Fig. 14), or in combinations of individual panels with fillings of minute decoration in medallions, cartouches and rosettes, interspersed with lines of verse delicately set in clouds (Fig. 15).

Since it was the calligraphers who had to leave the space free for the pictures it was often they who decided the form of composition by the fanciful layout of a few lines of verse on the page to be illuminated, and the painters not infrequently had cause to complain of undue interference with their own freedom of design; the principle itself was never challenged, however, and it is to its strict enforcement that we are indebted for one of the great charms of Persian book miniatures: the intimate harmony of text and picture. Where this constituted the primary aesthetic consideration

40

Plate III. The Archangel Michael from a Cosmography by Qazvin,
late fourteenth century, Baghdad.
Freer Gallery, Washington.

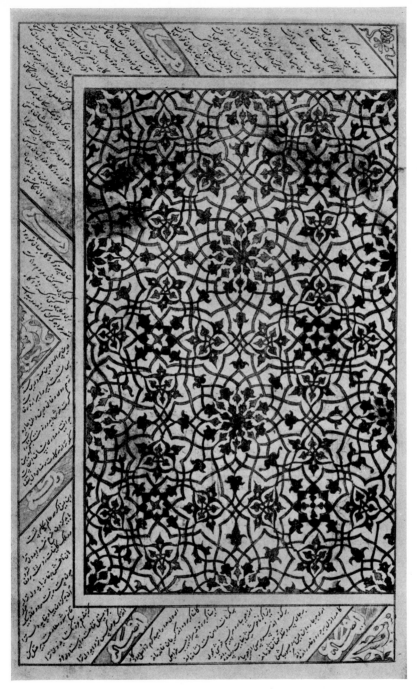

Fig. 14. Illuminated page from a Persian manuscript, dated 1410, Shiraz.
Gulbenkian Foundation, Lisbon.

41

the purely flat linear style had to be extremely rigidly preserved, avoiding both plastic modelling of the figures and every effect that might deepen space through perspective. This is what gives Islamic book illumination that look which may seem strange to us at first sight, and not any "primitive" concept of art, such as the critic versed in the western tradition tends to invoke.

The Persian-Mongol Period. Until the middle of the thirteenth century the Iranian book illuminator can be considered as dependent on the Baghdad school; there are several surviving examples to prove it. But soon after the Mongol invasion the situation changed, and the miniaturists, confronted with entirely new problems by their introduction to the East Asian view of art, now aspired to master the achievements of Chinese ink painting and create an Irano-Mongol synthesis. A rare bestiary preserved in the Morgan Library in New York, dated 1298 and painted in Maragheh in Persia, is interesting in this connection. It contains a number of miniatures in which the composition and colours are clearly in the tradition of the Baghdad school (Fig. 16), while others have adopted Far Eastern elements, particularly in the rendering of landscape, and others again appear to be direct copies of East Asian models.

The Ilkhans, the Mongol rulers of Iran, proved to be great patrons of the arts and especially of book illustration. One of their viziers, Rashid al-din, founded his own academy outside his residence of Tabriz and gave it the task, among others, of producing copies of the great world chronicle that he himself was writing. A few of these manuscripts have survived from the early fourteenth century, with exceptionally rich illumination, the strong East Asian influence expressed both in costume and landscape, and above all in the pale colours applied in washes (Fig. 17). The episodes from the life of the Prophet Muhammad are very interesting from the point of view of iconography; representation of the Prophet had been strictly avoided until that time, but the Mongols, themselves only recently converted to Islam, and extremely tolerant towards Christianity, Buddhism and other religions, had no qualms. The Iranian element that was to play so decisive a part in the further development is noticeable in the compositions. In spite of China's established lead in painting her direct influence was not lasting, because the themes that soon preoccupied the painters were so pronouncedly national that they were able to force even foreign elements into their own mould; also their technique was restricted. Had

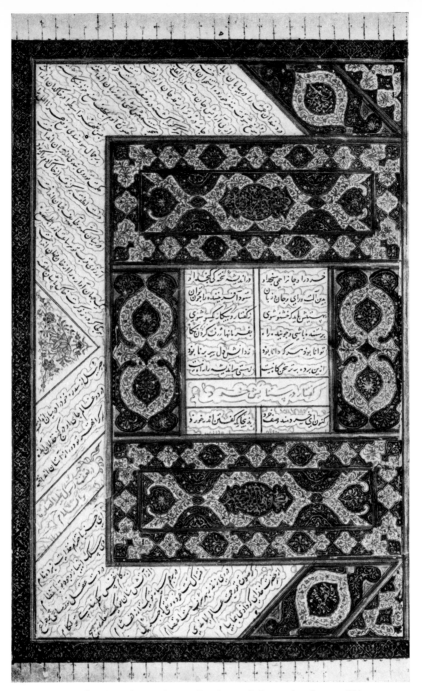

Fig. 15. Illuminated page from a Persian anthology, dated 1420, Shiraz.
Islamisches Museum, Berlin.

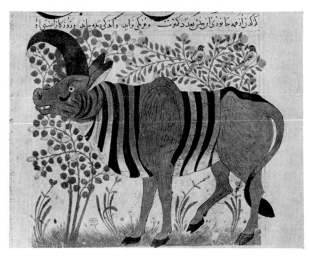

Fig. 16. The Rhinoceros, miniature from a Bestiary, dated 1298, Persia.
Pierpont Morgan Library, New York.

the East Asian fashion of hanging scrolls and hand scrolls made headway
in Persia (a fashion inhibited from the outset by a directly conflicting sense
of space), it is certain that large ink paintings would have treated the heroic
deeds of Rustam, and these in turn would have influenced book illustration.
As it was the whole development had to take place within the sphere of
the miniature in opaque colours, and it is not surprising that the Far Eastern
style made its mark less in the composition of the picture than in a general
Mongolization of types, and above all in the factor of landscape.

In smaller copies of Firdausi of the early fourteenth century the pictures
were first placed in strips between the text with a few figures picked out

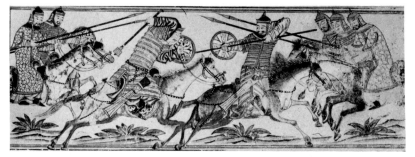

Fig. 17. Battle scene from Rashid al-Din's World Chronicle, dated 1307–1308,
Tabriz.
University Library, Edinburgh.

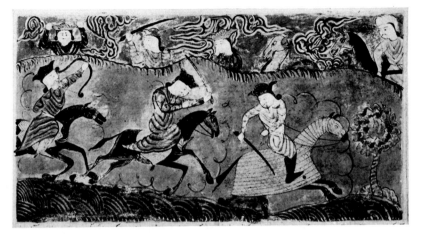

Fig. 18. Miniature from a *Shah-Nameh*. Fourteenth century, Fars.
Kofler-Truniger collection, Lucerne.

in bright colours against a red or yellow background. In Fars in southern
Persia, with Shiraz as its centre, this style seems to have taken root, and
East Asian elements did not entirely displace certain reminiscences of the
Baghdad school. Gradually the pictures became larger, but the other
colours lost intensity in favour of the dominant red background (Fig. 18).

At first the number and choice of pictures obeyed no definite canon;
it was decided anew in each case which events were to be illustrated, and
the models were handled in quite an individual manner. The more or
less stereotyped schemes that came into use were not worked out until the
following period.

A large and splendid copy of Firdausi's Book of Kings, formerly in the
possession of the antiquarian Demotte and now scattered among a number
of public and private collections, gives us an impression of the first great
flowering of Persian miniature art between 1330 and 1340. The scenes are
depicted with extremely lively expressions and gestures and a tendency
to submerge the figures into their surroundings; it is clear that the artists
were endeavouring to liberate themselves from Far Eastern tutelage and
achieve a freer style; Tabriz itself is probably the centre of this trend
(Fig. 19). No less remarkable for the unusual surety of its observation of
nature and for the effective treatment of the themes both from the point
of view of design and colour is a manuscript in Istanbul of the Fables of
Kalila wa Dimna, also in large format. Some names have come down to

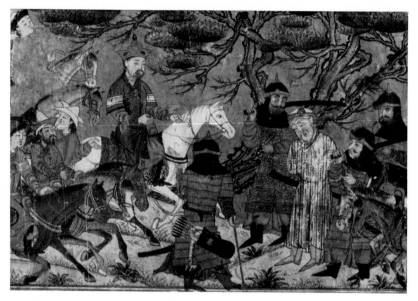

Fig. 19. Artaban taken prisoner before Ardashir, from a *Shah-Nameh*, c. 1330, Tabriz.
Coll. Véver, Paris.

us of the painters who led this national revival; the greatest is Ahmad Musa whose signature appears occasionally, usually on miniatures which are unmistakeably of the late fourteenth century.

Meanwhile the movement received great encouragement from the Jalairid sultans, both in Tabriz and in Baghdad, their two residences. When Timur conquered Baghdad, sweeping on his victorious campaign of 1393 through the Near East, he carried off Abd al-Hayy, the leading artist there, to his court in Samarkand. Another Baghdad artist, Junaid, has left a manuscript of poems dated 1396, preserved in London. The compositions breathe a loving, almost romantic immersion in nature and at the same time herald the development that was to be pursued by Persian miniature art in the fifteenth century (Fig. 20).

The Timurid Schools of Painting. We know from several reports that the great conqueror had his palaces in Samarkand covered with frescoes, most of them depicting his campaigns and other deeds. Of course the book illustrators whom he summoned from all parts were also given tasks, but as yet it has not been possible to distinguish a special Samarkand miniature school. Under his successors the two main centres were at Herat and

46

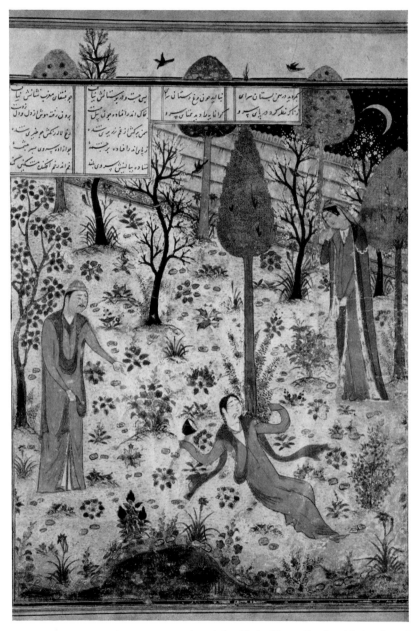

Fig. 20. Miniature from a manuscript of the *Khaju Kirmani* by Junaid, dated 1396
Baghdad.
British Museum, London.

47

Shiraz, while Tabriz at that time was rather in the background. Shiraz, which had already played an important part in the illustration of Persian epics in the early fourteenth century (see above) remained very active under the Muzaffarids (until 1393) and reached its greatest heights under the Timurid princes who resided there in the first half of the fifteenth century. Besides copies of the *Shah-Nameh* and Nizami's anthologies of Persian poets *Khamsa* (*Five Poems*) were their especial favourites, usually with main and border text and pictures between them. The painters of Shiraz preferred pale colours and were usually content with an economical and terse treatment of the subject. The leading artists are not known to us by name, but there is no lack of examples of telling and often sensitive painting of high quality (Plate IV).

Herat had less of a tradition than Shiraz, but the son of Timur, Shah Rukh (1404–47), a great bibliophile, was a generous patron. It is characteristic of him that he sent the painter Ghiyathuddin with an embassy going to China so that he should bring home new impressions from there. His son Baysonqur (d. 1433) exceeded even his father in his enthusiasm for books, and founded a kind of book academy in his palace by permanently employing a large number of calligraphers, illuminators, miniaturists and binders. He not only sent for well known artists from outside but in addition sent commissions for his library to Shiraz and other centres. Several manuscripts with his book plate are preserved, for example, a superbly illustrated copy of Firdausi's *Shah-Nameh*, dated 1430, which is still the property of the Persian court (Fig. 21). The thematic composition shows incomparable mastery, but as regards the interpretation of landscape it is surpassed by a rich example of Badpai's fables, also in Teheran. This masterpiece is by an unknown artist whose sensitivity to the fabric and movement of nature revives the old Iranian *hvarenah*, the divine radiance on earth (Fig. 22). Herati miniatures can generally be distinguished from those of Shiraz through the warmer tones and the more carefully balanced relationships between the figures and their surroundings.

Characteristic of the Timurid period is a gold or deep blue ground, the latter sometimes enlivened by shreds of cloud or stars. The outdoor scenes are among hills with sparse grass and bushes, often with a fantastical vista of rocky cliffs at the back. Sometimes the action takes place in luxuriant gardens with flowering trees and gay flowers bordering a silvery stream, or in a mysterious wood, or in the solitary wastes of the desert. Occasionally

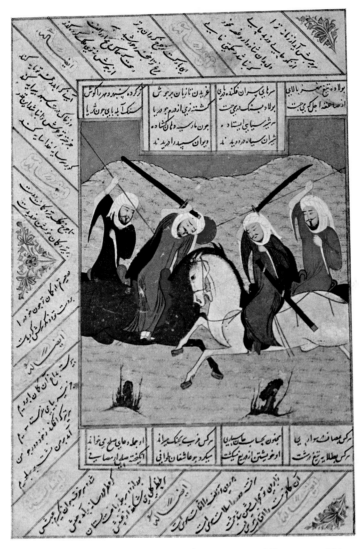

Plate IV. Miniature from an Anthology for Baysonqur Mirza, 1420, Shiraz.
Museum Dahlem, Berlin.

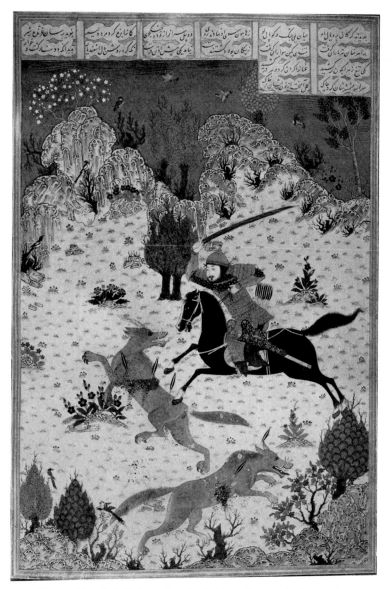

Fig. 21. Iskender's fight against the Wolves. From a *Shah-Nameh*,
dated Herat 1430.
Gulistan Museum, Teheran.

Fig. 22. From a manuscript of the Fables of Kalila and Dimna, c. 1420, Herat (?)
Gulistan Museum, Teheran.

an artist will add a personal note to his composition by a bold incursion
across the columns that frame his space. On the other hand the fifteenth
century painters cannot be exonerated from the charge of conventionality
in their treatment of the subject, their stiff inexpressive figures and purely
decorative groupings.

Timurid manuscripts of high quality are rare and much sought after by
museums and collectors, but separate leaves with delightful miniatures do
occasionally come on the market, though not always in perfect condition.

Bahzad and his School. The genius of Bahzad originated a style of painting
purified of foreign influences and free of all convention that aspired only
to render a lively account of the incident it was depicting. His creative
personality was of outstanding importance for the whole art of Persian
miniature painting. He was active in Herat between about 1470 and 1506
and then he moved to the Safavid residence of Tabriz, where he continued
working until about 1520. The manuscripts illustrated by him make it
clear immediately that he was not one to take orders from the calligraphers;
instead of accepting the written pages from them he himself chose the
subjects that interested him from an artistic point of view, almost always

Fig. 23. Timur at the building of a mosque. Miniature by Behzad,
late fifteenth century, Herat.
Walters Art Gallery, Baltimore.

stipulating that the whole page be reserved for him; for preference he painted over two facing pages, so as to have a larger area for his composition. Even the layman will have no difficulty in recognizing the enormous strides made since the previous period; the free gestures of the figures and the astonishingly rich characterisation of the types are immediately obvious, and if there is an opportunity to compare originals there will be no difficulty in picking out Bahzad's individual palette. He is without doubt the richest colorist among all the oriental artists; he scrupulously balances the tonal values and is a consummate master of the nuance, whether it be in the greens of the landscape or in flesh tones; a characteristic feature of nearly all his miniatures is the figure of a negro which he is obviously very reluctant to forgo because of the strong contrast it provides, while he equally obviously avoids depicting women as far as possible (Fig. 23).

The number of indubitably authentic works by the "Persian Raphael" is small, and since even in the sixteenth century Persian and Indian collectors were avid to acquire them there is a considerable quantity of leaves even from that century with his signature forged on them. Sometimes the pictures bear not the slightest approximation to his style, so that only the most ignorant purchaser could be deceived; in other cases and especially in later imitations they may be skilful in their way, but for the practised eye they present little danger. In any case a Persian miniature with the signature *Bahzad* is no less suspect than that hoary impostor, an old German painting signed with Dürer's monogram.

Bahzad had an imposing train of gifted pupils who continued to work in his style and who spread his gospel in all the centres of book illustration: Herat, Bokhara, Tabriz, Shiraz; Qasim Ali, Aga Mirek, Sheykhzadeh Mahmud, Abdullah, Mahmud the Gilder and Sultan Muhammad, of whom more will be said in due course, are among the most famous names, and all of them verified by surviving works. The illuminated copies of the *Shah-Nameh, Khamsa* and other works produced by them became models for following generations; but their more or less schematic compositions show no trace of spontaneity, and after the middle of the sixteenth century when Qazvin became the residence and came to the fore, illustrated manuscripts play a secondary role in the further development of miniature painting. The Metropolitan Museum has a particularly fine Nizami manuscript with miniatures by Sheykhzadeh Mahmud, dated 1525 (Fig. 24).

Fig. 24. Bahram Gur in one of the seven pavilions, dated 1524/25, Tabriz.
Metropolitan Museum, New York.

India and Turkey at that time also adopted the accepted norms for the choice and treatment of the illustrations when they took over the texts, but while the Mughal artists were able to add something of their own here and there, the Turkish school stayed more in the wake of the Safavid style, and it needs a sharp eye to pick out the signs, such as an inclination

Fig. 24a. Text by Sultan Ali with borders painted in gold, c. 1500, Persia.
Boston Museum.

to caricature, to be able to distinguish their work with certainty from that of contemporary work in Persia.

Complete examples of manuscripts of the sixteenth and seventeenth century with the paintings well preserved are not rare even today and are as a rule very overpriced; for greater artistic worth can only be attributed to them if they can be related more closely to one of the known artists. What is offered *en masse* are single leaves from manuscripts of this kind, often forged or painted into old texts by very skilful Persian painters working in Teheran and one or two European cities.

It is generally accepted that it was Bahzad who also introduced the technique of painting borders in the ink painting or water colour manner, in several tones of gold on paper of different colours round a text of fine calligraphy; at all events the oldest example of this known to us certainly comes from his circle. The motifs are never repeated; some are closely observed from nature, others entirely imaginary (Fig. 24a); they reveal an extraordinarily effortless power of invention combines with a facility with the brush that finds nothing an obstacle. The practice remained in favour throughout the sixteenth century and was continued after that especially in India, to decorate the borders of the mounts in collectors' albums.

PERSIAN MINIATURES

Timur is said to have brought together a considerable number of Chinese paintings in Samarkand, and this must have inspired the Iranian painters to tackle problems beyond those posed by simply illuminating a text. At any rate, attempts were made at his court at single paintings which show very strong traces of the East Asian models: battle scenes, genre paintings, dragons, cranes and suchlike. Even at that time the single leaves were glued together with older documents, examples of calligraphy and miniatures cut out of manuscripts, thus providing the first inspiration for the collectors' albums (*muraqqa*), a fashion which soon spread from the Timurid residence to Persia and India. It is interesting to follow the increasing Islamization of the motifs in the single leaves, while the ornamental affiliation to East Asia finally betrays its origin only in the subject matter. The drawing, quite unlike the Chinese impressionist manner, is often so fine that one is tempted to see the work as pen drawing; but it should be stressed that this technique remained entirely unknown in Persia and the hair brush was used always and exclusively, except sometimes to depict the fronds of feathers, and used by many artists with unbelievable skill. From the first these brush drawings were often slightly tinted and heightened with gold.

Sultan Muhammad appears to have been among the first to paint single leaf miniatures in opaque colours. He was the head of the painting school and director of the gallery of the art-loving Shah Tahmasp in Tabriz. A series of portraits from his studio has been preserved. From the costume alone they can be attributed with certainty to the Safavid court between 1530 and 1550, immediately recognizable by the baton in the turban. They are ideal portraits of elegant youths and girls, decoratively stylized and without any marked intention of realism (Fig. 25). Sultan Muhammad also occasionally treated genre subjects, but in this direction Ustad Mohammedi of Herat was the more important. He worked in the style of Bahzad but without any reference to a text and in pure wash technique, with observations of most convincing realism taken out of doors directly from nature, and with figures from the life (Fig. 26). He was succeeded towards the end of the sixteenth century by a large number of minor artists who

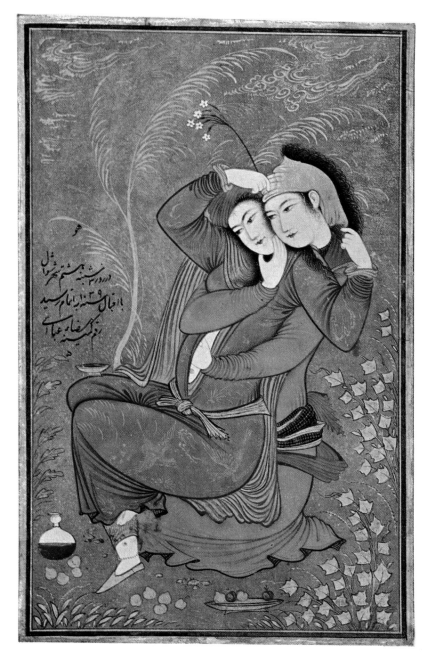

Plate V. Lovers, by Riza Abbasi. Miniature from an album.
Metropolitan Museum, New York.

Fig. 25. Portrait of Shah Tahmasp (?) by Sultan Muhammad, c. 1530, Tabriz.
Coll. Véver, Paris.

worked with brush or red pencil recording every fleeting impression,
often working up their drawing in colour afterwards to make the most
charming single leaves. Shah Abbas began to encourage this style when
he was in Qazvin and then drew many artists to his new residence in
Isfahan. He also introduced them to works of western painting.

The most outstanding personality here was Riza Abbasi. A large number
of his autographs survive. His reputation was very high in India too, and
ever since the seventeenth century his name has been much misused to
palm off, onto the unsuspecting, leaves in a similar style or forgeries of
varying grades of merit and refinement. Perfectly genuine works by Riza
are within the reach of everyone in good reproductions, and it needs only
a little effort to discern the qualities that distinguish him from mediocre
substitutes: the originality and lively vision behind the motif and its eco-
nomical rendering in a free, sure brush stroke (Fig. 27). He had a large
following, many of them highly competent, such as Muin, and illuminated
manuscripts also came under the influence of his school.

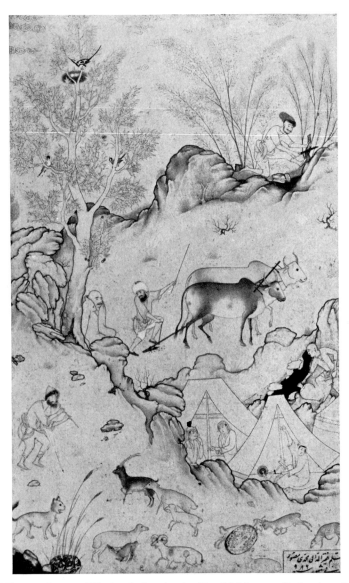

Fig. 26. Country Life, brush drawing by Ustad Mohammedi, dated 1578,
Persia (Qazvin).
Louvre, Paris.

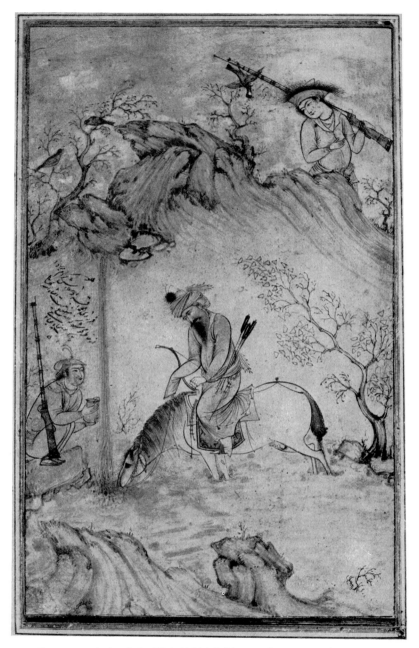

Fig. 27. Brush sketch by Rizâ Abbâsi, Isfahan, early seventeenth century.
Coll. L. Cartier, Paris.

He himself occasionally executed single leaves in opaque colours in a more careful style, for example the charming lovers in the Sarre collection with their delightful decorative curves (Plate V).

His son Shafi'i Abbasi, who later went to India, frequently repeated his father's sketches as paintings, and he imitated his signature with deceptive closeness. The influence of Riza was also felt in decorative wall painting and in other fields, particularly in ceramics and textiles.

In the latter part of the seventeenth century Shah Abbas II made an attempt to rescue book illustration from the stagnation and decadence into which it had fallen by sending several artists to Rome, but it was not a success. Muhammad Zeman was the only one to show any originality of response to western stimulation, but even he got no further than a rather gross mannerism when he ventured on Christian themes. Bazaar production was revived in the early nineteenth century but achieved nothing of artistic note.

Fig. 28. Group of Nomads, miniature by Muhammad Siyahi-Kelem.
Turkey or West Turkestan, fifteenth century.
Saray Library, Istanbul.

TURKISH MINIATURES

It has recently been demonstrated that there was a Turkish Mongol
school of painting in existence around the year 1400, though it is represented
only by a single gifted personality: Muhammad Siyahi-Kalam (Black Pen);
a considerable number of leaves, many of them with his name, is preserved
in one of the albums of the Saray Library in Istanbul. They surprise us
with their extremely brutal realism in the depiction of barbarian nomads,
among whom the painter must have lived: muscular dynamic figures
whose powerful movements and exuberant energy is stressed in the folds
of their garments, in their gestures and the facial expression which borders
on the demonic in its wildness. The figures, isolated or in loose groups and
always verging on the grotesque, reveal the artist's sharp observation and
a precise understanding of anatomy; the horses and other animals are no
less surely portrayed, often with bold foreshortening (Fig. 28). The artist
clearly stems from the East Asian tradition but he consistently follows a
very personal style, not least in his powerful colouring. He was destined
to have no successor.

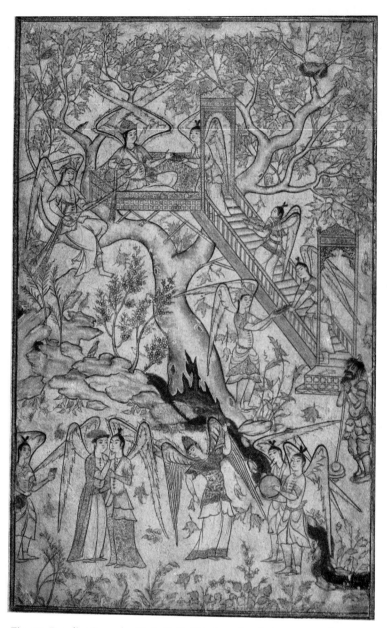

Fig. 29. Paradise Scene by Shah Quli. Tabriz or Istanbul, seventeenth century.
Freer Gallery, Washington.

In the sixteenth century the Turkish artists, as has already been said, showed little originality in illustrating Persian literary works. Among the artists who moved from Tabriz to Istanbul, Shah Quli is outstanding for his delightful and very delicate brush drawings, but they remain entirely Iranian in spirit. One of his best leaves shows a paradise scene a minutely drawn pleasure garden, full of atmosphere, with angels and genii watched over by a *div* as they gracefully disport themselves in a delicious landscape (Fig. 29).

Fig. 30. Sultan Mustafa enthroned. Istanbul, mid–sixteenth century.
University Library, Istanbul.

A distinct Turkish style only developed with the need to provide graphic illustration for the chronicles of the life and deeds of the Ottoman rulers, their campaigns, ceremonial receptions, processions, feasts at court and popular entertainments. It gave rise to the most faithful possible record of the events without any superfluous accessories. In the sixteenth and seventeenth century there were several artists who performed this task with skill; despite all the Persian and European influences, in so doing they developed a very independent Ottoman style which also took effect in work outside the sphere of the court (Fig. 30). The new painterly vision

which arose out of this development was also applied on occasion to excellent single leaves that are immediately recognizable as non–Persian, quite apart from the differences in costume (Fig. 31).

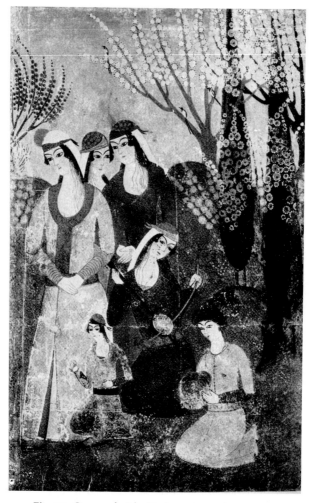

Fig. 31. Group of girls. Turkey, sixteenth century.

INDIAN MINIATURES

In India miniature painting under the rule of the Mughal emperors became a court art in the fullest sense of the word; the rulers were for long the only patrons, collectors and critics. Entirely dependent on their grace and whim, the artist was bound to prescriptions in content, form and technique that severely restricted his independence. Only the faintest personal touches were allowed to appear in his works, while the impersonal virtues of proficiency were at a premium. Wealth of invention or maturity of design were given no countenance in the guild, and technical skill alone counted for promotion; this scale of values naturally bred virtuosi who were plagiarizers and eclectics rather than creative talents. One is often constrained to associate even celebrated names with patent plagiarisms and it is rarely possible to distinguish any idiosyncracies of the various masters one from the other. Costume is the most reliable means of determining the period of a work apart from the general style which understandably changed with each emperor, but fashions changed more rapidly still. This criterion fails, of course, as soon as the question arises of later copies of older works. Most of the work was done on single leaves intended to be assembled in albums; and even when memoirs or other prose works were illustrated, the compositions were not always closely linked to the text: often the different themes were entrusted to different artists so that there was little likelihood of the whole maintaining any unity. Editions of Persian poets, on the other hand, were painted in the traditional manner and hence hardly entered at all into the Indian development.

Indian miniatures, especially bazaar wares of the nineteenth century, are frequently offered for sale. The collector is well advised, however, even when the leaf is clearly an early one, to subject the works to the most stringent standards possible as regards neatness of execution, and above all not be taken in by the charm of the "exotic". Many leaves are effective in colour but in other ways rough and mediocre.

The Sixteenth Century. The founder of the Mughal dynasty, Baber, attracted a few painters to his court from Bokhara; they introduced the style of Bahzad to the new guild in Delhi, though with a new direction in colour, departing from the rich opaque palette of the Persians to cooler

gouache tones which became characteristic of all Indian work. In this phase the dependence on the model is still very great; and even under Humayun, who indeed spent more than a decade as a refugee with Shah Tahmasp, the Persian influence is still strong. On the other hand, the individual Indian Islamic character is already apparent in the treatment both of landscape and figures. Under Akbar it developed into the full national style, and in this the influence of this most tolerant of princes was paramount, with his more than benevolent concern for the earlier cultural monuments of his people. He set about collecting Indian legends and stories and had them illustrated by native artists in his workshops. Here they came into contact with immigrant artists, and in the collaboration of the two elements the true Mughal miniature was brought to birth. The popular stories by Emir Hamze were copied in large format at that time and the most important scenes were represented by the court artists on linen in tempera; the Emperor even had one of his palaces decorated with frescoes by them, but attempts at a larger format seem to have ended there for the moment. At all events the Akbar period can be considered as the classical period of the large historical or dramatic composition, and the time when artists were most concerned with a vivid depiction of events and with the greatest possible heightening of expression (Fig. 32; cf. also Fig. 1).

The Seventeenth and Eighteenth Centuries. With Jehangir's accession in 1605 the court character of painting was intensified, even with regard to the subject matter. Themes are no longer taken from epics and sagas and artists are now required to describe the chronicle of court life with historical accuracy: receptions and audiences (durbar) festivities, hunts, polo tournaments and noteworthy episodes from the life of the ruler. For example if one of the leading court painters were comissioned to represent the Emperor with his entourage at ceremonial prayers in Idgah (Fig. 33) all those present at the function had to be depicted by portraits like enough to be easily identifiable, no small task within the confined space of a miniature. It was more usual however to portray the likeness of Jehangir himself, and the princes, dignitaries, officers, distinguished visitors and wellknown personalities of the time, poets and scholars, dervishes and holy men, in single portraits, giving to this form of art an importance which it has rarely achieved to the same extent in other cultural spheres (Fig. 34).

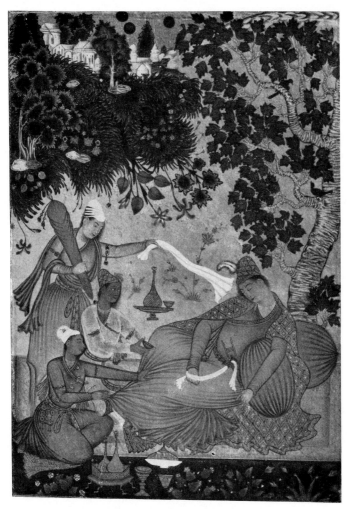

Fig. 32. The Emperor of the Deccan. India, c. 1600,
Islamisches Museum, Berlin.

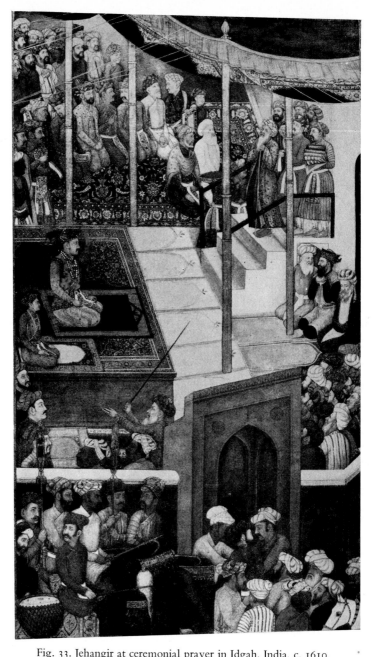

Fig. 33. Jehangir at ceremonial prayer in Idgah. India, c. 1610.
Islamisches Museum, Berlin.

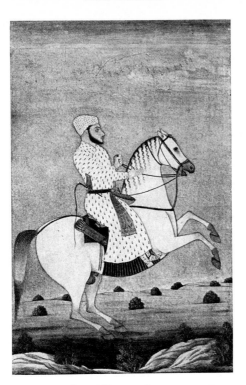

Fig. 34. Portrait of an Officer. India, seventeenth century.
Islamisches Museum, Berlin.

But even this did not suffice; the Emperor frequently required that true
likenesses be taken of his parade elephants, horses, hunting falcons and
exotic animals, notable trees and so forth, turning the painters into true
reporters. Some of them like Murad and Mansur specialized in animals
and acquired a superb mastery in this field (Fig. 35). There is much humour
in the way another painter depicts a herd of elephants playing about in a
rocky landscape and bathing in a pool, all treated with close observation
and with great affection (Fig. 36). Even the views from the terraces, which
seem directly inspired from nature, are veiled with the atmosphere of the
court. Landscape was not confined to providing a background but – pre-
sumably in response to instructions from above – was raised to the status
of an independent theme, coming close to European art in the use of
horizontal perspective. Western art enjoyed the particular interest of
Jehangir; his painters were made acquainted with Western paintings and

Fig. 35. Gazelles, miniature by Murad. India, seventeenth century.
Islamisches Museum, Berlin.

etchings through foreign diplomats and Portuguese Jesuits, and thereafter
often adopted details from them. In the imperial albums of this period the
borders were richly illuminated in gold, sometimes with figure motifs
dotted here and there in discreet colours (Fig. 37).

Under Shah Jehan the figure of the splendour-loving Emperor appears
more than ever in the foreground in scenes of durbar, ceremonial excursions,
battues and such like events. The art of the portrait continued to flourish;
the greatest attention was paid to the expression of the head, and the
outline of the figure was often only sketchily suggested or even left out
entirely. The severity and religious austerity of Aurangzeb's reign meant
that most artists were dismissed from the court and had to look about for
other employment. They found it for the most part in the palaces of the
emirs and rajahs, where they were generally made to extend the range of
their pictures in a more popular direction. Thus towards 1700 there appear
sentimental and romantic motifs dealing with hermits, handsome princes,
constant damsels (Plate VI), and other paintings in which many of the old

Fig. 36. Elephants Bathing. India, mid-seventeenth century.
Islamisches Museum, Berlin.

Fig. 37. The Emperor Humayun; painting in the border of the Jehangir Album.
India, early seventeenth century.
Formerly Staatsbibliothek, Berlin.

Indian themes were revived. Among these the *ragini*, musical modes in the form of visual melodies, were specially popular; they are among the most individual and attractive creations of Hindu culture (Fig. 38). In the later course of the eighteenth century the last springs of artistic inspiration ran dry, and an eclecticism, still supreme in technical mastery but drawing inspiration from every period other than its own, formed the prelude to a general artistic decline.

Rajput Painting. In the Hindu states that managed to lead an independent existence in isolation from the Mughal power, the traditions of painting deriving from the great numbers of Buddhist cave frescoes had remained

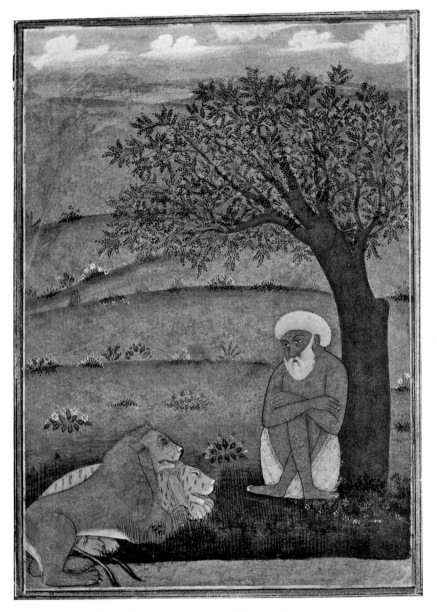

Plate VI. Miniature from an Album. India, c. 1700.
Islamisches Museum, Berlin.

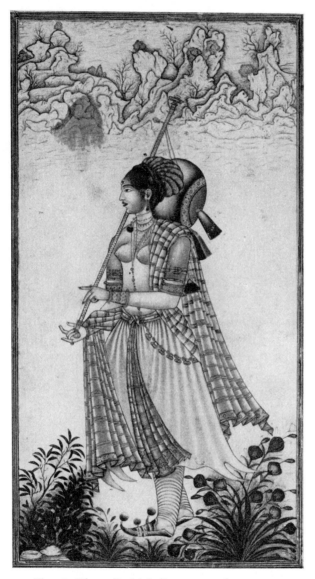

Fig. 38. *Vihagra Ragini*. India, seventeenth century.
Islamisches Museum, Berlin.

Fig. 39. Krishna and the Gopis. Kangra School. India, seventeenth or
eighteenth century.

alive. The Rajput princes, perhaps inspired by Akbar's example, gave them
renewed encouragement so that several schools (Kangra, Pahari, Basohli,
Jammu, among others) developed a special style which, though not un-
touched by influences from the art of the imperial court, nevertheless
followed on the whole its own path, not only in the choice of subjects
but in details of technique. The palette is generally brighter than in the
Mughal minatures and the drawing renounces even the slightest hint of
shadow and modelling. Indian racial characteristics, particularly the large
eyes, are deliberately stressed and European influences nowhere accepted
(Fig. 39). Early examples of this style are very rare and some are im-
pressively beautiful, though the nineteenth century examples were mass
produced. Its basic character is best understood by discounting the higher
valuation frequently placed upon it in recent years and regarding it for
what it really seems to have been: a widespread folk art, very varied in
quality.

Fig. 40. Koran Binding. Egypt, fourteenth century.
Islamisches Museum, Berlin.

BOOK BINDINGS

It is always important to establish whether the binding of an older
oriental manuscript belongs to it or has been substituted for the original;
in examining it further the first thing to ascertain is whether it has been
preserved complete, and especially whether the protective flap closing
over the front edge is not missing.

Tooled Bindings. In every Arabic-speaking country the simple leather
binding with modest knot pattern and other geometric motifs in blind
tooling was usual throughout the Middle Ages, and provincial differences
are therefore difficult to recognize. We have relatively early examples
both from Syria and Egypt as well as North Africa. Richer decoration

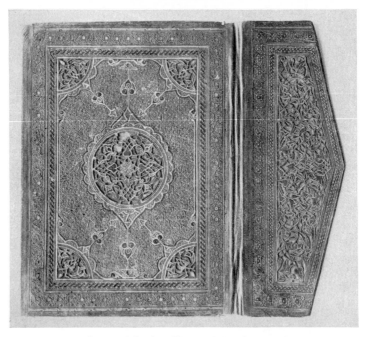

Fig. 41. Binding with leather filigree. Cairo, fourteenth century.

covering the whole surface with looped ribbons in star shapes or rich lattice work, often with a punched ground and a few lines in gold, is almost always the work of the Cairo binders' guild. This guild became very important in the Mamluk period and splendid examples were produced, especially of rich Korans for dedication to the mosques, with borders of inscriptions round a field ornamented entirely with geometric motifs (Fig. 40). From the fourteenth century onwards it was a favourite practice to enliven the covers with a separate medallion of arabesques or flowers, rendering parts of the pattern in open work, repeated in the corners and on the flap as well, and placing coloured silk underneath so as to vary the colour (Fig. 41). The same method was employed in Persia from the fifteenth century for decorating the inside of the book cover with the finest arabesque filigrees in leather and paper openwork (Fig. 42).

Gold stamping was universal at the height of the Timurid and Safavid periods; new designs were forever being invented for dividing up the surface, the motifs for the brasses being chosen according to the style and splendour of the contents, with animals and cloud bands playing a

Fig. 42. Binding with filigree. Persia, c. 1450.
Chester Beatty Library, Dublin.

considerable role (Fig. 43). The most usual form of design on Persian bindings, which was carried over to carpet patterns as well in the sixteenth century, shows a pointed oval medallion with small attachments in the centre of the field, and fillings in the corners, with a frieze of script round the border or elongated cartouches alternating with smaller rosettes. The scheme was subsequently adopted by the Ottomans as well, and with Koran covers especially it is difficult to distinguish the sixteenth century work of the two countries. Some brasses of this period have been preserved and give us an insight into the processes of the work (Fig. 44). In Turkey, the flower pattern, typical of all the crafts there, later prevailed;

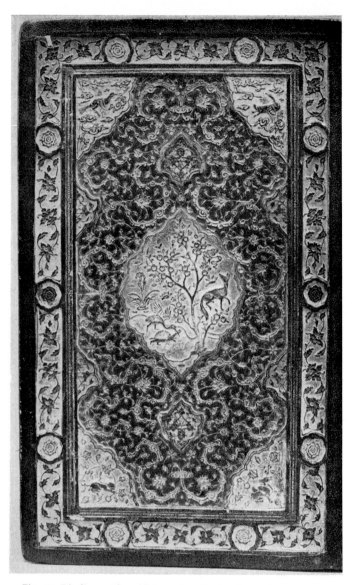

Fig. 43. Binding with gold stamping. Persia, sixteenth century.
Islamisches Museum, Berlin.

Fig. 44. Brasses for book binding. Turkey, sixteenth century.
Türk ve Islam Eserleri Müzesi, Istanbul.

it frequently covered the whole outer surface with a uniform design, or was used in the simplest of repeats; from Constantinople this mode of design was carried to the provinces.

Lacquer Bindings. The Chinese technique of lacquer was probably introduced to the Persian artists by Timur, but no certain examples are known to us before about 1500. The technique was first used for book binding at the court of Shah Tahmasp by Sultan Muhammad, mentioned above; other distinguished miniaturists took it up as well. They specialized on the one hand in larger compositions with brightly coloured representations of a prince's hunt or other such court activities, on the other in forest scenes with fabulous animal combats in gold and silver tones on a dark ground (Fig. 45). An outstanding example of the transference of lacquer technique to other material (papier mâché) is the letter casket made for Shah Abbas I in 1609, now in the Museum Dahlem, Berlin, with pictures of scenes from the Persian epics and the reception of foreign diplomats by the Shah (Fig. 46). The technique travelled from Persia to India where it flourished into the eighteenth century; on the whole the designs were restricted to floral still lifes with a few birds, beetles and butterflies scattered among them. (Examples of these are still available in large quantities.)

79

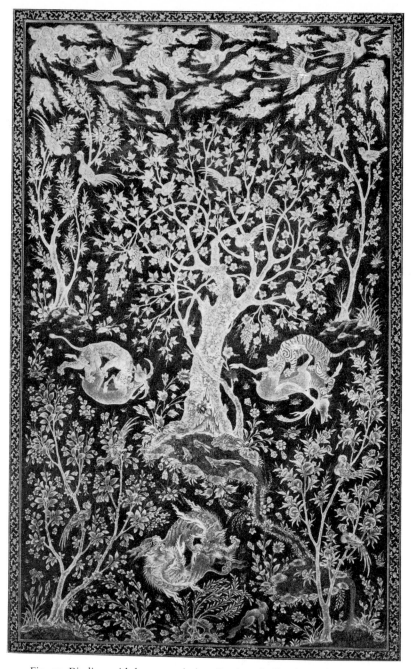

Fig. 45. Binding with lacquer painting. Persia or India, sixteenth century.
Museum für Kunst und Gewerbe, Hamburg.

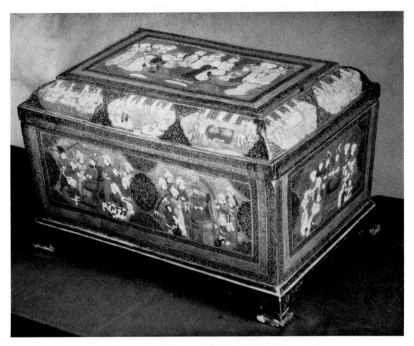

Fig. 46. Lacquered chest made for Shah Abbas I. Isfahan, dated 1609.
Museum Dahlem, Berlin.

The technique was also known in Turkey and used for Koran covers with
fine arabesque designs and delicate flower scrolls.

At the beginning of the nineteenth century lacquer painting, which had
more or less died out in Persia, was revived, and under Fath Ali Shah
(1793-1834) it was given such encouragement that neither bindings nor
jewel boxes, writing implements, hand mirrors nor any articles of this
kind were spared from its anaemic Iranian, usually figurative, motifs,
becoming one of the most easily obtainable of bazaar wares even today,
and much overrated by Europeans as objets d'art.

SHADOW PLAY FIGURES

The shadow theatre, probably of Chinese origin in the first place, has a long history in both Egypt and Turkey. The figures were always made of cut and pierced leather and they are usually articulated. They look extremely effective against a white wall when suitably illuminated. Early examples from the Mamluk period, which are very rare, are sometimes strongly reminiscent of early Hariri illustrations and of calligraphic flourishes (see below) and their decorative approach is entirely that of the art of the book (Fig. 47).

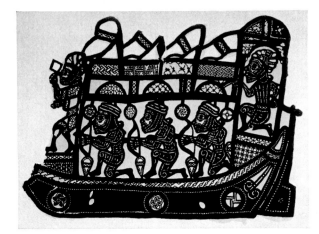

Fig. 47. Figure for Shadow theatre, leather. Cairo, fifteenth century.
Islamisches Museum, Berlin.

The silhouettes, still used in Turkey for the *Kara Göz* theatre which is fast dying out, are made of leather rendered transparent and variously coloured; they often show a close connection with the older figures, but are on the whole much coarser and usually show a strong European influence. The element of caricature is sometimes reminiscent of the Malayan Wayang figures better known in the West, which are similarly used for the entertainment of a Muslim population, though the whole idea is outside the framework of Islamic culture.

POTTERY

The quantity of pottery surviving is greater than in any other branch of Islamic art, and every year it increases, for if anything at all is discovered on excavations in the East it is invariably pottery. Not only is it extremely rich in quantity, but the production is exceptionally varied in technique and style. The various phases of its development and the connections between the different groups have not yet been finally established, but apart from a few conspicuous lacunae which will certainly soon be filled, we can now say that we are able to form a comparatively clear picture of this important field.

All kinds of technical peculiarities contribute important criteria to the general considerations of style used in attributing doubtful pieces to precise periods and regions. It is a constant source of surprise how quickly technical refinements spread throughout the whole of Islamic ceramic art, and how great the demand must have been for luxury ceramics, making foreign imports necessary everywhere alongside the excellent native wares. It is therefore not to be wondered at that forms and designs travelled unceasingly from one region to another and repeatedly effaced provincial traditions. In this respect, the thousands of sherds which have been brought to light from the rubbish heaps of Old Cairo are particularly instructive; among them are represented not only the whole of Islamic faience from Abbasid wares of the ninth century to Moorish majolica of the fifteenth, but various types of Chinese porcelain, Byzantine and even Western wares. The influences seem in general to have travelled from east to west rather than vice versa, and Persia in particular was a source of inspiration throughout the Middle Ages, though it should be remembered that she herself was being constantly stimulated by ideas coming from East Asia.

There is a basic distinction to be made in ceramics between vessels and tiles. In this work we are only concerned with those single tiles, each with a complete motif, that were used to face state rooms and are now collectors'

pieces; we leave out of account the many changes rung in architectural ceramics, from miniature faience mosaic to the large pictorial compositions made up of tiles. Among the forms of vessel (bowls, basins, dishes, plates, ewers, cups, jars) there are many features common to all areas, while glazed ceramics as a whole show much similarity in the range of colour deemed to suit the material. The four main tones are a creamy white, a strong cobalt blue, a soft turquoise green and a variable manganese purple, used in almost every region and every epoch; moreover the lustre painting so utterly characteristic of Muslim luxury wares was universally practised until the end of the Middle Ages from Persia to Spain, and in these two countries for much longer. This Islamic lustre ware has been regarded, not without justification, as a substitute for gold plate. Vessels of gold were forbidden by the Koran and were in fact made relatively rarely; this at least is the simplest explanation of the widespread practice of lustre painting. The colour of the lustre is not always the same; as well as golden yellow and copper red there are light brown and olive green shades. These do not always give secure criteria for dating or location; apart from the fact that occasionally several shades were used side by side, the metallic sheen, being applied over the glaze, is rather sensitive to external influences, and is liable to change colour.

In addition to lustre decoration, underglaze polychrome painting was another technique known to almost all Islamic countries, while such other practices as relief decoration, scratching, encrustation, piercing or impressed ornament, painting in matt colours, leaf gilding and so on were subject to limitations of time and place. Besides faience, unglazed and sometimes even unfired earthenwares were produced almost everywhere, but they seldom achieved any artistic importance; and efforts were constantly made in Persia, and at times in other countries, to substitute native frit wares for expensive Chinese porcelain.

In our review we shall deal with ceramic production according to the old established categories based on the real or supposed places of discovery and centres of fabrication, unreliable though they sometimes are, and then examine the correctness of these traditional attributions. But descriptions and pictures alone are always insufficient to show the characteristics of the different types. It is essential to compare pieces with verified originals; expertise can only come through an intensive study of a collection of sherds arranged systematically by find place and technique, such as are housed in

the Islamisches Museum in Berlin or the Ceramic Department of the Victoria and Albert Museum.

The problem of forgeries in Near Eastern ceramics has an unusual history. Towards the end of the previous century the first modest examples of lustre and polychrome faience were brought to Europe from excavations in Persia; shortly afterwards they were followed by all kinds of more or less damaged vessels, and suddenly by a series of intact pieces as well. These, according to the dealers, had mostly been found in Sultanabad (see below) and were regarded at first with some hesitation. At the Munich exhibition in 1910 it was pretty generally recognized that the suspicions had been unfounded, and today we smile at the doubts of those days. This experience with the so-called Sultanabad wares and the stream of subsequent finds has lulled many collectors into such a sense of security that they no longer contemplate the possibility of forgeries of Islamic faiences. It therefore needs to be firmly stressed that there are in circulation more or less successful imitations of almost all the types sought after in the trade. It is true that in many cases they are not difficult to recognize with a trained eye: fakes are liable to betray themselves by an otherwise unusual light brown nuance and by unsure drawing and thick application of the colour. On the other hand extremely competent restorations have been done, particularly in Paris and Teheran, with great care for the style, and not only in coloured plaster but even with burnt clay, so that even experienced connoisseurs have repeatedly been deceived, thinking they have acquired intact pieces. Then after some years the skilfully restored parts are revealed because they grow darker or lighter, and the piece proves to be very much less valuable. Examination with a quartz lamp now makes it comparatively easy to lay bare even the most delicate restorations. Forgeries of Moorish and Turkish ceramics will be dealt with later in conjunction with the relevant groups.

MESOPOTAMIAN POTTERY

Mesopotamia is given pride of place because it would seem from the present findings of research that the cradle of Islamic pottery is to be sought in the soil of the ancient land whose traditions reach back to the heyday of Babylon.

'*Samarra*' *ware*. In the cities of the Tigris in the ninth century the potter's art reached a wealth of forms and refinement of techniques scarcely equalled in later periods. The potter's long experience enabled him to benefit from the quantity of Chinese examples brought to the markets by trade with East Asia; the Abbasid rulers were connoisseurs, and provided much encouragement. The products of this early period were not known before the excavations carried out between 1911 and 1913 on the temporary residence of the caliphs at Samarra, and the wares found there must now be named after the find site, although in all probability they were made for the most part in nearby Baghdad. The ware, in spite of the exceptional variety of treatments, is relatively easy to recognize from the body, which is often very thin, of extremely finely levigated sulphur-yellow clay, and the soft very carefully applied tin glazes. Both vessels and tiles were decorated in lustre; the tiles were square, some with a thick scatter of brush dabs to produce "marbling", and small animal figures in garlands, some with larger heraldic style animals. The lustre used on them is a brilliant gold deliberately combined with other metallic tones (yellow, red, brown, ruby), all side by side – a technical achievement surpassing all the work of subsequent periods. Dishes and bowls (Fig. 48) were treated in the same way, again with single animals or larger ornamental motifs (winged palmettes and similar devices) on the inside and on the exterior almost always rings of dashes. The fact that the same lustre wares have also been found in excavations in Persia, Spain, Syria and Egypt suggests that we have here the first examples of a method of producing pots hitherto unknown, which was disseminated from Iraq throughout the whole Islamic world. The very early examples, perhaps still of the eighth century, are by their form and relief decoration and brilliant metallic sheen quite clearly successful imitations of similar late classical or Sasanid dishes of solid gold, and can thus be considered as the earliest substitute for the forbidden table wares of precious metal (Fig. 49).

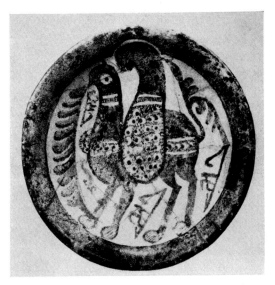

Fig. 48. Lustre bowl, so-called Samarra ware. Iraq, ninth century.
Louvre, Paris.

Fig. 49. Bowl decorated in relief and lustre. Iraq, eighth century.
Museum Dahlem, Berlin.

87

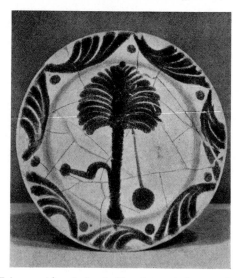

Fig. 50. Faience with painting in blue. Iraq, ninth or tenth century.
Teheran Museum.

Fig. 51. Lustre bowl with peacock. Iraq, tenth century.
Coll. Ernesto Wolf, São Paulo.

An extremely elegant type made a sudden and brief appearance at that time: it has simple patterns in yellow and black or green trailed glazes on the plain body; other techniques on the other hand, such as shallow relief stamping with green glaze, and blue painting on an ivory white ground (Fig. 50) became the stock-in-trade of Islamic pottery. There are interesting

Fig. 52. Earthenware jug with stamped decoration. Tenth or eleventh century. Museum Dahlem, Berlin.

attempts by the native potters to imitate the overrun stripes of green and yellow of Chinese mottled stoneware of which many examples were found; in other cases too the influence of the East is apparent. Fragments of white and grey (so-called celadon) porcelain excavated at Samarra give important evidence for the history of Chinese ceramics, showing these two types were not, as was previously thought, first produced and exported in the Sung, but already in the T'ang dynasty.

There are occasional signatures, especially on lustre faience, but no dates. Dating is made easier by the short duration of Samarra (838–883), but it has

Fig. 53. Upper section of a large clay vessel. Mosul, twelfth century.
Museum Dahlem, Berlin.

to be borne in mind that Samarra has not been proved to be itself the pro-
ducer of the faiences discovered there; Baghdad is the most likely place of
manufacture, and the various methods may of course have continued to
flourish after the abandonment of Samarra. This is particularly important in
connection with the many lustre vessels excavated in Persia in the Samarra
style, which certainly belong to the tenth century and no earlier (Fig. 51).

'*Mosul*' *Pottery*. It seems that at an early date in Mesopotamia, as again
and especially in the Seljuk period, unglazed earthenware reached quite a
high artistic level. There were two main techniques: the impression of par-
ticular patterns (animal friezes, heraldic and figure motifs, scrollery, inscrip-
tions and so on) by means of stamps and moulds to create a relief effect (Fig.
52), and incrustation (barbotine) in very individual designs, some fantas-

90

Fig. 54. Clay vessel in animal form. Mosul (?), eleventh or twelfth century.
Victoria and Albert Museum, London.

tical and some reminiscent of Buddhist imagery. Large jugs *(heb)* of this latter kind (Fig. 53) have appeared with unusual frequency in the neighbourhood of Mosul, and have given the name of this town to the other type as well, though it was common in a great variety of centres. The medallions with openwork figures that were often attached to either type have great charm (Fig. 54a). Outstanding pieces with double walls and strong relief effect are no rarity. Besides vessels in the form of pilgrims' flasks there are occasional ewers in animal form (Fig. 54). Even hand grenades, used to arm the *nafatin* (naphtha throwers) of the Abbasid troops, were often

Fig. 54a. Medallion, decorated in relief and openwork, from a clay vessel.
Twelfth century. Mosul (?)
Islamisches Museum, Berlin.

Fig. 55. Hand grenade of clay. Iraq, tenth century
Museum Dahlem, Berlin.

embellished with stamped decoration (Fig. 55); this seems to be the most appropriate identification for the pear-shaped vessels found in a number of Islamic countries.[1]

The period in which these unglazed low-fired potteries were produced in Mesopotamia and its border lands extends from the tenth to the thirteenth century. Closer dating of individual pieces has to be based on general stylistic considerations in each case: later pieces far outnumber the earlier.

[1] This identification is not accepted by Arthur Lane, *Early Islamic Pottery* (London, 1947) p. 27, who thinks they held vintage wine or perfume. [Translator's note.]

Fig. 56. 'Gabri' bowl. Persia, tenth or eleventh century.
Formerly Delmar collection, Budapest.

PERSIAN FAIENCE

Reference has already been made to the importance of the Iranian area in the whole development of Islamic ceramics, and we now pass to a rapid review of the most important phases of mediaeval production there. The later wares are all semi-faiences and will be considered further in a special chapter.

It should be remembered at the start that the Persians always laid particular store by pottery. The thought that we ourselves, like our vessels, are formed of earth has constantly inspired the Iranian poets and thinkers: two stanzas from Omar Khayyam (d. 1123) illustrate this idea:

A potter at his work I chanced to see
Pounding some earth and sherds of pottery.
I looked with eyes of insight, and methought
Twas Adam's dust with which he made so free.

Last night I dashed my cup against a stone
In a mad drunken freak, as I must own;
And lo, the cup cried out in agony
"You too, like me, shall soon be overthrown."[1]

Thus fine vessels enjoyed a special appreciation in Persia and were a favourite form of gift. They were used for instance to carry declarations of love in poetic form, the inscribed pot being sent to the admired lady.

Fig. 57. 'Gabri' faience. Persia, ninth or tenth century.
Koffler-Truniger collection, Lucerne.

'Gabri' Ware. In the first centuries of the Muslim era the ceramic arts plainly assumed the task of providing a more modest substitute for the silver dishes which had been so prized in the Sasanid period and were not, at least in orthodox circles, proscribed. There is a large number of early pieces for

[1] The Quatrains of Omar Khayyam, E. H. Whinfield, 1883, quoted in *The Ruba'iyat of Omar Khayyam,* by A. J. Arberry.

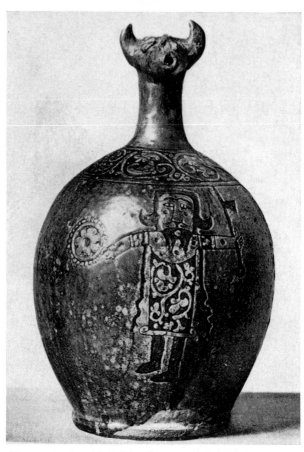

Fig. 58. Bottle with bull-head spout, 'Gabri' faience. Persia,
ninth or tenth century.
Louvre, Paris.

which only the metal model can give a plausible explanation of the manner
and choice of decoration. The patterns are defined in the so-called *sgraffiato*
manner in shallow relief, usually a dirty white with brown and manganese
purple or green in enamel glazes. Here and there the derivation of the
design from Sasanid art is still quite apparent (e. g. in the hunting scenes);
as a rule single motifs, such as animals, are stylized in a decorative sense, but
not entirely in the Islamic convention; in form they are mostly dishes and
bowls (Fig. 56). One type has the design sketchily outlined by scratching
and concentrated on one small figure or ornamental central motif (Fig. 57);
sometimes there is just painting in manganese or green without *sgraffiato*.

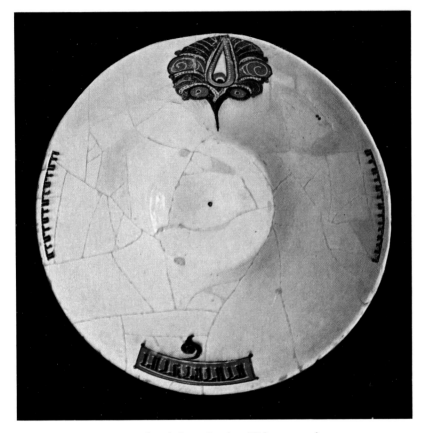

Plate VII. Faience bowl. Samarkand or Nishapur, tenth century.
Museum für Kunsthandwerk, Frankfurt.

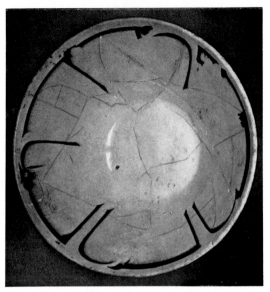

Fig. 59. Bowl with script decoration. Samarkand, ninth or tenth century.
Museum Dahlem, Berlin.

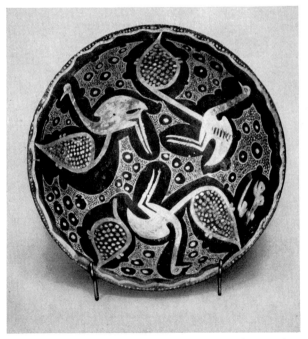

Fig. 60. Polychrome faience bowl. Nishapur (Persia), ninth to tenth century.
Formerly Eumorphopoulos Collection, London.

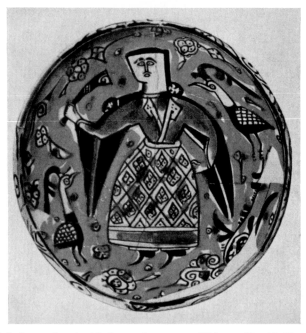

Fig. 61. Polychrome bowl with figure of a woman. Nishapur (Persia). Tenth century. Metropolitan Museum, New York.

This ware was virtually unknown before 1910 when it was found in large quantities and came onto the market principally in Paris. Considerable difficulties arise over dating and locating it, and in addition its age is often grossly exaggerated. It is very rare to meet examples that can be dated before 900. The majority of the pieces are certainly of the tenth or eleventh century and probably came from the area under the rule of the Buyids, who encouraged Sasanid traditions. In western Persia, which was under them, several centres are named which may have produced these wares (Zenjan, Sari, Amol) and which perhaps already played a role under the *Gabri* (Zoroastrians); certain motifs reflect the earlier symbolism (Fig. 58).

Samanid Ware. In the tenth century designers in West Turkestan under the Samanids mastered a means of using the script to decorate faience with an ornamental elegance never again achieved in any Islamic pottery. The principle centre was Samarkand. The usual inscriptions bear good wishes, written round the rim in a remarkably slender, elegant and rhythmically balanced hand, without any other ornament, in dark tones on white (Fig. 59) or, more rarely, picked out in light over a dark ground. Heavier forms of

Kufic also occur and sometimes there are flourishes and arabesques in addition. The colour is very attractive, especially rich in browns. Until the last few decades examples of this ware were almost impossible to find except in Russian collections; it is now appearing in large quantities, is much sought after in the trade and is represented in a few museums by truly splendid examples (Plate VII).

Nishapur Pottery. In the excavations conducted by the Metropolitan Museum in Nishapur, the ancient capital of Khorasan, a rough faience has been found in large quantities. There is a strong folk element at work in the motifs, very colourful and decorative in effect. It uses plant subjects and animal figures for preference and also human figures in curious costumes (Fig. 60, 61). It is probably all local production, mostly of the tenth century, and more of it is now coming onto the market. In the trade the finer wares characterized above as Samarkand are now also attributed to Nishapur because they too were excavated there. But they were certainly exported thither from Samarkand – both cities belonged to the Samanid empire – and were treasured as a finer pottery alongside the rougher.

THE POTTERY OF RAYY AND KASHAN

The city of Rayy (Raghes) near modern Teheran was of great political and cultural importance even before the Seljuk period of Persia. It seems also to have attained an early pre-eminence as a centre of ceramic production. Of course, only a proportion of the pottery that has been recovered in fact or by repute from the ruins there in the course of the last decades was made on the spot; we can straight away exclude the far from rare Samarra and Gabri wares, and equally other types that reached the site some considerable time after its destruction by the Mongols in 1221. Rayy never recovered from this blow despite the efforts of some of the Ilkhans, and it must be accepted that its faience industry had died out after the middle of the thirteenth century. Meanwhile other centres, above all Kashan, came to the fore and were in a position to take over the role previously played by Rayy.

Apart from other types that will be discussed later, the potters in Rayy seem to have tried to produce an approximation to Chinese porcelain; they made vessels of hard, sometimes transparent body, covered only with an ivory-white glaze and decorated with arabesques in the softest relief. The ewers, sometimes with bird-like spouts, were also modelled on East Asian examples and given Sasanid features as well (Fig. 62, 63).

'*Laqabi*' *Ware*. By this term is understood faiences which represent the ultimate refinement of the so-called Gabri style, more elegant and stylish in the relief design of animal motifs and figure scenes, with an individual colour scheme, mostly blue, turquoise and manganese on an ivory ground. Some showpieces of this ware, which is most probably to be attributed to Rayy, have reached European and American museums (Plate VIII); they probably belong mostly to the twelfth century.

Lustre Faience from Rayy and Kashan. It was mentioned earlier that large quantities of lustre ware of the tenth century were found in Persia, and some authorities have been of the opinion that they were also produced there. But the body and the manner of glazing coincide so completely with Samarran ware and are so contrary to what is characteristic of Persia that their origin in Iraq is not to be doubted. They were evidently an import much sought after in Iran. This is not surprising, since we have no indication that Persia was at that time making ceramics with a metal sheen. This did

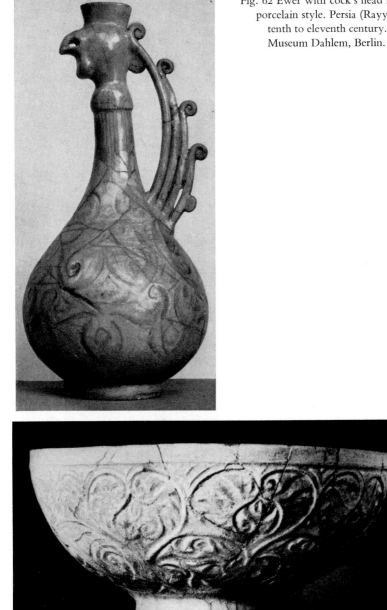

Fig. 62 Ewer with cock's head in the
porcelain style. Persia (Rayy?),
tenth to eleventh century.
Museum Dahlem, Berlin.

Fig. 63. Bowl decorated in relief in the porcelain style. Persia (Rayy?),
eleventh century.
Victoria and Albert Museum, London.

not happen until the late twelfth century, and it seems that one of the great contributions made by Rayy was the introduction of a new style of lustre which reached its apogee in the early thirteenth century, when its brilliant achievement was imitated as far afield as Spain. The great variety of forms of vessel provided all kinds of possibilities in the arrangement of decoration.

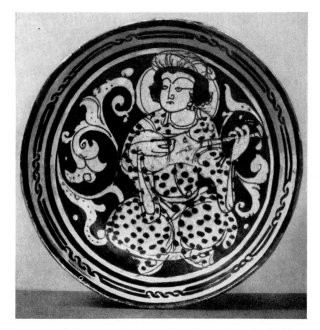

Fig. 64. Bowl decorated in lustre with a lute player. Persia (Rayy).
Late twelfth century.
Museum Dahlem, Berlin.

In general the aim was to obtain a linear effect for the pattern by broad brush strokes; otherwise it was carried out in very fine drawing so that the pattern covered the whole surface with a close filigree of lustre, leaving the motifs in reserve (Figs. 64, 65). The colour was usually gold or greenish yellow, often running into reddish tones in the outlines, sometimes even brownish or coppery; it was applied to the usual ivory white and sometimes also onto cobalt blue and turquoise; straight-sided basins in particular would have two or three alternating ground colours on the sides. The exterior of dishes, bowls and plates and the feet of ewers, jugs, bottles, vases and jars are frequently covered with a blue glaze. For the motifs on the main surface

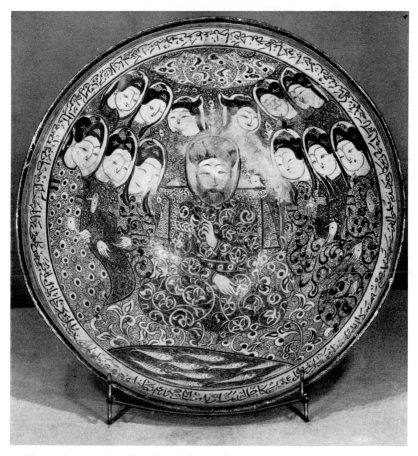

Fig. 65. Lustre-painted bowl with figure of a poet, dated 1210, Persia (Kashan).
Metropolitan Museum, New York.

single figures were popular (lute players, peacocks and so on, Fig. 64) and
also larger compositions (throne scenes, groups of horsemen or scholars,
popular episodes from the Persian epics and many more, Fig. 65), with
arabesque patterns filling the background and decorating the garments.
Persian verses are usually engraved round the rims of the dishes; sometimes
these contain a reference to the vessel, and not infrequently they give a
precise date (the earliest is 1179). Clay figures modelled in the round are
more numerous than usual at this period (pourers, bath scrapers, and so on)
decorated in lustre painting on a white or blue ground (Fig. 66); Christian
motifs appear on them very occasionally.

It has recently been established that most of the lustre pottery previously attributed to Rayy, in particular that with the finest miniature detail and reserve patterns (Fig. 65) was made in Kashan; not a few of the pieces are dated and even name the place of production. Before this Kashan was thought of only as the centre for the large numbers of tiles that survive; they declare their origin by their Persian name of *kashi* which clearly refers to Kashan.

For facing walls with tiles painted in lustre the system of interlocking star and cross shapes was universally adopted by this time, and this certainly cannot be traced to Rayy; it originated in Kashan, where the industry survived and continued to flourish after the Mongol invasion. When these tiles served to embellish the walls of private houses they were decorated with vigorously drawn animal figures and often even with humans (Fig. 67). There is a series dated 1262 with a purely orna-

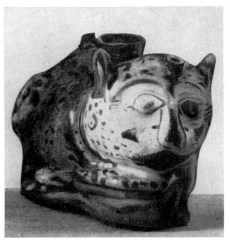

Fig. 66. Faience figure, (cat), lustre-painted. Persia (Rayy or Kashan) thirteenth century.

mental design, coming from a mosque in Feramin, which has wrongly been ascribed to this town as its place of production; it is without question the work of a Kashan potter. In the fourteenth century relief decoration becomes common and the patterns are markedly poorer. The workshops of Kashan played an important part in architectural ceramics, which we are not considering here, by producing carved friezes with inscriptions and niches (*mihrab*) for the mosques.

'*Minai*' pottery. Next to the lustre majolica, the fame of the ceramic art of Rayy rests on a product at least as costly, the so-called '*minai*' ware. This is a series of vessels, and more rarely tiles, which are painted in several colours over the fired ivory glaze. The outlines are done in red and the designs are gilded in places before the pot is refired. The designs lay more stress on the pictorial element (riders, friezes of figures, princes enthroned with their

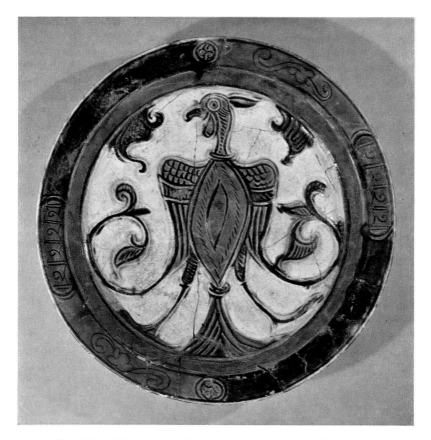

Plate VIII. Dish with heraldic eagle. Persia (Rayy), twelfth century.
Museum Dahlem, Berlin.

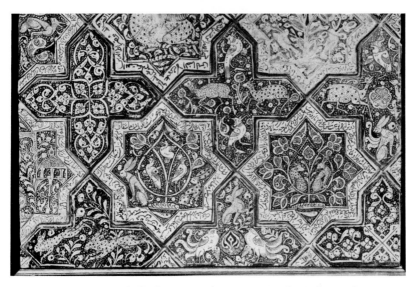

Fig. 67. Lustre-painted tiles from Damghan. Persia (Kashan), thirteenth century.
Islamisches Museum, Berlin.

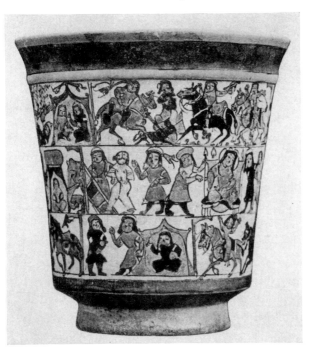

Fig. 68. '*Minai*' beaker with scenes from Firdausi. Persia (Rayy), c. 1200.
Freer Gallery, Washington.

105

retinue, sphinxes, legendary or genre scenes); in more than one respect they are connected with the contemporary Baghdad style of miniature painting. Closer contact may well have existed at this time with that city (Fig. 68, Plate IX; see above, p. 46). Dishes, beakers, jugs and bottles in this fine and fragile ware have mostly come down to us as fragments; pieces that look

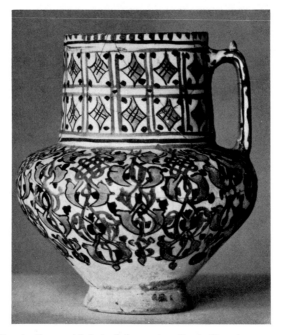

Fig. 69. Ewer with '*minai*' decoration. Persia (Rayy) c. 1200.
Victoria and Albert Museum, London.

intact are often only skilful restorations and should always be very carefully examined under the quartz lamp. Numbers of them were painted only with arabesques and without figures (Fig. 69).

It is not infrequent for the design to be painted on blue instead of white, sometimes exceptionally on turquoise, with a simple ornament in leaf gold, red, white and black; this type has been identified with pots referred to by a fourteenth century Persian author as '*lajvardina*' ware (Fig. 70). With such pieces, the collector must be careful to ascertain that the colours are truly fired on and not simply painted and easily scratched off with a knife. The latter practice is often used to give a more valuable look to simpler plain blue wares.

It is probable that polychrome faience was manufactured in Kashan and Save as well as in Rayy. Elaborate pieces with pierced bosses and other raised ornament, usually with alternating glazes and much gilding, perhaps at times overloaded in effect, also belong in the '*minai*' group (Fig. 71). There are also tiles in the '*minai*' style with figures raised in relief, works of the

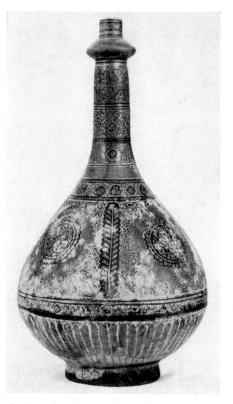

Fig. 70. Bottle, '*lajvardina*' faience. Persia (Rayy), thirteenth century. Antique trade. New York.

highest craftsmanship and technical perfection, but only very rarely to be met with (Fig. 72).

The inscriptions round the rims bearing good wishes, mostly in Arabic and written in Kufic or *naskh*, have not so far offered much guidance for exact dating. It must lie somewhere between the last decade of the twelfth and the first of the thirteenth century. That its main centre of production was Rayy is indicated by some sherds found there which are painted in poly-

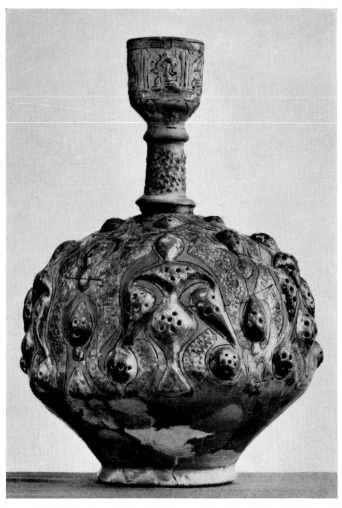

Fig. 71. '*Minai*' bottle with knobbed decoration. Persia (Rayy), thirteenth
century.
Museum Dahlem, Berlin.

chrome and lustre combined, both of the highest quality: this was inciden-
tally a technical achievement of a high order, since it must be supposed that
each process required very different temperatures in the firing.

'*Sultanabad*' *Ware*. Several of the other Persian faiences of this period may
justifiably be attributed to the kilns of Rayy and Kashan, unless they be
regarded as forerunners of the group known as Sultanabad. Among them
are the ivory coloured ware with free black drawing of leafy shrubs,

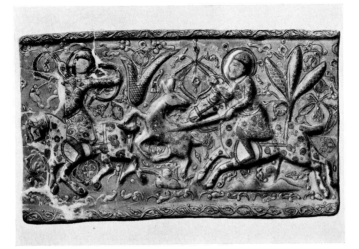

Fig. 72. Relief tile with '*minai*' decoration. Persia (Kashan?) Thirteenth century. Islamisches Museum, Berlin.

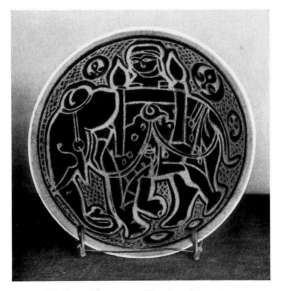

Fig. 73. Black-and-green *sgraffiato* bowl. Persia, c. 1200, Louvre, Paris.

109

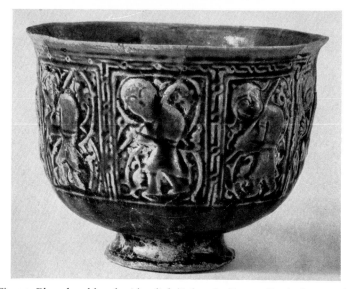

Fig. 74. Blue glazed bowl with relief. 'Sultanabad' ware. Persia, fourteenth
century.
Museum für Kunst und Gewerbe, Hamburg.

sometimes between oblique blue stripes, and also a black and green *sgraffiato*
decorated with extremely fine ceramic feeling, mostly purely ornamental,
in rare cases (Fig. 73) with figures.

Sultanabad refers to the place where certain groups of pottery were first
excavated in large numbers, though there is no indication that it was a
centre of production. They are later than Rayy wares and they differ quite
sharply from those of Kashan in certain technical features. They are closer
to the Raqqa pottery discussed below (see p. 118) in having for the most part
transparent lead glazes which tend to deteriorate and iridesce, unlike all the
other Persian types. The lustre pieces, vessels and tiles, are decorated in a
similar manner, but in addition to the cobalt blue there is a liking for dashes
of turquoise. The drawing of both ornamental and figure motifs is still
masterly, but there is nearly always an unmistakeable Mongol inspiration,
and here and there an early tendency to schematic repetitions; this becomes
stronger in the fourteenth century, particularly in the tiles, where efforts
were made to heighten the effect by rendering the patterns in relief.

Relief gives a special character to Sultanabad pottery as a whole; it was
used above all on monochrome (cobalt blue or turquoise) glazed vessels and

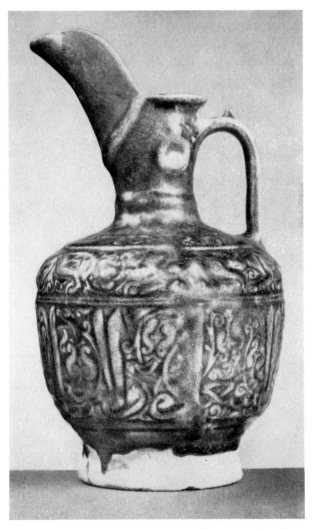

Fig. 75. Ewer with relief decoration, 'Sultanabad' ware. Persia, thirteenth century
Museum Dahlem, Berlin.

tiles (Fig. 74, 75). Another typical product of this centre is the ware painted
in dark blue and grey black on white, which is quite often found intact;
there is a delightful single motif, only very slightly raised, so that the relief
is scarcely noticeable, and picked out with the finest skill through pattern
and colour (Fig. 76). There is also a type with the design in black under a
transparent turquoise glaze.

111

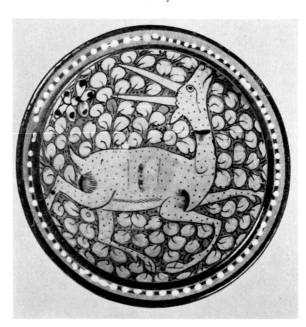

Fig. 76. 'Sultanabad' faience. Persia, fourteenth century.
Freer Gallery, Washington.

Figures in the round were made occasionally in all the various Sultanabad techniques, the most usual being small bath scrapers with a roughened under-surface, candle snuffers and so on (Fig. 77). Small models of houses also belong in this category, usually turquoise in colour, either closed on top or with an open roof and several inhabitants. Their use is unknown; perhaps they were hung on ribbons from the ceiling as decoration (Fig. 78).

Dated pieces are not very numerous but are important as documents. They show that the kilns which can be associated with Sultanabad flourished between about 1250 and 1350. Inscriptions of good wishes in elegant ornamental Kufic sometimes dominate the decoration (Fig. 79).

'Gurgan' Faience. Since 1945 excavations in Gurgan in northern Persia near the Caspian Sea have been producing faiences which have given reason for this place, hitherto unknown, to be regarded as a ceramic centre. One especially interesting object found there was a large clay container with a considerable quantity of fine pottery intact inside it, in brilliantly splendid condition; most of it was lustre ware. The vessels coincide so nearly with the wares characteristic of Rayy and Kashan that it is extremely difficult to distinguish them, except that they are so extraordinarily fresh; and but for

112

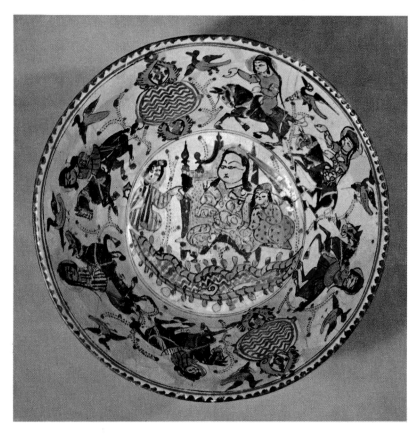

Plate IX. Faience bowl with '*Minai*' decoration. Persia (Rayy) c. 1200. Museum Dahlem, Berlin.

Fig. 77. Figure of a lute player. 'Sultanabad' ware. Persia, fourteenth century.
Metropolitan Museum, New York.

Fig. 78. Faience vessel in the form of a house. 'Sultanabad' ware. Persia,
fourteenth century.
Museum Dahlem, Berlin.

113

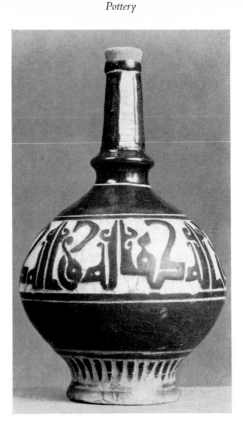

Fig. 79. Bottle with script decoration. Persia, fourteenth century.
Formerly Skaller collection, Berlin.

the excellence of their quality one would be led to suppose them to be modern forgeries. There are dates of between 1204 and 1217, and two signatures of Kashan potters. There is inherently less to be said for the probability that these masters were active for a time in Gurgan than that the pieces are imports from Kashan; perhaps they have been discovered exactly as they had been packed for transport (Fig. 80).

The trade has eagerly seized on the term 'Gurgan' to give a new name to intact and specially fine objects. Every collector will take pleasure in the fact that pieces acquired by him are said to come from Gurgan, but he should not let himself be persuaded that they also were produced there.

'*Daghestan*' *Ware*. This term is used to describe those faiences, almost exclusively dishes, that are painted in black under a green glaze with leaf scrolls and similar ornament in a manner already somewhat degenerate.

114

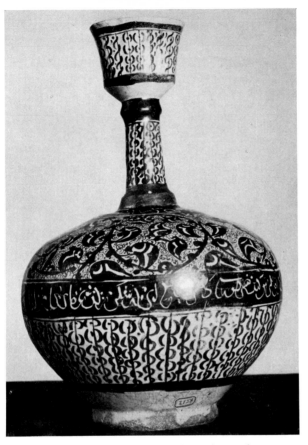

Fig. 80. 'Gurgan' faience. Persia, (Kashan), thirteenth century.
David collection, Copenhagen.

They belong as a group to the end of the fourteenth and the fifteenth
century – dated examples are not rare – and are attributed without any
real foundation to this region by the Caspian Sea. They are not remarkable
artistically and only interesting because they are products of the Timurid
period, a time when architectural ceramics certainly reached great heights
but in which the art of potting vessels apparently grew much poorer.
Under Timur himself, in the last quarter of the fourteenth century, pieces
of this kind (Fig. 81) were decorated in the same manner but with much
more care, and in the same colours, though frequently with the addition
of blue. However, the technical analogies are not sufficient to justify
calling them Daghestan, though the name is frequently applied to them;

115

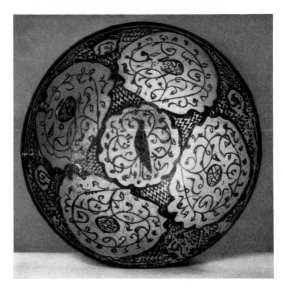

Fig. 81. 'Daghestan' bowl. Persia or Caucasus, late fourteenth century.
Formerly Skaller collection, Berlin.

they could equally well be associated with the Sultanabad group on other criteria.

'Kubacha' Ware. In a centre located in the Caucasian province of Daghestan, Kubacha (or Kubachi) by name[1], faiences were produced in the fifteenth to seventeenth century which are certainly similar to so-called Daghestan ware but offer much more variety in motifs and colours than these latter. They are made with a soft porous body and a thin glaze with a tendency to hair cracks. There are many pieces decorated in blue-and-white and others with a richer colour range. Besides blue, grey, and yellowish, greenish and other tones, they nearly all have a characteristic tomato red, not as bright as the bole red of the Turkish kilns (see below) but which may have served as a model for these. Production continued for a time concurrently with the porcelain style in Persia; lively drawn figures are the most frequent motifs (Fig. 82) especially on the fairly common tiles of this type.

[1] Cf. Lane, *Later Islamic Pottery*, p. 34: intact pieces were found there, but no indication of production.

116

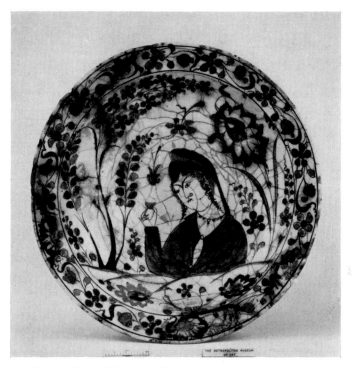

Fig. 82. 'Kubachi' faience. Caucasus, late sixteenth century.
Metropolitan Museum, New York.

SYRIAN FAIENCE

Syria is certainly the Islamic country whose role in ceramic history is least well established. The wares that can be attributes to her with any certainty show associations, some with Egyptian, some with Persian or Mesopotamian pottery, but it is impossible to give any confident explanation of how the influences travelled from one region to the other.

Fig. 83. Lustre-painted bowl. Raqqa, twelfth to thirteenth century.
Gulbenkian Collection, Lisbon.

Raqqa Ware. The fact that Harun al-Rashid resided for a time in Raqqa on the Euphrates has led to the assumption that the consistent group of faiences excavated from the ruins there was to be associated with him and thus dated correspondingly early. In fact they come mostly from the twelfth to thirteenth centuries, during which time Raqqa's ceramic

118

industry flourished; there was a lively export trade, especially to the courts of the Ayyubid princes. In spite of its geographical position this town had closer artistic ties with its western neighbour, to whom it belongs politically today, and its pottery is quite rightly reckoned to belong

Fig. 84. Lustre-painted tile. Raqqa, tenth to eleventh century.
Museum Dahlem, Berlin.

to the Syrian group. The faiences differ basically from those of Iraq through their friable body and the lead glaze common to all the types. This was originally transparent but easily becomes iridescent through chemical action. Almost all pieces of Raqqa ware that have been excavated show these signs of deterioration, often attractive enough in themselves, but frequently destroying the original effect of the colour entirely. The lustre ware, here for the first time occasionally contrasted with blue, is of a warm brownish tone with large arabesque palmettes, single seated figures or close volutes and inscriptions of good luck (Fig. 83); very occasionally one finds earlier tiles, square as in Iraq, with stylized animal figures in the centre (Fig. 84).

The most usual type is the turquoise glazed faience either painted with a variety of motifs under the glaze in black, or decorated in relief; objects like stools, mostly tall and hexagonal, some four-sided and elongated of

119

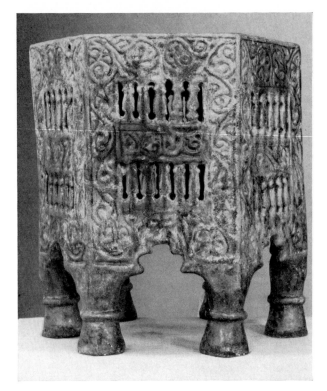

Fig. 85. Stool with relief decoration. Raqqa, thirteenth century.
Antique trade.

unknown use, form an interesting local variant of this ware (Fig. 85).
One also meets black and cobalt blue decoration on an ivory white ground,
and in most of the techniques mentioned there are occasional smaller
animals in the round or even human figures (Fig. 86). Large vessels with a
plain green glaze and several small handles are for the most part wrongly
attributed to Raqqa, and some belong to the pre-Islamic period.

In the museums of Berlin, Paris, London, Istanbul and particularly
New York the ceramics of this centre can be well studied, and they play
a considerable part in the art market too; the ware is quite individual in
spite of its many varieties (Fig. 87).

Other Syrian Pottery. The lustre ware, apart from that of Raqqa, that can
today be unhesitatingly ascribed to Syria was for long called 'Siculo-
Arab'; it is notable from the start in that its finest pieces are almost all
in the form of the typical apothecary's jar (*albarello*), clearly native here.

120

Plate X. *Albarello* with lustre. Damascus, fourteenth century.
Museum für Kunsthandwerk, Frankfurt.

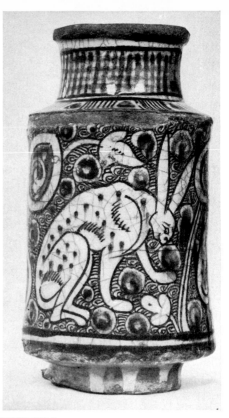

Fig. 88. *Albarello* with animal
motif. Syria (Damascus),
fourteenth century. Formerly
Canessa collection, Paris.

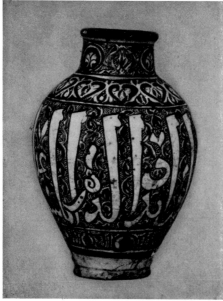

Fig. 89. Faience vase with large
script. Syria (Damascus),
fourteenth century.
Metropolitan Museum,
New York.

122

They are luxury vessels of great value, and they fetch high prices on the market. Generally they are glazed in blue and painted in vertical or spiral bands with arabesque scrolls and blossom clusters in olive green lustre (Plate X). Vases, bowls and dishes were also sometimes decorated in the same technique, with flying birds among leaves, good luck inscriptions

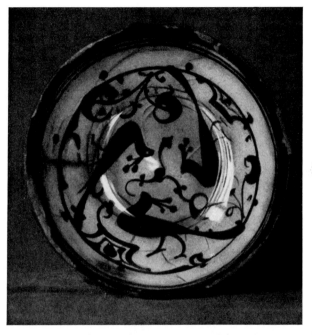

Fig. 90. Bowl with stylized peacocks. Syria, thirteenth century.
Formerly Fouquet collection, Cairo.

and so on. The type as a whole seems to belong to the later thirteenth and the fourteenth century. Its precursor is represented by sherds often excavated in Fostat, of vessels with lustre painting on a white, turquoise and exceptionally even on a pink ground; since for various reasons there is no question of these being either Egyptian or Persian work their attribution to Syria is probably correct; they probably belong to the Ayyubid period (late twelfth to mid thirteenth century).

Somewhat later in date is a number of magnificent vases, bowls and *albarelli*, with masterly designs in black and blue on white. Some of them show very close affinity with certain Raqqa faiences, others with typical Sultanabad patterns (Fig. 88, 89). Sherds of these pots were excavated out-

The earthenware filters of water jugs are popular with collectors, being both very attractive and cheap. They too were produced in Cairo in hundreds of variations, perforated with ornamental or animal motifs (Fig. 92).

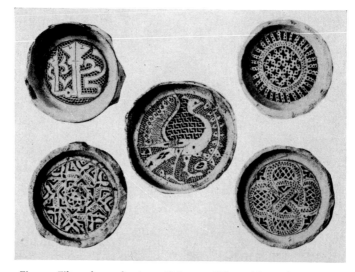

Fig. 92. Filters from clay jugs. Cairo, twelfth to thirteenth century.
Museum of Islamic Art, Cairo.

Fostat Lustre Ware. In the Tulunid period the imperial Abbasid style was standard, in ceramics as in other fields, in the Egyptian workshops, and we possess a large number of fragments proving that at that time the technique of lustre painting was introduced into Fostat in close association with Samarra ware (see above, p. 86). The underside of the pieces, as in Samarra, was painted with rings of dabbed-on brush strokes while the main pattern acquired a more local character through the imitation of Coptic motifs. Production did not flourish much until the Fatimid regime however: the nuances in the lustre become more varied, although each piece never has more than one lustre, and the motifs become richer. Most popular were animals in scrolls, birds, fishes and short good luck inscriptions in decorative Kufic over arabesques, or hares, peacocks, griffons or harpies in the central position of the deep bowls or dishes. Falconers, lute players and other interpretations of the human figure, even Christian motifs, are no rarity. In many vessels broadly drawn heart palmettes and other schematic motifs supply the decoration. The work of the masters

Muslim and Sa'ad can be assembled from their signatures. There are no tiles: they were never made in Egypt. Intact specimens of Fatimid lustre ware are rightly considered as great rarities; the Islamic Museum in Cairo possesses an especially rich collection of imposing dishes with figure decoration (Fig. 93). There is nothing of note in the later production of Egypt in

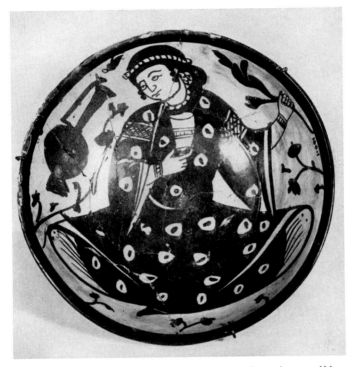

Fig. 93. Lustre-painted dish with figure motif. Cairo, eleventh to twelfth century. Museum of Islamic Art, Cairo.

this field; the technique seems to have declined utterly after potters went over to relief decoration in the Mamluk period, so that from the fourteenth century much Malaga and Valencia majolica was imported to meet the demand for lustre wares.

Overrun Glaze and Celadon Faiences. As had already happened in Samarra, but in this case clearly inspired directly by Chinese examples brought onto the market by trade with the Far East, there was a constant production from the tenth to the fourteenth century of faiences with overrun glazes without any specific patterns, the potters evidently simply

perfectly analogous, with no *sgraffiato*. On the other hand there are even pure relief designs in the same technique, and some smaller objects modelled in the round. The motifs on the main surface panels are usually either animals (single panther, eagle, fish and similar creatures) or the emblem of the rank of the notable for whom the piece was destined (sword, beaker, chess board, polo and so on); often too the border inscriptions, written in large round hand, are interrupted by emblem medallions (Fig. 96). The importance of this heraldry at the Mamluk court was also expressed on utensils of other materials (bronze, glass); on pots the few surviving intact pieces cannot all be associated with historical personages. Sheref al-Abuani seems to have been one of the leading craftsmen here, and his name is constantly met with. Figure scenes, such as riders fighting wild animals, are sometimes found, and technically there is a relationship, albeit not entirely clear, with contemporary Byzantine ceramics.

Monochrome glazing was also very widespread in the Mamluk period (white, yellow, light blue, emerald green and so on), but the ware of this type is much rougher than that produced in the Near East.

Spain consistently dominated the ceramic production of Western Islam and in their prime the Andalusian kilns provided every kind of luxury faience for the cities of North Africa; only utilitarian wares were made on the spot and neither in Morocco, Algeria nor Tunis did they ever rise beyond a humble folk art. From sherds found in Madinat az-Zahra near Córdoba, in Elvira, on the citadel in Málaga and in the Alhambra in Granada, though they still await thorough scrutiny, it is obvious that from the tenth to the fourteenth century there was unbroken contact with the ceramic tradition of Mesopotamia and Persia, even though the individuality of the Moorish style was always maintained in the ornament. In spite of the strict Sunnite adherence, there are occasional examples,

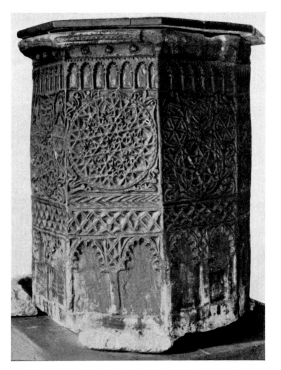

Fig. 97. Faience well-head. Spain (Seville), fourteenth century.
Archaeological Museum, Córdoba.

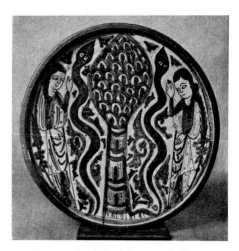

Fig. 100. Mudéjar faience with figures.
Valencia (Paterna), fourteenth century.
Louvre, Paris.

Fig. 101. Mudéjar dish with emblem. Valencia (Manises),
c. 1420.
Kunstgewerbe Museum, Berlin.

134

Fig 102. Dish with Portuguese 'não'. Valencia (Manises), c. 1400.
Victoria and Albert Museum, London.

characteristics recur in the whole group of monumental handled jugs of
the fourteenth century known as Alhambra vases and now conclusively
proven to have come from the kilns of Málaga. The fabric is yellowish
or pink, the glaze white; it often has patches of blue painting over it and
there are close designs of leaf scrolls and arabesques in a greenish-yellow
golden tone on a background of curling tendrils, decorative epigraphy in
Kufic and *naskh* – sometimes Arabic verses – and sometimes also the
emblem of the kings of Granada or, very occasionally, animal figures in
strict ornamental stylization (Fig. 99). Even fragments of these *jarrones*
are hardly ever to be met with in the trade or in private collections. Large
and small 'winged vases' were forged in considerable numbers during the
nineteenth century and even found their way into museums. Tiles seem

135

manganese purple painting on a white ground, also produced in a similar style in Teruel and other places, are connected both as by colour and design with the more or less contemporary Italian 'Orvieto' ware which likewise has an outspokenly oriental character; one is led to presume that there were common influences.

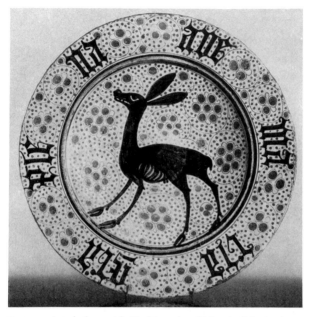

Fig. 104. Lustre-painted plate with Gothic script. Valencia (Manises), c. 1430. Personnaz collection, Bayonne.

Lustre Majolica from Manises (Valencia). Manises was another suburb of Valencia where lustre majolica was produced from the fourteenth century onwards, though it was unable to compete with the creations of Málaga until the manufactory there declined in the following century. Then the workshops of Valencia were at their peak, producing dishes, vases, plates, apothecary's pots (*albarelli*) and small handled bowls (Italian: *scodelle*); sometimes whole services were ordered from them. A large part of the table ware was decorated in splendidly brilliant lustre and blue, still quite strictly in the Islamic tradition, with Kufic letters, arabesques, sailing boats (Figs. 101, 102) and so on, but soon the Gothic vine, blossom scatter and similar motifs were competing energetically (Fig. 103); on pieces destined for Christian countries the Arabic benedictions, long since garbled,

137

made way for a pious "Ave Maria gratia plena" round the rim, while the centre was taken up either with animal figures or often with the emblems of the clients, who were usually Italian. (Fig. 104).

The widespread dissemination of these lustre wares in East and West alike is proved by the discovery of examples of it in the most diverse places, and in especially large quantities in Cairo where clearly no offence was taken even at Christian mottoes. In Italy at this time the influence of Valencia introduced lustre painting to the majolicas of Deruta and Gubbio.

The continuous changes in patterns, which became increasingly dense, can be followed almost decade by decade in the fifteenth and sixteenth century by documentary pieces, and the technique flourished in Manises in further variations right into the seventeenth century without entirely losing the traces of its Moorish origin. Later they made so with a rough copper-red peasant ware, and finally they tried to imitate the older types which became so much in demand. These fakes are sometimes deceptive but in general the metal tones are not successful, and only the most naive of amateurs will need to be warned against them.

PERSIAN SEMI-FAIENCES

The Persian potters, even in the Middle Ages, had been inspired to develop their native hard faiences as a substitute for the universally coveted Chinese porcelains which were imported in considerable quantities into Persia. Their efforts led to interesting experiments in stone-ware and frits. There are frequent cases of white pieces so highly fired that a very hard body and some translucency resulted; in others the walls or base have been perforated in the manner of "rice grain" porcelains and covered with a transparent glaze; yet again, there are many attempts to discover the secret of celadon, and some of the imitations are very skilful.

The really systematic approach to the problem began in the sixteenth century under the Safavids, who were constantly concerned to encourage and revive native industries. At this time an attempt was made to produce a fine ceramic that would approach in value the Chinese blue porcelains manufactures expressly for the Islamic orient and imported *en masse*. From this time all Persian pottery comes more or less under the spell of East Asia, and pure faience vessels on the whole only appear as a kind of primitive folk art.

'*Shah Abbas' Lustre Ware*. The last representatives of lustre ware in the Iranian region, indeed anywhere in the Islamic world, are bottles, bowls, vases, spittoons and so on painted in brilliant gold tones with flowers, *taliq* script, birds or *chinoiseries* over a white-glazed frit-like body: all works of high quality (Fig. 105). They are associated with the name of the great splendour-loving Shah; but in fact the period during which they must have been made does not coincide with the reign of Shah Abbas I (1587-1629) but is for the most part later in the seventeenth century. Sometimes broadly painted bands of blue alternated with the metal lustre and often the whole lustre decoration is carried out over a blue ground. The name Khatim appears frequently as a signature, but nothing more is known about this potter, nor about the provenance of the group as a whole.

'*Persian Stone-ware*'. In the same period occasional pieces are found in a kind of stoneware with green glaze: most of them are bellied or flattened bottles with East Asian motifs or reliefs with figures in the style of the

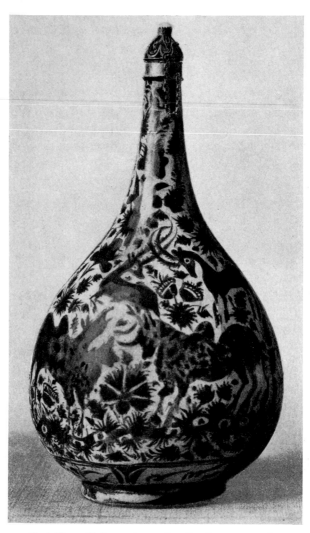

Fig. 105. Sprinkler with lustre decoration. Persia, seventeenth century.
Louvre, Paris.

painting school of Isfahan (see above & Fig. 106). They will be easily
recognized as semi-faience on closer examination; for the time being
they cannot be given a provenance either.

'*Persian Porcelain*'. In the tomb mosque erected in Ardebil in the sixteenth
century for Sheykh Safi, founder of the dynasty named after him, there
still exists the "Porcelain Chamber" with its contents. The walls were

140

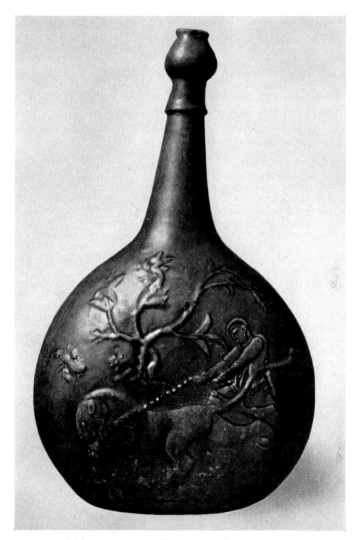

Fig. 106. Sprinkler in stoneware-like pottery. Persia, seventeenth century.
Gemeente-Museum, The Hague.

covered almost to the ceiling with niches of different shapes containing
the Chinese porcelains preserved here; they go back in date to the fifteenth
century (Fig. 107). Even the fine ware in use at court came from the Far
East at first, until it was replaced at least in part by native products. Sultan
Muhammad, court painter to the Shah Tahmasp, is said to have been the
first to set up a porcelain factory in Tabriz, but nothing more is heard of

141

it. Then about the middle of the sixteenth century pieces of semi-faience painted in white, blue and grey-black were produced, the decoration at first still restricted and stylized in the Islamic manner, though the designs soon became quite free in Chinese style, and by the seventeenth century were extremely varied. A review of the great quantity of vessels of this type preserved in our museums – among them rice bowls, sherbet and

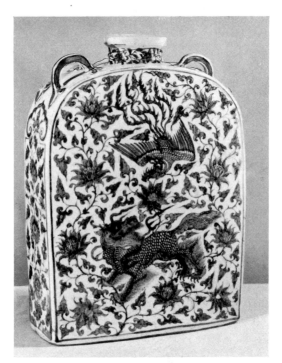

Fig. 107. Flask of porcelain from the Ardebil shrine. China, fifteenth century. Archaeological Museum, Teheran.

rose-water bottles, flower vases with several spouts, plates of the most varied shapes, hookah bowls and so on – leaves one constantly astonished at the facility and clarity brought to the interpretation of a completely foreign world of forms (Figs. 108, 109). Not only the multifarious fabulous beasts (dragon, phoenix, ch'i-lin and others) are adopted, but even the characteristic features of the Far Eastern landscape with its appropriate creatures, familiar from the paintings: cliffs with wild geese flying over them, or cloud bands, bamboo thickets with cranes, large flowering bushes with beetles and so on. Small wonder that enterprising Dutchmen fell

142

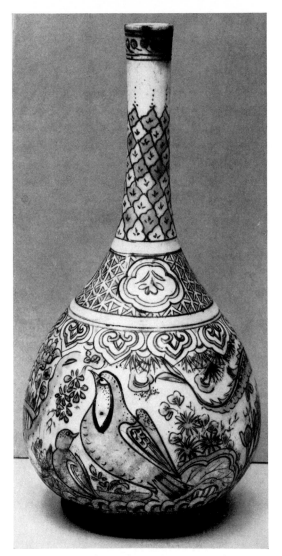

Fig. 108. Bottle in porcelain style. Persia, seventeenth century.

upon the idea of passing off these wares in Europe as genuine porcelains, and thus providing serious competition to the Chinese. Attempts were made to render the deception even more complete by scratches in the base which might be taken for Chinese potters' marks or characters.

These pieces certainly have the advantage over their models of greater warmth of colour. The painting, as we have said, is for the most part in

143

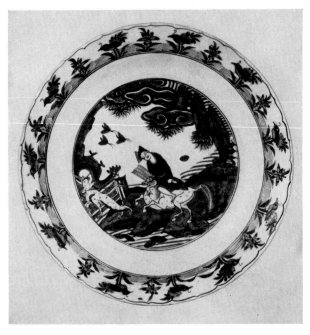

Fig. 109. Bowl in porcelain style. Persia, seventeenth century.
Museum für Kunst und Gewerbe, Hamburg.

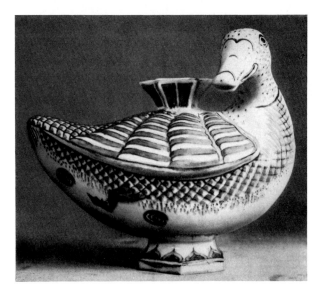

Fig. 110. Porcelain vessel. Persia (Mashad), early seventeenth century.
Victoria and Albert Museum, London.

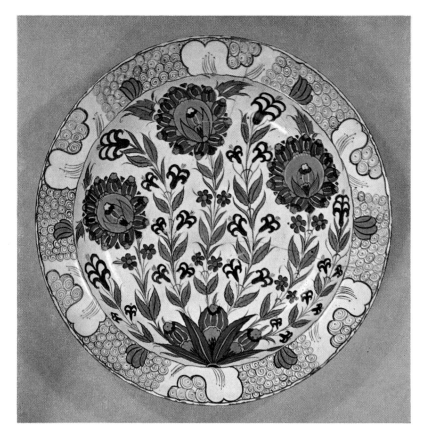

Plate XI. 'Damascus' plate. Turkey (Iznik), sixteenth century.
Museum Dahlem, Berlin.

blue, but this is done in several shades and with black outlines, or on some pieces entirely in grey-black. In a few rare cases the fabric is so translucent and fine-grained that it really is indistinguishable from the wares made with kaolin; but on the whole a cursory examination is enough to dispel any doubts as to whether the body is of porcelain or faience, whereas the

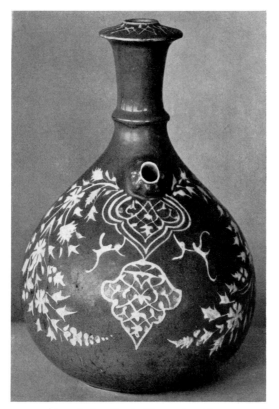

Fig. 111. Lower section of pipe. Persia (Kerman), mid-seventeenth century. Victoria and Albert Museum, London.

influence of East Asia on the decoration does not always make it possible to arrive at the correct attribution on stylistic grounds (Fig. 110). Sometimes on the other hand figure motifs are adopted from the Riza miniature style, and even Christian themes and pictures were exploited for the European market. In the eighteenth century the Persian semi-faiences become impoverished and hasty in the drawing and lose much of their former neatness of execution; their only appeal henceforth is their decora-

tive quality. The Chinese style, however, continued until late into the nineteenth century alongside a modestly decorated peasant type.

Kirman Ware. It has not yet been possible to verify more closely the grounds for using this term; it is employed to describe semi-faiences, mostly bottles, vases and plates, on which the Chinese character of the decoration is less stressed than the Persian Islamic. They often have arabesques, carnation stems and other such flower motifs divided up into medallions, and olive green and some bole red (related to the Turkish Rhodian ware, see below) almost always appear beside the blue (Fig. 111). They are of the sixteenth and seventeenth century, and technically belong to the group just discussed; they often have a mark like a fir tree on the underside. Fine examples of them are so rare that fakes have been in circulation for some time past. Kirman is repeatedly mentioned by European travellers of the seventeenth century as an important ceramic centre and is entitled to consideration as the provenance of other "porcelain" faiences as well. The other prominent centre seems to have been Mashhad.

'Gomrun' Ware. These pieces, usually deep dishes or bowls, are late, mostly of the eighteenth century. They are painted in primitive imitations of Chinese motifs in a dull blue with black outlines; on the rim, and sometimes down the outer sides, they are perforated with a close cross-pattern so that they appear transparent. They can hardly be considered as serious collectors' pieces.

'Shiraz' Ware. The last type of Persian ceramic that was in any way original was a class of semi-faiences decorated in vivid colours including a striking strong pink with roses and other naturalistic floral ornament. Shiraz seems to be established as the place of production, but can hardly have become prominent before the end of the eighteenth century; the pieces current in the trade are for the most part quite Victorian in flavour.

TURKISH POTTERY

Nothing very precise can be said about the mediaeval faience industry of Asia Minor during the Seljuk period; tile fragments found in Konya itself and in the neighbourhood (at the palace of Kubadabad) imply that there was close contact with Rayy and other Persian centres, while the unglazed earthenwares of the thirteenth century point to connections with Mesopotamia. Faience mosaic, originating from Iran, played an important role in architectural decoration. At the excavations at Miletus, one of the classes of finds was of terracotta jugs with pressed decoration, apparently of the fourteenth to fifteenth century, which were certainly produced in that neighbourhood; Brusa probably also produced vessels of similar decorative effect, besides the architectural ceramic for which it was so famous. Furthermore, the Ottoman rulers started up the production of semi-faiences with underglaze painting, destined to become very important in the following centuries. Their different styles will be discussed in more detail in due course. It has recently been claimed that they were all made until some time in the eighteenth century in Iznik, the ancient Nicaea, of which the first mentions as a ceramic centre date from 1495 and 1505.

The Style of Abraham of Kutahya. This description, which has not yet been universally adopted, includes vessels – mosque lamps, bowls, jugs, ewers, dishes, basins – with either loose or close decoration of sure and elegant flower scrolls, arabesques and inscriptions in cobalt blue, usually of two tones, and sometimes also in turquoise on matt white. The hard fabric is a porcelain-like semi-faience. They belong in part to the fifteenth century (Figs. 112, 113). They are named after a jug dedicated in an Armenian inscription to the memory of "Abraham of Kutahya" and dated 1510. Whether it was made there or in Iznik is an open question. Another Armenian text of 1529 referring to a commission in Kutahya is on the base of a bottle decorated with a close pattern of delicate spiral stems, which belongs to a special group erroneously termed Golden Horn ware for a time. Kutahya or Iznik, the blue-and-white type here described belongs to the most aesthetically and technically perfect products of Islamic pottery (Fig. 114). Intact pieces of this style, in which tiles with complete designs were also produced, are relatively rare; they are distinguished by their finer

drawing and more discreet colouring from the rather later group next described, although they are sometimes included in it. The Gulbenkian Collection in Lisbon contains a particularly impressive group of outstanding examples.

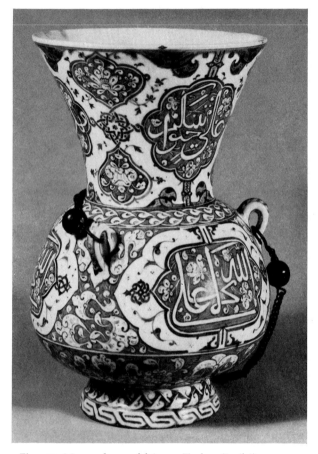

Fig. 112. Mosque lamp of faience. Turkey (Iznik?), c. 1500.
Godman collection, Horsam.

'*Damascus*' *Ware*. The erroneous attribution used for this very widespread Anatolian pottery of the sixteenth century has become so universal that it cannot very well be avoided as the current technical term. Its use is probably explained by the fact that the mosques of Damascus are partly faced with early tiles of similar design.

The vessels (dishes, plates, lamps, jugs, vases etc.) are ornamented with plant motifs in various colours on a white ground; blue, turquoise and olive together with manganese purple are especially characteristic. The Turkish artists' love of nature and gift for decoration found their most eloquent

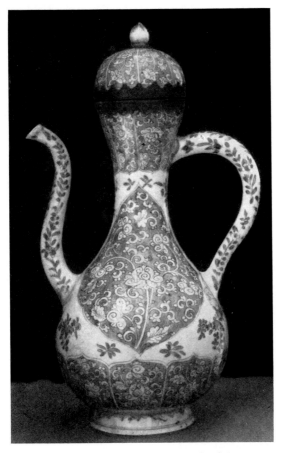

Fig. 113. Blue and white ewer. Turkey (Iznik?) c. 1500.
Turkish Islamic Museum, Istanbul.

expression in these fertile and varied designs (Plate XI, Figs. 115, 116, 117). Tulips, carnations, roses in bud and full blown, hyacinths, lilies and other flowers, grapes, artichokes, cypresses and every kind of leaf and stem pattern all reflect clearly the inspiration of nature, while Persian palmettes, lanceolate leaves and rosettes, arabesques and cloud bands provide the stylized

Fig. 114. Plate decorated
with tendril scrolls.
Turkey (Iznik or
Kutahya), early sixteenth
century.
Musée des Arts
decoratifs, Paris.

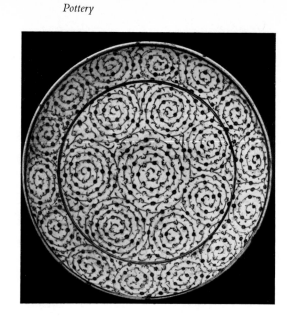

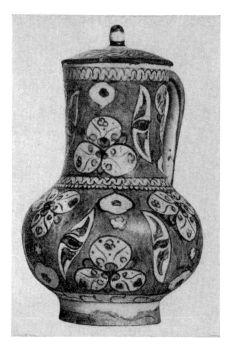

Fig. 115. Lidded jug, 'Damascus'
faience, Turkey (Iznik), sixteenth
century.

150

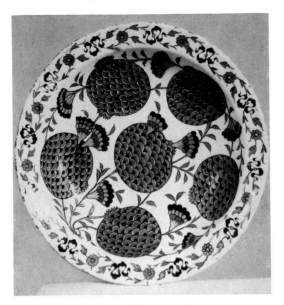

Fig. 116. Plate, 'Damascus' faience, Turkey (Iznik), mid-sixteenth century.
Formerly F. v. Haniel, Berlin.

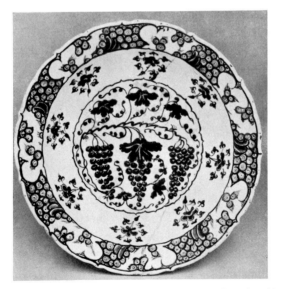

Fig. 117. Plate with grapes in the 'Damascus' style. Turkey, (Iznik) c. 1540.
Metropolitan Museum, New York.

plant ornament. Scale patterns are a favourite means of filling the ground, and spiral twisting cloud bands are popular as border motifs. Inscriptions only appear on mosque lamps, usually reserved in white. Wall facings of tiles were very widespread in Turkey at this time and the same motifs were used as on the vessels; the rectangular tiles each contained a complete pattern while later, either square or rectangular, they only formed details of larger compositions.

'*Rhodian' Ware.* A fantastical theory deriving from a large number of pieces in the Musée de Cluny acquired by chance on the island of Rhodes is responsible for the inappropriate name of the most widespread of the types of Ottoman semi-faience. Today we can confidently assert that it was produced in the town which earned the name of Chinili Iznik (Faience Nicaea) from its lively activity in producing pottery. Its greatest flowering was from the middle of the sixteenth to the end of the seventeenth century. The forms and decoration are for the most part the same as in the Damascus group previously described; mug-like flower vases with angular handles are

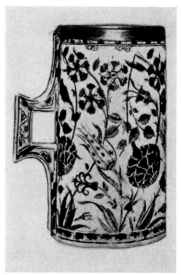

Fig. 118. Mug, 'Rhodian' ware. Turkey (Iznik), late sixteenth century. Louvre, Paris.

especially frequent here (Fig. 118); and in addition to the designs mentioned above there are sailing boats and animal figures, sometimes human as well, some European subjects, buildings and the like (Plate XII, Figs. 119–122). The main difference lies in the range of colour, from which the manganese purple is absent, while a tomato-red bole applied thickly enough to produce a noticeable relief is dominant, and a sure diagnostic of this type. The ground is still usually left white, though sometimes tinted dove grey or salmon pink; in rare cases the patterns (inscriptions or arabesques) are done entirely in reserve in the bole.

Masterly composition and sensitive combination of colour puts some Rhodian faiences among the most outstanding, and on the art market the most sought-after, of the products of Islamic pottery. Later pieces can be

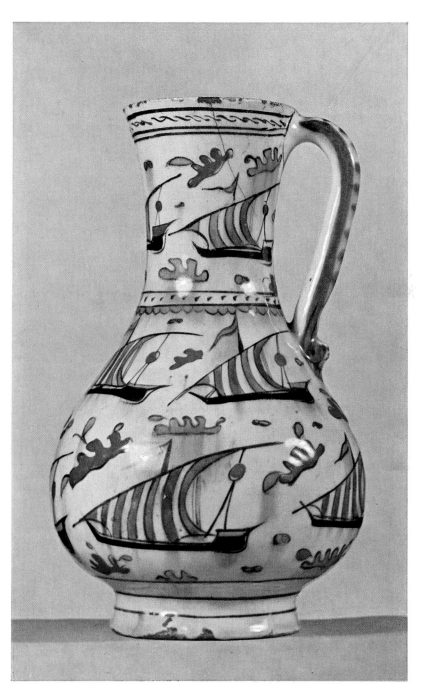

Plate XII. 'Rhodian' jug. Turkey (Iznik), seventeenth century.
Museum Dahlem, Berlin.

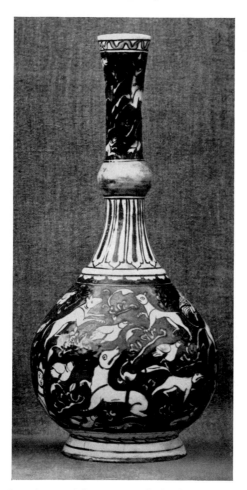

Fig. 119. Bottle with animal decoration, 'Rhodian' ware. Turkey (Iznik), late sixteenth century. Victoria and Albert Museum, London.

recognized by the coarser body, impure white, blurred designs and crackled glaze; a few have Greek inscriptions. Most mosques in Constantinople and many in the provinces are faced with tiles of this type, which have been produced in large quantities since the seventeenth century; the number of vessels that also survive is so large that one is led to wonder whether they could all have been produced in Nicaea. The centre's reputation is supported, however, in an unusual way by a silver lid on a faience jug in the Museum in Halle. It is dated 1582 and is inscribed with a jingle in German which reads:

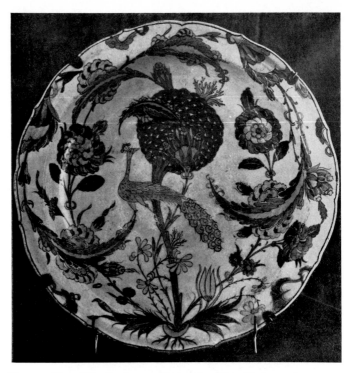

Fig. 120. Plate, 'Rhodian' ware. Turkey (Iznik), mid-sixteenth century.
Formerly R. Koechlin collection, Paris.

"In Nicaea I was wrought
And now to Halle in Saxony brought."
(Zu Nicaea bin ich gemacht,
Und nun gen Halle in Sachsen bracht.)

Imitations of the so-called Rhodian ware were produced in Padua – not, as was thought earlier, in Candiana – in the seventeenth century; they have a yellowish brown instead of the bole red. In the second half of the nineteenth century various potters in Paris, England, Florence, Athens and Rhodes tried to make imitations of this and the 'Damascus' faience, mostly bona fide; but there are also extremely successful porcelain-like forgeries on the market, especially of the earlier types, of which the collector should beware.

Late Kutahya Ware. From the eighteenth century the greatest production from Kutahya was of smaller objects of use (coffee cups, ink pots, plates, bowls, jugs and so on) in gay colours (blue, red, yellow, purple, green) and small-scale floral patterns (Fig. 123). Pieces with Christian saints and Arme-

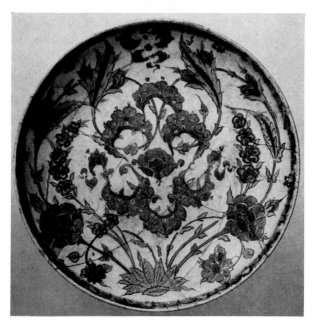

Fig. 121. Plate in 'Rhodian' style. Turkey (Iznik), early sixteenth century.
Museum Dahlem, Berlin.

nian inscriptions are quite frequent, Armenian craftsmen being in the
majority in the potters' guild in the town, where they are mentioned for the
first time in 1608. Glazed monochrome and coarser blue-and-white wares
were produced there too, and in the nineteenth century attempts were made
to imitate certain Persian semi-faiences as well as the older 'Damascus' ware.
None of these was of any distinction, and their interest is only academic.

Dardanelles Ware. This is a late true faience manufactured in Chanak
Kalessi. It is made from a red clay and decorated in discreet colours with a
great variety of motifs, some of them European-inspired; it is unassuming
and decorative in the manner of all peasant wares.

Turkestanian Pottery. This often appears on the market, and should be
mentioned here as a facet of folk art of the Turkish tribes, though more un-
der the influence of Persia in decorative taste. It is a rather coarse faience
mostly glazed in yellowish white with mainly green and brown painted
decoration, produced in the eighteenth and nineteenth centuries and sold in
Samarkand and Bokhara. It often has quite charming motifs (Fig. 124), but
on the whole deserves little attention as an art form.

155

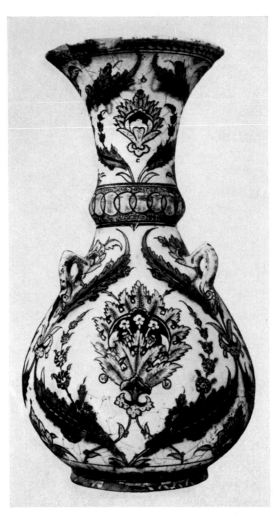

Fig. 122. Faience vase in 'Rhodian' style. Turkey (Iznik), sixteenth century.
Museum of Islamic Art, Cairo.

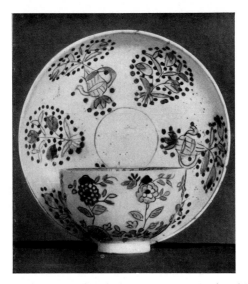

Fig. 123. Cup and saucer with polychrome painting. Turkey (Kutahya),
eighteenth century.
Museum Dahlem, Berlin.

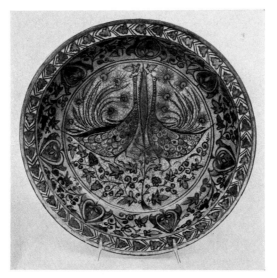

Fig. 124. Plate with polychrome decoration. West Turkestan, eighteenth century.
Formerly antique trade, Paris.

157

METALWORK

Bronze alone of all the metals had a consistent formal and ornamental development in the Islamic cultural sphere. As in the ancient Near East and East Asia, it was the chosen medium for astrological, mantic and symbolic ideas and thus had a privileged role both in ordinary domestic utensils and in luxury furnishings. Forms, decoration and technique all show many points of contact with oriental and classical antiquity, but it is perhaps in the Islamic sphere that they appear at their most creative; for their part they repeatedly influenced the mediaeval West. The religious prohibition on the use of vessels of gold and silver quickly led the smiths to attempt to use the baser metal for artistic purposes, and they turned to inlay in the same way as the potters turned to lustre to give a festive air to bronze objects intended for gifts or display. Even more important here than in other branches of craft was the personal interest of the patrons, who often expended considerable wealth to give the artists the opportunity to show all they could do with patient and arduous work. Once the single commission was replaced by repetitive work for the bazaars any development ceased; this stagnation started earlier in bronze working than in other fields, to a great extent even in the fifteenth and sixteenth centuries.

MODELLING AND RELIEF IN BRONZE

Deriving from the Sasanid, perhaps also from Chinese models, large ewers and incense burners in animal form were cast in Khorasan and West Turkestan in the early Islamic period. The surface was either smooth or detailed in high relief engraving on horses, cocks, ducks, deer and so on, and the effect was monumental. The few surviving examples are mostly in Russian collections and range in date from the eighth to the tenth century; the Berlin Islamische Abteilung has one such incense burner in the shape of a bird

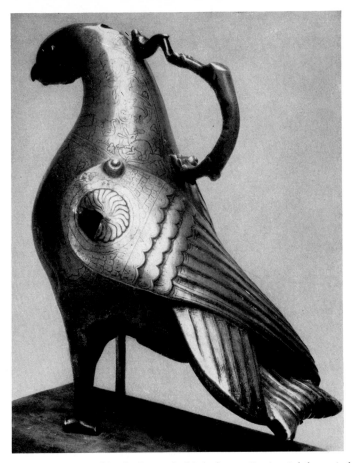

Fig. 125. Incense vessel in the form of a bird of prey. Persia, eighth to ninth
century.
Museum Dahlem, Berlin.

of prey with an animal-shaped handle (Fig. 125). These objects must also have
reached the West, where a related development soon began along formally
different lines.

Somewhat later (eleventh to twelfth century) objects modelled in the
shape of animals were produced for decorative purposes at the Fatimid
court in Cairo, some of them were covered with engraved ornament (Fig.
126). The famous griffin, almost a metre high, on the Camposanto in Pisa
also belongs in this class. Several incense vessels in the form of a lion, cast and
perforated, have appeared from Persia (Fig. 127), probably all of the Seljuk

159

period; the Metropolitan Museum has in its possession one particularly large example of this type. Lastly, animal figures of this kind were occasionally made in Spain; there is one example from the tenth and two from the twelfth century.

Smaller crests in bird form – eagle, falcon, duck – were often used as decoration for a handle or lid on early mediaeval Persian and Egyptian vessels, and similarly the feet and handles of incense burners, door knockers and taps were shaped into lions, panthers, bulls and so on (Fig. 128). It is rarely possible to be very precise about the period and place of their manu-

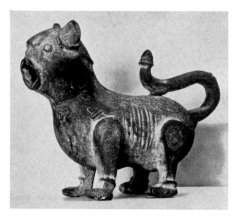

Fig. 126. Small bronze lion. Egypt, eleventh to twelfth century.
Museum Dahlem, Berlin.

facture. They mostly belong to the Seljuk period, as do the mortars preserved in a number of variants with rows of bosses and rings with animal head attachments (Fig. 129). An outstanding example of ornamental sculpture is the door knocker from a twelfth century mosque in the Dahlem Museum; it has a pair of opposed dragons whose tails turn into bird heads, on either side of a lion head (Fig. 130).

Persia was again first in the field in relief casting; this technique was applied to ewers that still show the effects of Sasanid silver and gold style. Later there are very large mirrors with representations of the planets or the zodiac (Fig. 131), smaller ones with two opposed sphinxes – known in many examples – and others clearly influenced by Chinese models, with a great variety of motifs. West Turkestan and the Caucasus originated the large charcoal basins that were to preserve the same form throughout the Middle Ages,

160

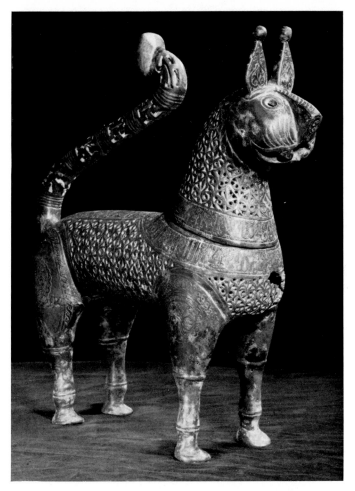

Fig. 127. Incense vessel in the form of a lion. Persia, twelfth century.
Museum of Art, Cleveland.

with animal friezes or inscriptions engraved in relief round the rim (Fig.
132).

Chased relief hardly developed at all as an independent technique, but was
allied to engraving and inlay which will concern us in more detail presently.
Only the small decorative plaques and shaped pieces of unknown use that
are found particularly in the Caucasus, are worthy of note in the present
context; these suggest animal, sometimes human forms as the ultimate
inspiration of the design.

161

Fig. 128. Incense bowl on animal feet. Persia (Khorasan), eleventh century.
Museum Dahlem, Berlin.

Fig. 129. Knobbed mortar with animal head ring attachments. Persia (Khorasan),
twelfth century.
Museum für Kunst und Gewerbe, Hamburg.

Fig. 130. Door knocker with dragon motif. Mesopotamia, twelfth century.
Museum Dahlem, Berlin.

Fig. 131. Bronze mirror made for an Ortoqid ruler. Mesopotamia, twelfth century.
Fürst Ottingen-Wallerstein.

Fig. 132. Charcoal basin with relief frieze. Caucasus, twelfth to thirteenth
century.

ENGRAVED BRONZES

If one finds oneself confronted with Islamic bronzes decorated purely in engraving one may almost always be sure that they were made either before or after the classical period of inlay. This, leaving out the preliminary stages and the aftermath, embraces essentially the thirteenth and fourteenth centuries in the Near East and Egypt. This point of reference will be useful for the collector to bear in mind in assessing them correctly, and for a close attribution of the older pieces (tenth to twelfth century) he need only choose to all intents and purposes between two countries: Egypt and Persia. He must be wary however, for it has recently occurred to some enterprising individuals to engrave undecorated bronzes (dishes, ewers, vases) with motifs in the Fatimid or Seljuk style, to make them look more impressive; even antique objects, of some value in themselves, have been "improved" in this way.

Kitchen ware and incense equipment were so much influenced in the Tulunid period in Fostat by similar Coptic work that it is often difficult to recognize them as Islamic at all. Not until the Fatimids did they acquire the characteristic style given them by their usually very shallow engraved patterns (interlacery, animals in scrolls, good wishes in Kufic). Kettles and pans, dishes, bowls and boxes, mortars, candlesticks in multiple sections and round trays – all with a high copper content – have been excavated in large numbers, most of them badly oxidized and seriously damaged. The inscriptions, often sadly blemished, give neither names of patrons nor dates.

The Persian group has very similar Kufic eulogies over leaf scrolls and single ornamental or figure motifs; the incense vessels stand out by reason of their wealth of forms. Almost every surviving example is of a different type, bowl-shaped, niche-like (Fig. 133) or in two parts, the upper perforated to let out the vapours, and removable. Slender candlesticks with an elaborate profile similar to those of the Fatimid period, bellied ewers and low standing bowls are more frequent in the twelfth century; the decoration is enriched with animal patterns and the inscriptions are often in the "animated" Kufic or *naskh*, with the shafts of the letters turning into human heads and the endings into bird bodies and such like (cf. Fig. 166). Eastern Iran (Khorasan) seems to have been the leading inspiration in the technique

Fig. 133. Incense vessel with engraving. Persia, twelfth century.
Museum Dahlem, Berlin.

of engraving; it is likely that elegant openwork candlesticks were also pro-
duced there occasionally (Fig. 134).

One rather timeless and homeless group is formed by the instruments
used all over the orient for astrology and cabbala: globes, astrolabes, quad-
rants, magic bowls and amulets. Since they were produced for centuries in
the same forms and always exactly to the specifications of the learned client
they remain outside the inherent development of the metal style, although

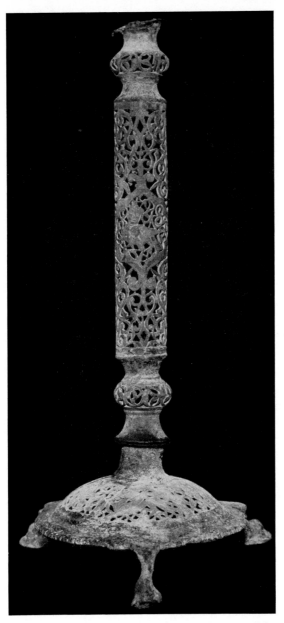

Fig. 134. Lamp stand with openwork decoration. Persia, twelfth century.
Art Museum, Detroit.

Fig. 135. Ewer with relief decoration and copper inlay. Persia, ninth to tenth
century.
Hermitage, Leningrad.

useful information has often been gleaned from the engraving on them, and
dated examples are frequent.

The later style of chiselled work, which has continued in several Islamic
countries until the present day, will not detain us long since it retained no
artistic importance after the decline of inlay, apart from which it had none
at any time. By and large it rapidly fell into decadence and responded only
to the most pressing decorative needs of a cheap brass ware industry.

INLAID BRONZES

The first examples of copper inlay are found on some of the cast Persian bronzes with incised relief and engraving used for the details of the design. They still bear the imprint of the Sasanid period. A touch of animation is given by thin threads or rough strips and drops of red metal (Fig. 135). The real development of inlay technique begins in the Seljuk period. The arts at that time all received enthusiastic encouragement from the small courts of the atabegs, and every technical innovation was seized upon.

Inlaid Bronzes of the Twelfth Century. In eastern Persia in the region of Khorasan, copper and silver inlay was already in full swing by the middle of the twelfth century; the technique was handled in the fashion that continued to be practised in the Near East; the motifs were engraved into the metal body in single friezes – figures, "animated" inscriptions etc – in coarse outline with roughened edges. Then the inlays were hammered in from thin plate and finally the more delicate detail was scratched onto the inlay itself. But at first even then the copper was used sparingly, making an effective contrast with the deep engraving and the areas with a black paste ground that produces a similar effect to niello. A magnificent kettle in the Hermitage has a series of horizontal bands showing various representations in copper and silver inlay of enthroned monarchs, huntsmen, musicians and acrobats, and inscriptions. It gives us an idea of the masterly skill possessed by the metal smiths of Herat in the year 1163 (Fig. 136). The epigraphy is in three variants: below appears a band of *naskh* with the shafts turning into faces, in the middle is interlaced Kufic, and above is a rounded hand with shafts that end in vigorous human torsoes and bird heads.

There was also a more delicate style of inlay, probably practised in the Caucasus or in Armenia, used on thin-walled embossed candlesticks decorated with repeating animal reliefs and on fluted ewers; only very few of these are preserved in the large European museums (Fig. 137). Mostly the silver lamellae have fallen out and thus much of the detail of the designs is lost; the designers seem to have favoured zodiacal figures and symbols of the planets together with purely ornamental patterns and inscribed rims.

'Mosul' Bronzes. The apex of the development of the technique of inlay was reached – in silver, with sparing use of gold – in northern Mesopotamia

Fig. 136. Inlaid kettle, dated 1163, Persia (Herat).
Hermitage, Leningrad.

Fig. 137. Base of candlestick with chased relief. Persia, twelfth century.
Louvre, Paris.

about the middle of the thirteenth century. Inscriptions by the artists on a
large number of outstanding pieces confirm beyond question that the town
of Mosul held undisputed supremacy in the craft. From here expert crafts-
men travelled to other places, as far as Persia, Syria and Egypt and rapidly
disseminated the typical features of their art throughout a wide area. Be-
cause of the close contact with the mother guild and because in fact there are
as yet no clear criteria for regional groupings, it has become the custom to
call all Near Eastern inlaid work of the thirteenth and fourteenth century
'Mosul' bronzes, though strictly speaking only those pieces made in the
city on the Tigris itself have any right to the name. These latter are still the
easiest to distinguish from among the large amount of material available:
there is a characteristic ground of interlocking T-shapes (Fig. 138) and there
are certain idiosyncracies in the handling of the figures.

Otherwise the decorative scheme first devised in Mosul spread every-
where: horizontal bands, on dishes and plates arranged concentrically, hold
alternate friezes of epigraphy interrupted by small rosettes, animals friezes
and figure medallions; sometimes there are complete scenes, e. g. battle

171

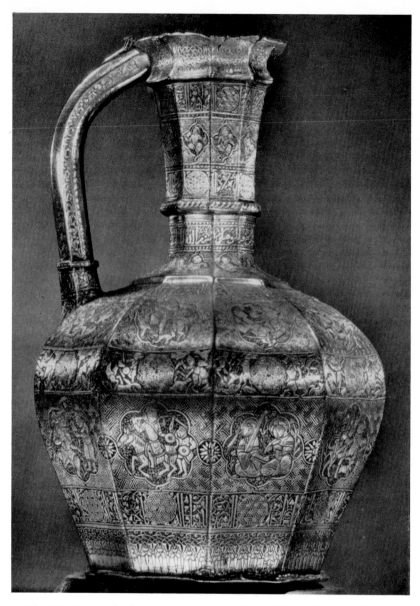

Fig. 138. Ewer with silver inlay, dated 1232, Mosul. (Master Shuja ibn Mana.)
British Museum, London.

scenes continuing round the whole vessel. The themes of the compositions were taken almost exclusively from court life: princes enthroned with servants at their sides, or revelling with a long retinue of courtiers, or being entertained by musicians and acrobats, or games of polo, hunts and so on, often in very lively drawing (Fig. 139). For single figures horsemen and planet symbols were the favourites, and in addition there appear symbolic animal combats and the fabulous beasts of antiquity (sphinx, griffin, siren), joined after the middle of the thirteenth century by those adopted from the Far East (dragon, phoenix, ch'i-lin and others).

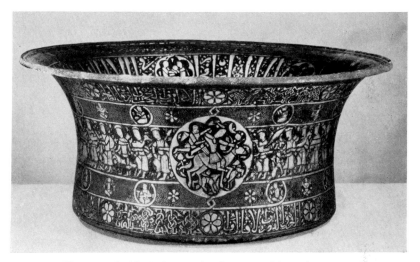

Fig. 139. Inlaid basin in Mosul style. Persia, thirteenth century.
(Master Ali ibn Hamud.) Gulistan Museum, Teheran.

Christian subjects (saints standing under arcades, or scenes from the life of Jesus) were sometimes used for objects intended as gifts to a patriarch or a Western prince. The majority seem to come from the Syrian area, where gold and silver inlay was much in use in the thirteenth and fourteenth centuries to create a close patterning of knots, interlacery, scales and so on; carried thence to Venice, it was practised far into the sixteenth century by Muslim craftsmen (see below). It is no easy matter to decide which groups of inlay work are of Near Eastern and which of Persian manufacture, though at least for the latter there are a few reliable signed pieces.

Of the forms of object chosen to be adorned with this delicate and minute embellishment the candlesticks are the most striking; they occur everywhere

173

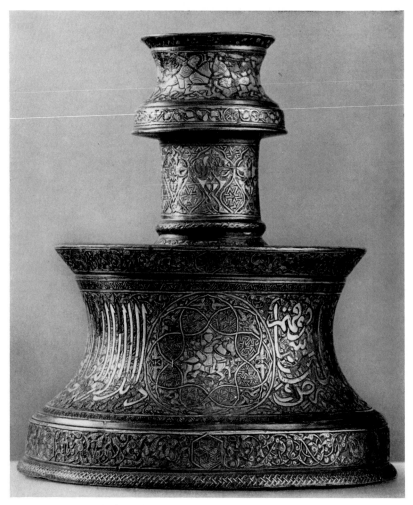

Fig. 140. Inlaid candlestick in Mosul style. Persia, thirteenth century.
Museum Dahlem, Berlin.

in the most varied dimensions of the same type: the base is a truncated cone,
possibly flattened or waisted, and above it rises a tube-like neck with an
overhanging top echoing the form of the base (Fig. 140); other types of
candlestick and lamp stand exist, but are much rarer. Vases and ewers, water
bowls and deep basins, the latter usually with a bevelled rim, are specially
frequent among the Mesopotamian pieces, while boxes and jewel caskets,
writing paraphernalia and incense globes seem rather to have been the

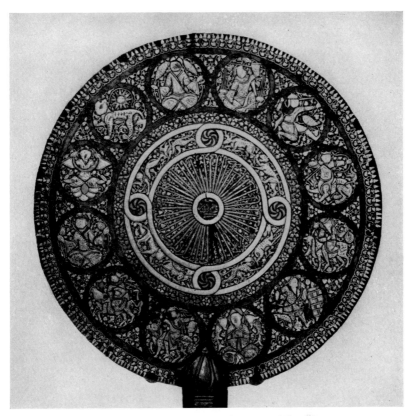

Fig. 141. Bronze mirror with silver inlay. Syria (Aleppo), c. 1320.
Saray Museum, Istanbul.

speciality of the Syrian workshops. Both Damascus and Aleppo had flourish-
ing workshops; a mirror decorated in the most delicate inlay with pic-
tures of the zodiac, an animal procession and a rayed rosette of epigraphy,
fashioned for a Mamluk governor (Fig. 141), gives proof that in the four-
teenth century the Syrian smiths were still following a different path from
Cairo. On occasion goblets, kettles and small buckets appear (the latter
plainly for use in ritual ablutions) or incense vessels (Fig. 142), and they are
difficult to attribute geographically with any exactitude. Larger objects of
inlaid metalwork were unknown anywhere in the area.

'Mosul' bronzes of whatever provenance are among the most sought-
after of Islamic works of art and they fetch very high prices on the art mar-
ket. Collectors must be very much on the alert against skilful imitations.

175

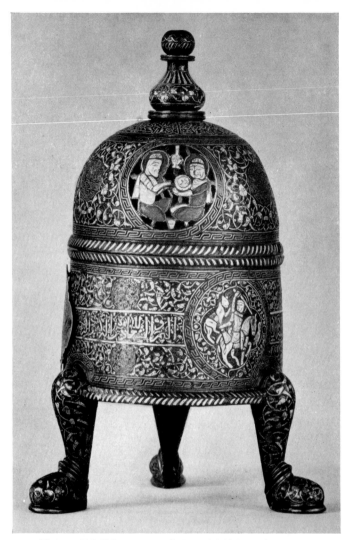

Fig. 142. Inlaid incense vessel. Syria (?), thirteenth century.
Victoria and Albert Museum, London.

A common practice is to "complete" old pieces that are only engraved by hammering on little strips of silver, but the delicacy of execution and the detailed drawing does not compare with that of an original.

Mamluk Bronzes. Cairo was another centre where a school of inlay was set up in the thirteenth century by craftsmen from Mosul. The school took an independent path in that figure decoration was frowned upon, if not entirely

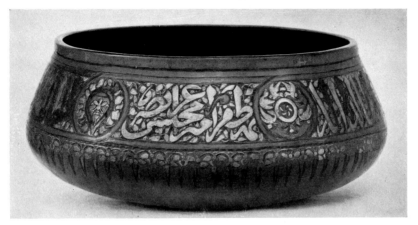

Fig. 143. Mamluk bowl with inlay. Egypt or Syria, mid-fourteenth century.
Museum für Kunst und Gewerbe, Hamburg.

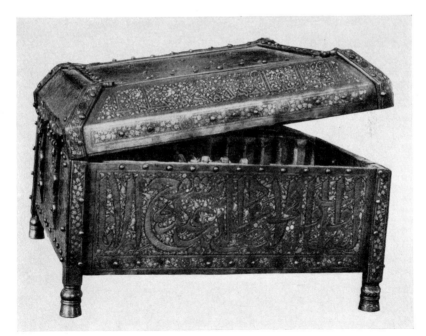

Fig. 144. Koran chest with inlay. Cairo, mid-fourteenth century.
Islamic Museum, Cairo.

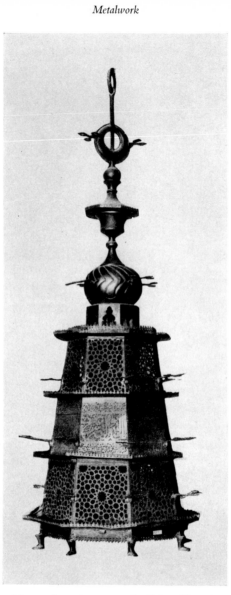

Fig. 145. Mosque lamp in openwork. Cairo, fifteenth century.
Islamic Museum, Cairo.

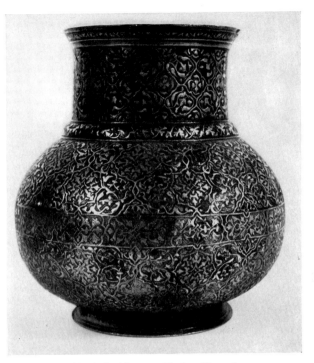

Fig. 146. 'Azzimina' bronze. Venice, fifteenth century.
Art Museum, Seattle.

prohibited, from the outset, and alongside the abstract ornament epigraph-
ical decoration was all the more richly developed. A favourite device was
to cover the surface area of the body of a candlestick or ewer, or the centre
panel of a dish or tray, with good wishes or quotations from the Koran in
the larger forms of *naskh;* very often, too, the narrower borders are chiefly
animated with round or angular epigraphy over leaf or flower scrolls. Even
the disc medallions that interrupt the text with their palmette flowers or
emblems of office are sometimes also provided with inscriptions (Fig. 143).
Exceptionally, Koran chests (Fig. 144) and hexagonal lamp tables, called
kursi, were in Egypt inlaid with silver, while the custom was to restrict the
decoration of the house- or tent-shaped bronze lamps, common especially
from the later Mamluk period onward, to engraved and openwork orna-
ment (Fig. 145). They were also produced in the same manner in Constan-
tinople from the sixteenth century. As a rule the inlays still provided for in
the design are missing from later pieces.

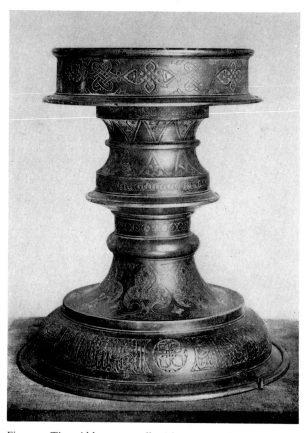

Fig. 147. Timurid bronze candlestick. West Turkestan, c. 1400.
Louvre, Paris.

'*Azzimina*' *Bronzes.* As has already been mentioned, inlay technique spread
to Venice, probably before the end of the fourteenth century, and it is
known that a proper guild of Saracen craftsmen settled there. Their work is
sometimes distinguished between "all 'azzimina", i. e. in the Persian manner
(*al-ajamiya*) und "alla damaschina", but usually the former designation
includes both. The vases, candlesticks, incense globes, lidded boxes, dishes
and plates of this type are recognizable by the close arabesques (Fig. 146),
sometimes interrupted by Arabic inscriptions or Venetian emblems. Many
bear the signatures of artists, among others that of Mahmud al-Kurdi.

Timurid Bronzes. We have already referred to the spread of the Mosul
school into Persia, and it is to be expected that inscribed pieces will in time

180

appear to allow an increasingly clear distinction of an Iranian group from among the at present unattributed material of the thirteenth and fourteenth century. Its importance can be gauged from the large quantity of works of the late fourteenth and fifteenth century which have appeared all over Persia. The arrangement of their decoration is unmistakeably reminiscent of the previous period of inlay. Although they were no longer done in silver they still show the characteristic roughening of the outlines to secure the strips of metal, and thus give an unfinished impression (Fig. 147). The type maintained a certain standard into the Safavid period; there are few works of notable artistic content, but a few new forms of candlestick appeared.

PRECIOUS METALS AND ENAMEL

Islamic vessels and utensils of gold or silver are extremely rare. Although the repeatedly mentioned Koranic prohibition was often enough overlooked at the luxury-loving courts, the intrinsic value of the material has militated against the preservation of older works. The odd examples that have nevertheless survived this hazard show them to be untypical of their period, and largely dependent on other techniques for form and decoration. Only in early Islamic Persia do we still find a relatively consistent series of

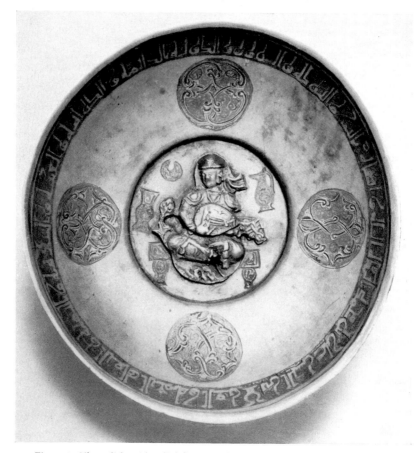

Fig. 148. Silver dish with relief figure and niello. Persia (?) Eleventh century.
Museum Dahlem, Berlin.

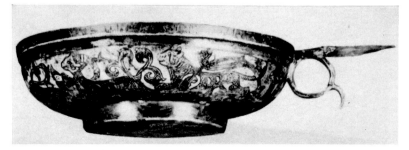

Fig. 148a. Drinking bowl. silver with niello. Persia, eleventh century.
R. Harari, London.

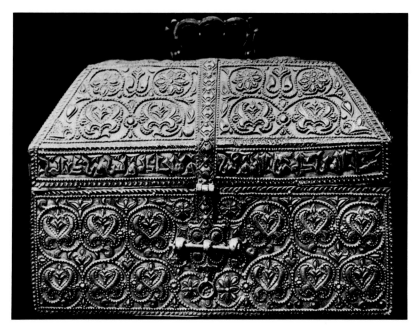

Fig. 149. Jewel box of silver. Spain, tenth century. Cathedral, Gerona.

silver dishes; they have artistic charm but can not be regarded as anything
more than the minor successors of the Sasanid style which had reached its
greatest heights in vessels of this kind. Objects of plain undecorated or
chased silver and gold were sometimes still made in Persia in the tenth or
eleventh century (Fig. 148, 148a). Any that appear in the trade are to be
greeted with the greatest suspicion, precisely because of their rarity. Gold
work in particular has recently been much and very skilfully forged. In
Spain, under the Umayyads, a small number of jewel boxes of chased silver

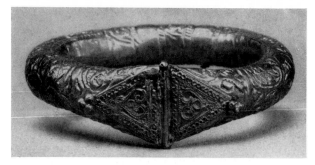

Fig. 150. Arm band of gold plate. Egypt, c. 900.
Museum Dahlem, Berlin.

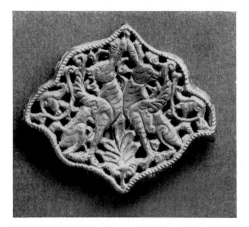

Fig. 151. Belt clasp of gold. Persia, thirteenth century.
Museum Dahlem, Berlin.

were openly produced, despite the religious prohibitions, in the usual form
of the ivory casket with a gabled lid (Fig. 149).

In jewellery the precious metals were used everywhere, and careful exam-
ination of the surviving examples allows us to distinguish groupings. They
seem rather to be based on ethnic connexions, as is to be expected from
objects that were particularly subject to national and regional traditions.
There were of course also temporary fashions which influenced the jewel
industry at least in the towns. Thus we can for example recognize Egyptian
armbands of the Tulunid period by the chased scroll work (Fig. 150), and
belt clasps of the Seljuk era of the thirteenth century by their stylized animal
ornament as surely as the Alhambra style can be diagnosed by the arabesque
filigree of certain gold pendants. The jewellers who produced the prohibited

184

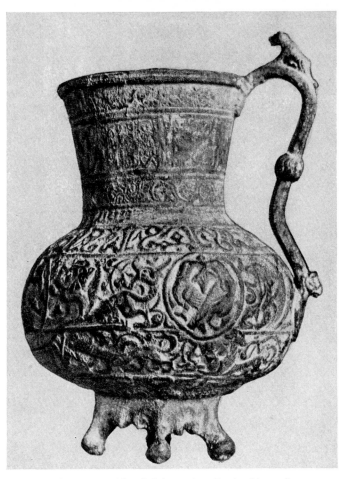

Fig. 152. Silver ewer with relief decoration. Persia, thirteenth century.
Museum Dahlem, Berlin.

finery in precious metal were not always Muslims: they were often Jews,
as is often the case in some parts of the East to this day.

The Seljuk silver plate excavated in Persia is close to bronze work in
form and decoration; sometimes dishes of the Mongol period also appear.
Examples like the beautiful ewer in the Islamic Section in Berlin are in fact
extremely rare. This one has animal motifs and inscriptions in chased relief
and a plain handle with a lion as a thumb stop (Fig. 152).

Cloisonné and translucid enamel were apparently hardly used in Islamic
metalwork except for decorating the hilts and scabbards of swords and dag-

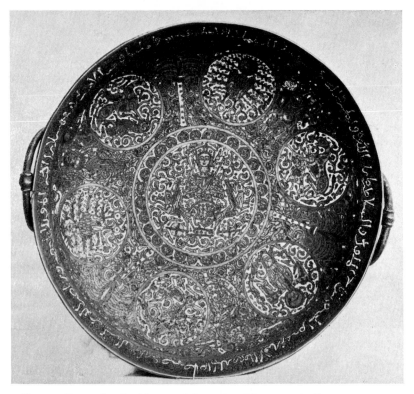

Fig. 153. Bronze bowl with enamel decoration. Mesopotamia (?), c. 1120–1140.
Ferdinandeum, Innsbruck.

gers. A completely isolated surviving example does at least suggest that as in China and Byzantium the Islamic smiths occasionally covered copper or bronze objects with a close design of figures in enamel. The case in point is a splendid dish in Innsbruck which according to the inscription on its rim was made for the Ortoqid atabeg Daud b. Sukman (d. 1144); it was manufactured either in Diyarbakr itself or nearby in Armenia. The two-handled dish (Fig. 153) is decorated on both sides in polychrome cloisonné with six medallions (eagle in front view, griffin and lion over their prey, people making music and wrestling) between palm trees and dancing girls. In addition, on the centre of the inside, there is a representation of the apotheosis of Alexander, a theme which was current in Christian iconography.

There are also rare examples of small decorative plaques with enamelling, from Fatimid Egypt.

ARMS AND ARMOUR

The importance of weapons in the artistic activity of the Near East is very widely known, and if its importance were to be given corresponding treatment here it should have a large chapter to itself. On the other hand it is less the lovers of Islamic art than collectors of weapons who will be prepared to give these objects close attention, and the latter will find better and more thorough instruction in the specialist literature than can be given here. We must content ourselves therefore with a short review of the objects that are especially remarkable from the artistic point of view and which cannot be ignored by even those whose interest is of the most general.

It should be stressed at once that in scarcely any other field were imitations so early and so frequently in circulation as in that of weapons; even today many otherwise respectable collections are swollen with modern Persian pieces, and though the boom in these weapons is now at an end, forgeries are still constantly appearing. Furthermore it must be remembered that Hungarian and Russian weapons in particular were for long under Turkish or Persian influence and with insufficient expertise can easily be confused with original oriental work.

Inlay played a dominant role here, as in bronze work, but was handled differently; either gold thread was driven into the iron or steel body, or thin gold leaf was hammered onto the previously roughened ground (overlay or damascene).

Swords and Daggers. Oriental blades – especially the "damascene", i.e. of watered steel – were coveted in the West for centuries on account of their special qualities, and were often given precious mounts in Europe even when they had no ornamental embellishments. Among those others that have been preserved with their original hilts, and sometimes with scabbards as well, and which are notable for their decoration, there is a distinct Moorish group with a straight blade and bent down quillons; these are the Boabdil swords, so-called after the last king of Granada with whom several examples are historically associated. They all belong to the fourteenth to fifteenth century and are splendidly decorated on the hilt and scabbard with gilded openwork arabesques and multi-coloured

187

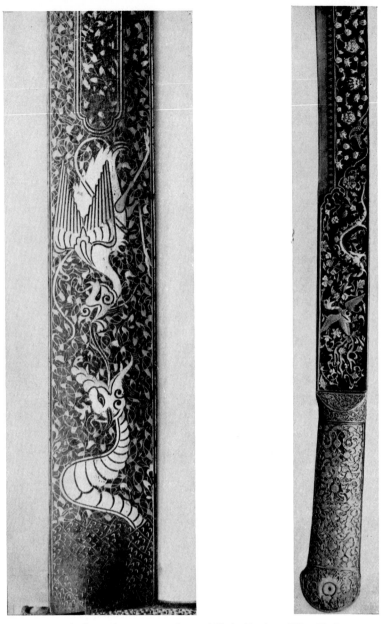

Fig. 154. Inlaid motif on a Mongol sword blade. Persia or West Turkestan,
fourteenth century. Army Museum, Munich.
Fig. 155. Short sword with iron engraving. Persia, sixteenth century.
Saray Museum, Istanbul.

cloisonné (Plate XIII). More or less contemporary, some perhaps earlier, the so-called Mongol blades were forged in Persia or West Turkestan. A smaller number of them are known; they also are straight and broad, with the motif of the dragon and phoenix in an effective close design of gold and silver inlay (Fig. 154).

There are examples of blades from Mamluk Egypt, with reliable epigraphy, in the Saray Museum in Istanbul; the inscriptions are partly executed in careful calligraphy, partly hastily scratched on, and sometimes they carry a note explaining that they belong to the arsenal in Alexandria.[1] Entirely trustworthy examples of older Islamic striking weapons cannot as yet be produced.

Curved sabres were apparently long customary in the Orient before they were known in Europe; in Persia however they cannot be vouched for before 1500. The Safavid blades are rarely matched elsewhere for the elegance of their curve; sometimes they were split below, in imitation of the famous "dhullfikar" of Ali, the son-in-law of the Prophet. Right into the nineteenth century they were often richly inlaid with gold in ornamental designs and inscriptions in *thuluth* and *nast'aliq*, sometimes also with motifs carved in the iron near the haft or on the hilt, though this was more usually inlaid with horn or jade; the quillons were also decorated.

Persian blades often bear the motto that they come from the hand of the master Asad-Allah of Isfahan; the name of this famous sword smith was frequently misused, right into the nineteenth century. The examples ran into hundreds, with dates of 811 H to 1223 H. We know nothing of him from historical sources, and can only deduce that he must have been active for the Persian court at the latest at the end of the sixteenth century. The other frequently recurring remark that the blade was worked for one or other of the Safavids (sixteenth to seventeenth century) is no more reliable.

Turkish swords in general follow the same type in form and furniture and are often difficult to distinguish from the Persian; the same is true of Indian swords of which there are very few notable older pieces. Hilts, quillons and scabbards were often incomparably richly decorated in these

[1] These may be in many cases blades from the arsenal of the Knights of St. John at Rhodes, captured in 1525. [Translator's note.]

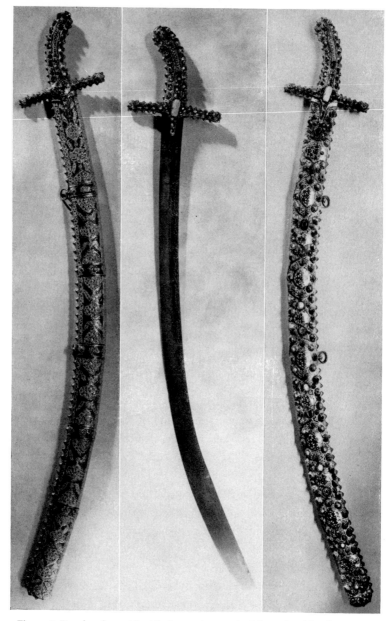

Fig. 156. Parade sabre with rich decoration on the hilt and scabbard. Turkey,
seventeenth century.
Schatz des Deutschen Ordens, Vienna.

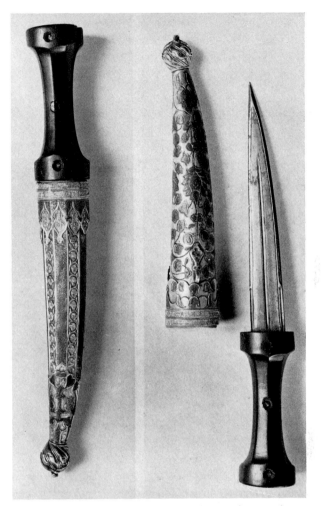

Fig. 157. Daggers with sheaths. Persia or Turkey, mid-sixteenth century.
Kunstgewerbe-Museum, Bratislava.

countries, especially on the Turkish parade swords in the seventeenth
and eighteenth centuries. A ceremonial sabre in the Schatz des Deutschen
Ordens in Vienna may serve as an example here (Fig. 156). The blade
has Persian verses in fine inlay, the scabbard has silver relief incrustation
on one side, on the other small enamel medallions between a close order
of stones and pearls.

The short swords customary in the Islamic orient in the sixteenth to
eighteenth centuries (*khanjar*) were also very richly furnished. They are

191

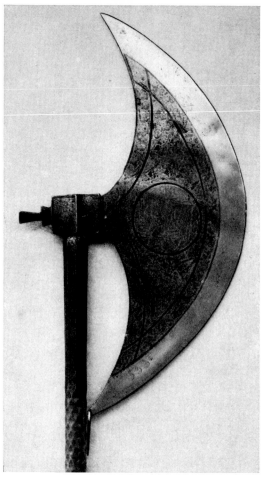

Fig. 158. Battle axe with intarsia decoration. Egypt, fourteenth century.
Historisches Museum, Dresden.

made without guards and the blade slopes slightly inwards (Fig. 155).
The classic type of dagger was evolved round 1500 in Herat, sometimes
straight, usually curved and decorated with carving, often with openwork
ornament or gold intarsia. The hilts were either also of solid metal or
silver plated with translucent enamel, more often of jade with small pre-
cious stones, or sometimes again of ivory; the scabbards are of leather,
snake skin or wood with enamelled or niello silver incrustation (Fig. 157).
Older Moorish daggers with straight blades are very rare, but strongly
curved ones with hilt and scabbard of engraved silver have recently been

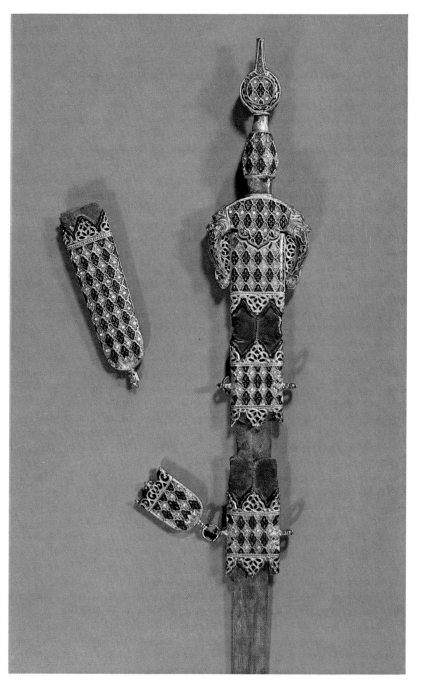

Plate XIII. So-called Boabdil sword. Granada, fifteenth century.
Landesmuseum, Kassel.

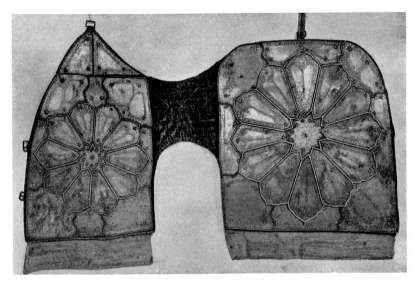

Fig. 159. Horse caparison of inlaid steel. Turkey, seventeenth century.
Landesmuseum, Karlsruhe.

produced in large quantities, particularly in south Morocco, and have been popular with Europeans as travel souvenirs. In India the native form was the *kattar*, with a broad ladder grip held by cross bars, and the *yatagan* also.

Battle Axes and Maces. Battle maces, often only intended as emblems of authority, were made from early times in the most varied materials; the solid cast and fluted or knobbed body was sometimes richly decorated with inlay. *Bogozany* is the name for Turkish clubs made in one piece with a pear-shaped smooths head, a type which was introduced into Hungary. Hundreds of splendid engraved iron or steel battle axes were made in Persia in the sixteenth to eighteenth centuries, some with figure motifs; the broader and flatter axe shape was characteristic of the Mamluk period in Egypt, with a beautifully curved blade decorated with inscriptions and ornament in gold inlay, sometimes also with openwork (Fig. 158). The shorter form of battle hammer with a long handle, and the double axe which was probably only ever intended as an emblem of authority seem to have been especially popular in Turkey in the seventeenth century.

Armour. Whole suits of armour are very rare, at least of a good period and complete with helmet, coat of mail with breast, side and back pieces and arm guards, mail leggings with knee joints and so on; but single pieces

193

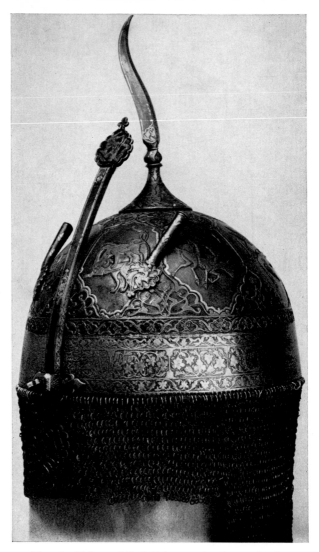

Fig. 160. Helmet of Shah Tahmasp, dated 1528, Persia.
Saray Museum, Istanbul.

are met with more frequently. In Persia and in Turkey in the sixteenth and seventeenth century they were inlaid with designs, mostly rather sparse and free. Similarly wrought parts of horse armour, chamfrons etc. are also obtainable (Fig. 159). In the nineteenth century oriental armour was faked in considerable quantities.

Helmets. It is very rare to find artistically outstanding examples of oriental helmets complete with all their fittings (nose pieces, neck guard, cheek pieces, plume (and spoon) holder, point and mail) as they were when they were worn; nearly always one or another part is missing or is a later replacement. Old Persian examples are almost always decorated on the broad brow band and on some narrower surfaces with rich damascening, and it sometimes spreads across the always round and uniform bell; as a rule this is left quite smooth, though on some pieces there is relief engraving with animal combats or figures (Fig. 160). Vizors were doubtless used quite frequently, but are very rarely preserved. India on the whole remained faithful to the Persian type of helmet, but older examples from this country are especially rare.

The Mongol or early type of Turkish helmet is considered to be that of large dimensions – it was worn over the turban – and made in one piece with eye holes and a few spiral or sometimes vertical (and if so, then narrower) flutings in the bell, completely covered with arge-scale arabesques and inscriptions in silver inlay. This is executed by laying thin silver wires close together on the roughened ground and hammering them down; the ground is punched and sometimes gilded (Fig. 161).

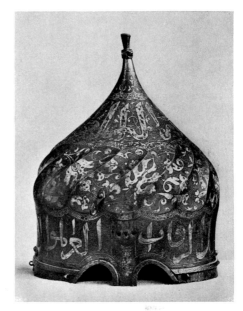

Fig. 161. Mongol-Turkish helmet. West Turkestan (?), fifteenth century. Museum Dahlem, Berlin.

It has not yet been satisfactorily explained what changes the helmets of the Mamluk period underwent; after the conquest of Egypt by the Ottomans they came to Istanbul in large quantities and a fine array is still to be seen in the Army Museum there (Fig. 162). Possibly they contributed much to the form of the characteristic Ottoman fluted battle helmet

195

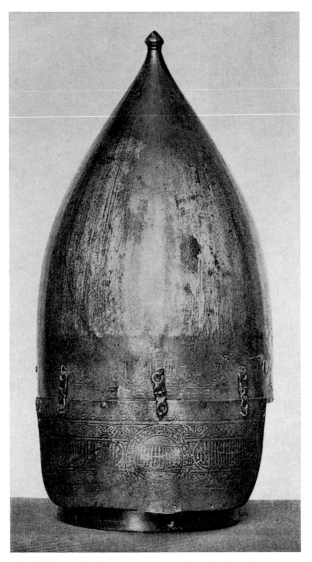

Fig. 162. Helmet with the name of the Sultan Barsbay. Egypt, c. 1430.
Louvre, Paris.

which became popular in Germany in the seventeenth century, having
come there by way of the Turkish wars through Hungary and Poland
(*shishak*; the Hungarian origin is recognizable less by the shape than by
the strongly Europeanized though orientally intended etched ornament).

For a time it seems that the Janissaries at least wore helmets shaped in imitation of their felt bonnets – derived from dervish caps – which like these still had a holder for plume and spoon on them (Fig. 163).

Shields. In Egypt round shields with scrollery and inscriptions in cartouches were made fully in keeping with the inlaid bronzes of the Mamluk period, while in Persia they were decorated differently according to the material. Here too they were always round with a protruding boss which was rivetted in iron on to wooden shields covered in leather and painted. From the high period of the sixteenth century a few parade pieces of iron or steel are preserved with rich gold intarsia in designs perfectly true to style (Fig. 164). Turkish and Indian examples of metal shields are very rare, and so are Moorish; the usual type was of plaited reed work or leather with steel bosses (Fig. 165).

Belts and Harness. Buckles and sections of sword and dagger belts furnished numerous opportunities for encraving on iron and inlay. Especially in Persia in the Safavid period, they were surprisingly richly decorated both with abstract ornament and figures.

The only part of the saddle that is of interest to the lover of oriental metal work is the stirrups, of which fine examples are occasionally to be found and acquired. They always had a broad tread such as is still used in the regions remote from European influence. In Turkey especially they often gave the opportunity for rich openwork in iron or gilded brass, and were also encrusted with stones or enamel. Harness in Turkey was often encrusted with engraved silver or mounted in gilded bronze with glass paste. Interesting horse-bits occasionally appeared in the Caucasus region in the early Islamic period in original modelled shapes; notable later pieces with openwork and inlay are almost impossible to find.

Kettle Drums. It is doubtful whether the few known Islamic kettle drums served a military purpose.[1] A miniature of 1237 (cf. Fig. 12) shows that they were used at that time, and that they were of some considerable size; and a bronze drum of the same type, but earlier, being of the twelfth century, with a large inscription in animated Kufic over engraved arabesques, is preserved in Istanbul (Fig. 166). Smaller drums of the same shape were used by mounted falconers (Mamluk examples of the fourteenth to fifteenth century are in the Armoury in Stockholm).

[1] But see F. Lot, *L'art militaire et les armées*, (Paris 1946) II, 291; at the battle of Las Navas de Tolosa they were used to rally the Moorish troops. [Translator's note.]

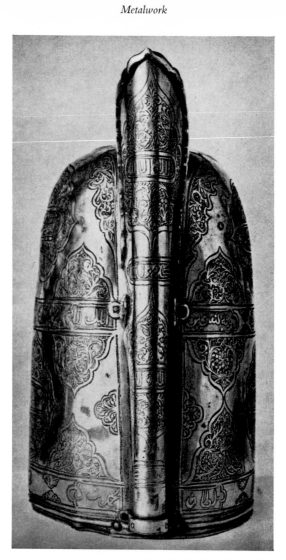

Fig. 163. Helmet of a sultan's guard (Peyk). Turkey, sixteenth century.
Bayerisches Nationalmuseum, Munich.

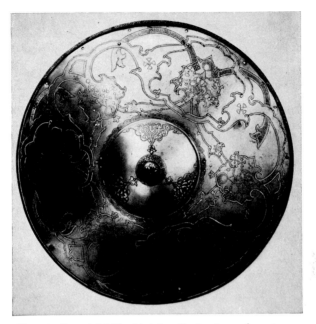

Fig. 164. Round shield with inlay. Persia, sixteenth century.
Kunsthistorisches Museum, Vienna.

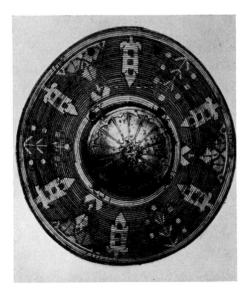

Fig. 165. Reed-work shield with iron pommel. Turkey, seventeenth century.
Landesmuseum, Karlsruhe.

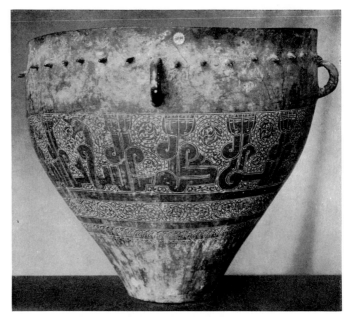

Fig. 166. Kettle drum with engraving. Persia, (Khorasan), twelfth century.
Museum of Turkish and Islamic Art, Istanbul.

GLASS AND CRYSTAL

ROCK CRYSTAL

The church treasures of Europe and the court collections have contained objects of rock crystal since very early times; these have always carried with them a more or less legendary tradition of oriental connections, without giving any more precise information about where they came from. We know now that nearly all belong to one centre and one definite period: they were perhaps the most brilliant offspring of the artistically fertile Fatimid period in Egypt and can all be placed between 970 and 1170. The not inconsiderable number of surviving pieces seems ridiculously small when we read of the mass of treasures of this kind that filled the Fatimid palace in Cairo. They are of different kinds and sizes but always worked from one piece, and they are often in western mounts.

The most important are the ewers, usually with one handle, cut with a design of opposed lions, animal combats, birds in vine scrolls, arabesques and so on, running round the body, and a Kufic inscription on the shoulder (Fig. 167). Pieces in smaller format include bottles which may have served for keeping medicines or scents (Fig. 168); then there are sceptre knobs or heads for battle maces, chessmen (of which several were for long considered as the "gift of Harun al-Rashid to Charlemagne") and lastly lions, fishes and other small animal figures with a hollow tube bored through them; these were brought back from the East by pilgrims and crusaders and seem to have served from the first as reliquaries. In the museum at Karlsruhe there is also a large water sprinkler in the form of a lion's head and in Nuremberg is a sickle-shaped ring of unknown use with an Arabic inscription, mounted as an ostensorium.

Smoothly facetted ewers without cut decoration and with one or two angular handles – the most imposing in the Kunsthistorisches Museum in Vienna, is 40 cm high – used also to be considered as of Fatimid manufac-

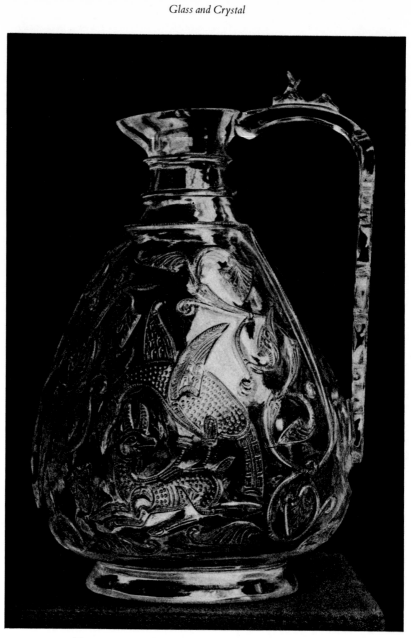

Fig. 167. Ewer of rock crystal. Egypt, eleventh century.
Victoria and Albert Museum, London.

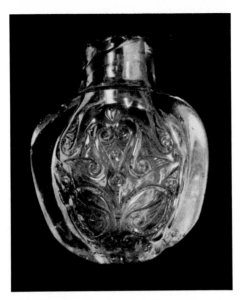

Fig. 168. Small bottle of rock crystal. Egypt, eleventh century.
Marquis de Ganay collection, Paris.

ture; today they are generally thought to be Western, Venetian or Bur-
gundian, and of later date.

The rarity of the material means that one is comparatively safe from
forgeries of these luxury articles; it should be remembered, however, that
in the Fatimid period flasks were already being made of heavy clear cut
glass and they are so similar to those of rock crystal that they can only be
distinguished by the difference in temperature: the semi-precious stone
feels rather cooler than glass to the touch.

The Islamic orient is so closely dependent on classical antiquity in the matter of glass technique that in many instances no precise identification can be made for a piece because there are insufficient criteria. For example, specimens of *millefiori* with its fused multi-coloured pastes have been excavated both in Fostat and in Samarra, and it is not yet possible to decide whether or for how long they continued to be produced in the Islamic

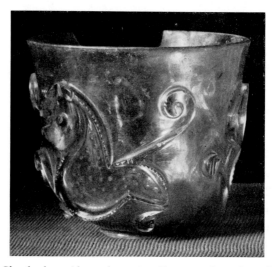

Fig. 169. Glass beaker with cut decoration. Egypt, tenth to eleventh century. Treasury of San Marco, Venice.

period. There is also a quantity of small ewers, dishes, bowls and so on with little or no decoration, whose forms are completely Hellenistic but which were found in contexts that suggest an early Islamic origin. The iridescence is often identical on earlier and later pieces and cannot help us out of the dilemma. The main reason for the close similarity with a considerably earlier period is certainly that glass production remained concentrated in the same countries that were in the lead in classical times, namely in Egypt and Syria, and the continuity of tradition was ensured here throughout the Christian period. Doubtless the workshops often survived unchanged in the same places, and sometimes even it is possible

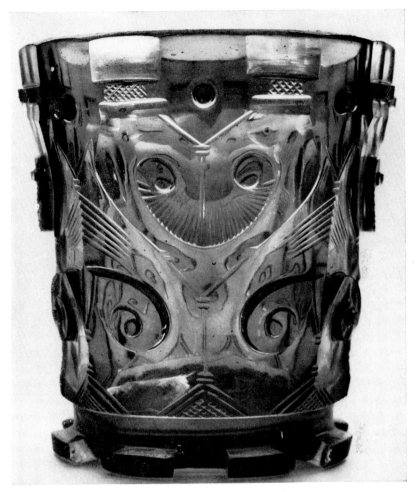

Fig. 170. 'Hedwig' beaker, Egypt, twelfth century.
Art Collection, Veste Coburg.

to trace their hesitant moves and reorganizations. Sometimes a slow technical change can give an indication, as for instance when the bull-like pattern known in antiquity is combed or mavered in at an increasingly superficial depth and in the end, while the motif is retained unchanged, it is simply painted on like enamel. Basically, however, it can be said that a sharp division only occurs when the decoration becomes more dominant, and then the new attitude to ornament cannot be mistaken. The collector must proceed extremely carefully with the acquisition of early Islamic

205

work, fascinating as it often is; pieces are forged in the orient itself with the greatest refinement – even magnificent iridescence can be produced by keeping the piece in dung-watered soil for a year or so – and can only be detected with certainty by the formal contradictions that are rarely absent.

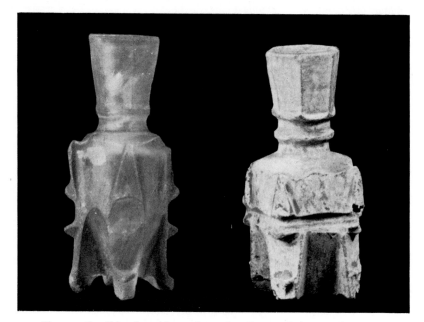

Fig. 171. Small bottles with cut decoration. Egypt, ninth to tenth century. Österreichisches Museum für angewandte Kunst, Vienna.

Cut Glass. We have already referred to Fatimid imitations of contemporary rock crystal vessels; they are the clearest proof that the carving technique evolved for the nobler material was transferred at once to the cheaper glass (Fig. 169). The so-called Hedwig goblets show this new technique at the height of its achievement now continuing on an independent course; they are massive beakers cut out of a single lump of glass and covered with cut decoration in a broad design. Their curious name comes from two examples preserved in Breslau which are both supposed to have been in the possession of the sainted Duchess of Silesia of that name; altogether about a dozen of them are known (Fig. 170). Opposed lions, birds or arabesques are used as motifs, once also something like an emblem in Ayyubid rather than in Fatimid style, and probably to be dated to the end of the twelfth century.

There are also smaller glasses in white, blue or green from the ninth to twelfth century with simple cut facetting. Molar shaped flasks with four pointed feet were particularly popular (Fig. 171); equipment things and such-like small utensils are rarer. Very fine cut glass wares with animal motifs, arabesques and so on seem also to have been produced in Iraq in the Samarra period, judging by some fragments found in the excavations. They are markedly distinct from the work of Egypt and Iran.

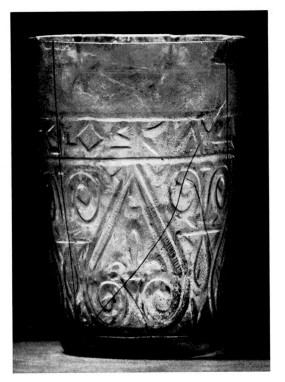

Fig. 172. Beaker with cut decoration. Persia, eighth to ninth century.
Museum Dahlem, Berlin.

In Persia large numbers of vases, goblets, bottles and other vessels have recently been excavated, some of thick, some of thin walled glass with abstract cut decoration; they are mostly early Islamic and some may even be of the eighth century. Their Iranian origin is indubitable and leads us to conclude that there was an older tradition. The Islamic Section of the Berlin Museums possesses a large number of these pieces (Fig. 172).

207

Fig. 173. Bottle with knobs and glass thread applied decoration. Syria, eighth century (?)
Museum Dahlem, Berlin.

Fig. 174. Flask with thread decoration. Syria, seventh to eighth century (?)
M. P. Billups, New York.

Fig. 175. Cup with applied and cut decoration. Egypt, eighth to ninth century.
Museum Dahlem, Berlin.

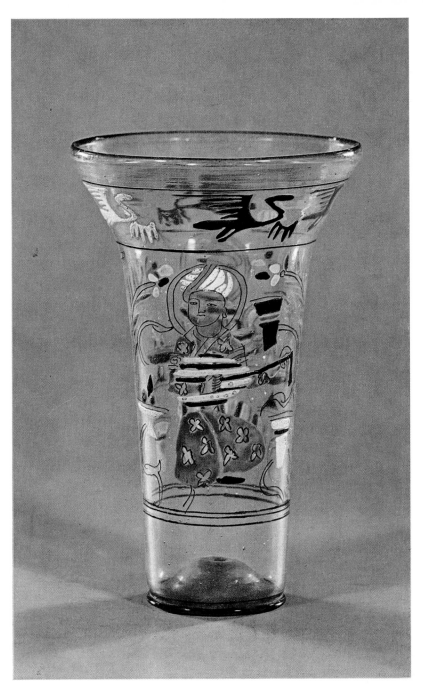

Plate XIV. Enamelled glass beaker. Syria, c. 1300.
Landesmuseum, Kassel.

Glass with Tonged Decoration, Incrustation, etc. Several classes of glass ware that can be attributed with some certainty to Syria (where the same method of decoration was practised in antiquity), show pinched-up knobs or incrustation with threads or trails, either of the same or different coloured glass (Fig. 173, 174). Sometimes the vessel has animal forms fused on to it, and very frequently the handles and spouts of small ewers are plastically modelled in this way. If they are not pre-Islamic, they may at least have continued into the Umayyad period.

Much larger numbers of dishes, ewers, bottles, bowls, and vases are preserved where the motifs (smooth fluting, scales, lozenges; button-, honeycomb-, and claw-like patterns; stylized leaf shapes and birds, among many more) were pressed, tonged or squeezed into the mass while it was still warm. Sometimes it is thick, sometimes quite thin and often coloured green, yellow, purple or blue (Figs. 175, 176). They can be apportioned between the Umayyad, Tulunid and Fatimid periods of Egypt. Here too the technique of blowing was so refined that pieces were made and can still be found that are light as a feather and paper thin – but in these circumstances undecorated.

Lustred Glass. The use of ornamental lustre painting on glass is indubitably of purely Islamic origin and again to be explained by the prohibition on the use of gold utensils. Only a very few rare examples of this craft survive. A few fragments found in Samarra with close patterned scrollery with a metallic sheen suggest that the technique, like lustre faience, was invented in Iraq in the eighth or ninth century and came thence to Egypt. For the pieces which are likely to have been made in Egypt are certainly rather later in style – mostly of Fatimid date – and more open in the design (Fig. 177). An exceptionally magnificent dish with fishes round a bird (Fig. 178), extremely effective in colour, shows the technique at its peak.

Fig. 176. Bottle with honeycomb
pattern. Egypt, ninth to tenth
century.
Egyptian Museum, Cairo.

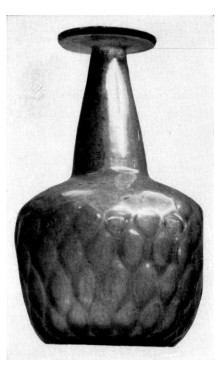

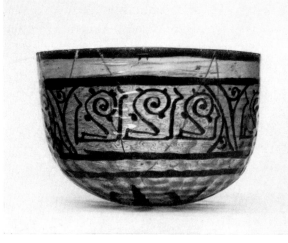

Fig. 177. Bowl
with lustre
decoration.
Egypt, eleventh
century.
British Museum,
London.

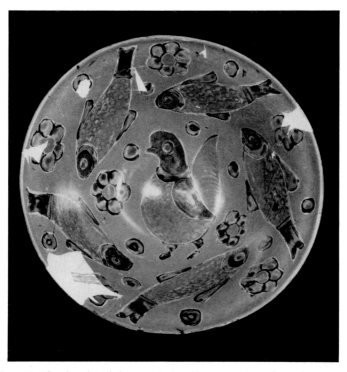

Fig. 178. Glass bowl with lustre painting. Egypt, tenth to eleventh century.
Ernesto Wolf Collection, São Paolo.

Fig. 179. "The Luck of Edenhall". Syria (Aleppo), thirteenth century.
British Museum, London.

ENAMELLED GLASS

In the twelfth century, just when the other glass techniques seemed condemned to perpetual repetition of what had been already achieved without any hope of further development, the Syrian craftsmen turned to the gilding and enamelling that had occasionally been tried out already, and applied it in all directions. Soon they had reached the culmination of perfection. The Muslim luxury vessels of the thirteenth century constitute the peak of the decorative development of all post-Christian glass work and rightly belong among the most precious objects known to the antique trade. The most outstanding pieces come from the workshops of Aleppo, whose fame spread well beyond the Islamic world, to the Far West and as far as China. Timur made an unsuccessful attempt to move the whole industry to Samarkand after he had taken the town, which shows clearly what importance this great ruler, who understood the political signi-

Fig. 180. Beaker with enamel decoration. Syria (Aleppo) (?), fourteenth century.
Formerly Eumorphopoulos collection.

ficance of culture, attached to the craft. Besides Raqqa and Aleppo (Damascus is also named), there may well be other places involved, and some rather more coarsely executed pieces are quite likely to have been made in distant places in imitation of the finer Syrian wares, but they can hardly have been later than these. All such pieces are preponderantly of the thirteenth and fourteenth century.

The most numerous examples of the craft are beakers with no foot and generally flaring slightly outwards at the mouth; in Raqqa this shape is more pronounced. They seem to have been used wherever revelling and carousing was customary, that is to say throughout the Near East. In

213

Fig. 181. Goblet with enamel decoration, Syria, c. 1280.
Metropolitan Museum, New York.

the hand of a prince especially, who is often portrayed with a gesture approximating to the westerner's "toast", they seem to have held some symbolic meaning.

This idea is corroborated by the fact that the beakers have often been found as grave gifts, in the Caucasus region among other places. The decoration is extremely varied, ranging from the very rich, with figure designs covering the whole surface (Plate XIV), to the extremely chaste, with a few ornamental bands. The ballad of the Luck of Edenhall celebrates

214

Fig. 182. Two-handled ewer with enamel and gilding. Syria (Aleppo),
thirteenth century. Freer Gallery, Washington.

a beaker, still treasured in its leather case by the family of the Lords of
Edenhall in the eighteenth century, and now in the British Museum.
This was one of these Syrian beakers of the thirteenth century (Fig. 179).
Examples from the fourteenth century often already show a Mongolian
influence, and a looser or freer placing of the motifs (Fig. 180).

Larger drinking vessels were decorated in like manner but few have
survived. They were goblets with a high foot, handled vases, bottles and

215

Fig. 183. Bottle with enamel decoration. Syria (Aleppo?) c. 1300.
Victoria and Albert Museum, London.

Plate XV. Mosque lamp with enamel and gilding. Syria, fourteenth century.
Österreichisches Museum für angewandte Kunst, Vienna.

so on (Figs. 181–183), many with rich gilding. Inscriptions with historical import giving exact dates are virtually non-existent among the profane pieces, but mosque lamps form a particularly numerous category in this technique, and these sometimes carry dates. These lamps were always of the stereotyped form, vase-shaped with the neck set at a sharp angle to the body and a foot of varying height, sometimes squat and sometimes slender, with fused-on loop handles through which thin chains were drawn so that the lamps could be hung from the ceiling (Fig. 184, Plate XV); the oil and flame were held in a separate funnel shaped compartment. These lamps were a favourite form of gift from the Mamluk Emirs to the Cairene mosques; the Islamic Museum there possesses more than seventy of them. In conformity with the religious context for which they were destined they are decorated only with scroll work and epigraphy in the large Mamluk *naskh* or in florid Kufic; quotations from the Koran and inscriptions about the donor provide the text. Only exceptionally does one meet a piece which declares its profane intent by showing horsemen or other figures.

In every case the motifs are first drawn in red outline, both for the enamel colours and for the gilding; the colour scheme is extremely rich. As a general rule it can be said that those examples with a sparse decoration of single bands on clear blown glass are still of the thirteenth century, and those with much enamelling on a body with more bubbles in the fabric belong to the fourteenth. Some rougher pieces even reach into the fifteenth century. In Venice this technique, which had been introduced from the orient, was used at that time to produce highly delightful work in delicate if not very varied abstract patterns and figure decoration.

Brocard produced the first successful imitations of Syrian glass vessels in Paris, with no nefarious intent but – as a comparison with the originals shows – from sheer delight in their technical perfection; only later, when some pieces reached enormous prices on the art market, did forgeries begin to appear, some of them so exquisite that even the most expert connoisseurs were taken in. The surest way of recognizing them, apart from inconsistencies or hasty work, even when the enamel colours and gilding seem irreproachable, is that the red drawing is not fired on but can be scratched off with a knife.

In the fourteenth century, when mastery of the craft knew no bounds, certain Islamic workshops, probably in Cairo, ventured on imitations of

Fig. 184. Mosque lamp, dedicated by Emir Qusun, Syria, early fourteenth century.
Metropolitan Museum, New York.

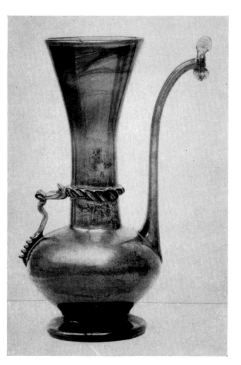

Fig. 185. Sprinkler, Persia (Shiraz), eighteenth century.
Musée des Arts Décoratifs, Paris.

Chinese porcelain in a very deceptive milk-white paste, and they even succeeded in producing very respectable imitations of the enamels of the Far East in the enamels they used to decorate them; nothing survives of these pieces but fragments.

LATE GLASS

When the workshops of Aleppo and Damascus had ceased production in the sixteenth century, mosque lamps and other glass wares continued to be decorated in more modest quantities in Constantinople. Some were

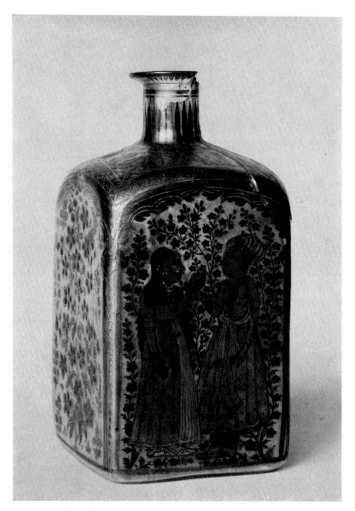

Fig. 186. Flask with gold and enamel decoration. India, seventeenth century. Metropolitan Museum, New York.

gilded, some simply painted; nothing artistically outstanding was produced, but faience lamps from Iznik provided a high quality substitute (cf. Fig. 112).

More frequently one finds the Persian products of an industry that was perhaps started by Shah Abbas in Shiraz and apparently continued active late into the eighteenth century; handled ewers, vases, droppers for rose water in monochrome – blue, green yellow, manganese red – often blown quite thin, sometimes decorated with trailed threads in the same colour and fluted or channelled bands (Fig. 185).

In Spain, Valencia and Barcelona emerged as the centres of glass production; but even their earliest work known so far, which is of the fifteenth century, is no longer Moorish art but belongs to the mixed *mudéjar* style.

There are very rare examples of vessels produced in India in the seventeenth and eighteenth centuries with coloured enamelling and gilding, some with figure motifs in the style of the Mughal miniatures (Fig. 186).

IVORY, WOOD, STONE AND STUCCO.

IVORY

Sword and dagger hilts were sometimes carved of ivory in the Islamic countries, and small plaques of this material were often utilized as decorative inlay on doors, pulpits and other wooden furniture. Separate complete objects of ivory are known mainly in the form of caskets and chests that served to hold jewellery and spices, musical horns and chessmen – all of them objects often made for the Western market and so destined to exercise a frequent and marked influence on the ornamental repertoire of small-scale Christian sculptures. There is no immediate evidence of a clear development to be deduced from the various groups of oriental work that belong here. Their early stages will have to be sought in Egypt and Syria, where carving in bone and ivory had achieved considerable importance in the early Christian period and now acquired new functions with the advent of Islam.

Umayyad Caskets. At the zenith of the caliphate of Córdoba, in the tenth century, jewel boxes of various sizes were made in the capital itself and in the residence of Madinat az-Zahra. They were either oblong or round, and the outer surface was entirely covered with carving, either purely ornamental, with close patterns of fronded arabesques and palmette leaves, or divided more richly into medallion compartments with figure scenes, usually with a Kufic border round the edge, generally giving the name of the patron and the date (Fig. 187–189). The scenes, apart from the manifold background fillings of opposed motifs, are mostly on the theme of court life, and influenced by Late Classical, Sasanid and other models not yet identified; the fact that there are figures at all, though an exception in the world of Moorish art, need not surprise us in view of the tolerant cultural policy of the Umayyads. Especially important examples are in the Museo Arqueológico at Madrid, in the Louvre and the Victoria and

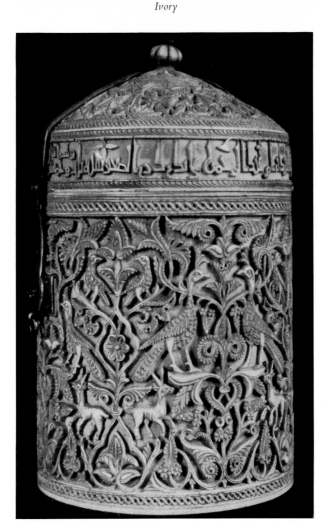

Fig. 187. Ivory box with carving, dated 964. Spain (Madinat az-Zahra).
Museo Arqueológico, Madrid.

Albert Museum. The most magnificent of the caskets is in Pamplona
(Fig. 188) with astonishingly rich and varied carving.

A smaller series of these works begins in the eleventh century and
already shows a decline of the style into weaker figures and friezes of
schematized animals; they were no longer produced in Córdoba but in
Cuenca (Castile), which is named on several examples. But even these
pieces are still to be regarded as exceptionally valuable. Objects of this

223

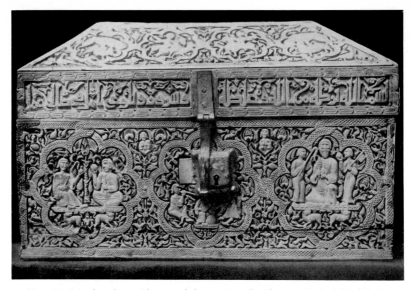

Fig. 188. Jewel casket with carved decoration, dated 1005. Spain (Córdoba).
Cathedral, Pamplona.

kind hardly ever appear on the market, and forgeries in real ivory are
highly lucrative. Francisco Pallás, who died in 1927, was extremely clever
at this work, and even imitated Kufic in a highly skilled manner.

Oliphant Horns. Among the works in ivory which go under this mediae-
val name, and which can in part be brought into more or less legendary
association with historical personalities, is a comparatively well-defined
group that can be claimed as Islamic, alongside several Byzantine and
Western ones. It has not been possible up to now to assign them to any
precise locale. The main surface has a number of single animals in circular
scrolls; these also appear at the mouth and at the bell, or instead they have
a border edging of animal processions, interlacery or wave scrolls, and
other plant ornament (Fig. 190). Some examples, probably of a relatively
early date, have a smooth facetted body and decoration only at the bell,
others again are divided lengthwise into bands.

Stylistically, these horns are close both to the Fatimid period of Egypt
and to the orientally influenced romanesque art of southern Italy, and it
is quite possible that they were produced exclusively for Christian countries
in the Norman kingdom of Sicily during the eleventh century by Saracen
craftsmen. The same is true of a smaller number of boxes executed in

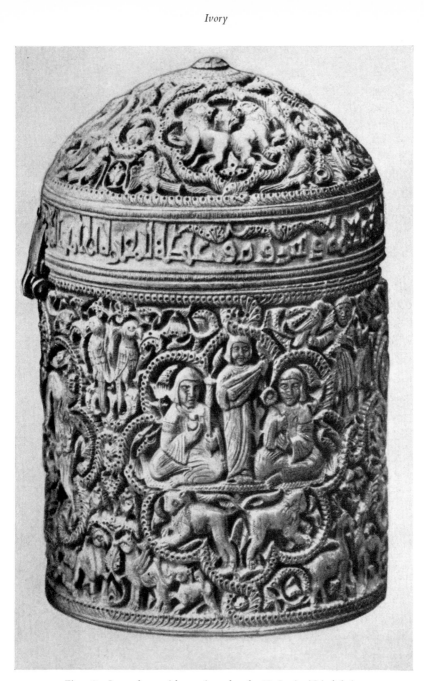

Fig. 189. Ivory box with carving, dated 968. Spain (Córdoba).
Louvre, Paris.

Fig. 190. So-called Oliphant. Sicily (?),
eleventh century.
Metropolitan Museum, New York.

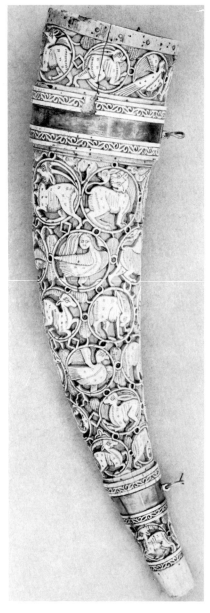

an identical style with the same
subjects, (huntsmen, animal com-
bats, opposed motifs) all repeated
(Fig. 191); two of them have beard-
ed men on the sides. In the other
groups of similar horns, Islamic
influences are equally apparent, and
one is inclined to conclude that
some of them were also from
southern Italy, but carved by
Christians. Imitations of Islamic
oliphants, some dating from the
Middle Ages are occasionally met
with; more recent ones betray
themselves by careless and un-
loving execution and a suspicious
patina.

Chessmen. Chess was brought to
Europe from the East in the early
Middle Ages, and it is understand-
able that for a long while the fig-
ures for it were obtained from
the orient. It was mentioned earlier
that they were sometimes made
of cut crystal; more usually, how-
ever, they were carved in ivory,
thus giving occasion for sculptural
artistry. Unfortunately very few
Islamic examples have survived,
apart from some very primitive
ones (Fig. 192, 193) and we know nothing of the history of how some of the
figures evolved. An entirely isolated example, and extremely imposing,
is a king on his elephant throne; it is a purely Indian sculpture, but signed
by an Arab carver, in the Bibliothèque Nationale in Paris. It must be

226

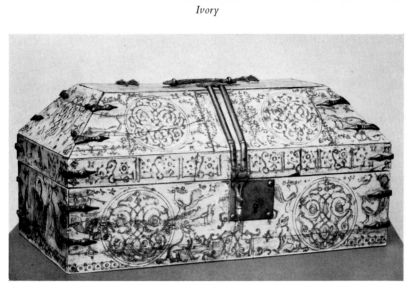

Fig. 191. Jewel casket with carving. Sicily (?), eleventh century.
Museum Dahlem, Berlin.

borne in mind that considerable differences exist between the original names and those used by us now. Throughout the East the series runs: King, Vizir, Elephant ('*al-fil*' is still today the Spanish name for the Bishop), Knight, Castle (as a war chariot, probably of Indian inspiration), Soldiers. Sets of figures carved to illustrate their identities were a favourite luxury to give as presents, often in quite large sizes, and very early on in the East they developed their special type and style. Usually, however, people used simpler pieces for playing the game itself, as they do today in the East, their function characterized simply by special notches, projections and contours (Fig. 192).

Openwork Carving and Similar Work. There is a small series of pyxes in which the body is deeply carved in simple geometric lattice-work under an inscription of good wishes in *naskh*; and it must remain an open question whether these thirteenth century pieces belong to the Almohad period of Spain or, as is more probable, to the Egyptian Ayyubid period. More interesting and important are a number of completely perforated and richly decorated plaques which were evidently fastened to wooden boxes, perhaps first backed with silk. They show figure motifs, observed from the life and handled with exceptional gaiety, and belong without doubt to the high period of Fatimid art; their nearest parallels are with Cairene wood

227

Fig. 192. Chessman (Bishop).
Egypt or Arabia, eighth
century.
Metropolitan Museum,
New York.

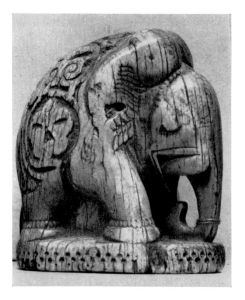

Fig. 193. Chessman (Bishop).
Iraq (?), tenth century.
Museo Nazionale, Florence.

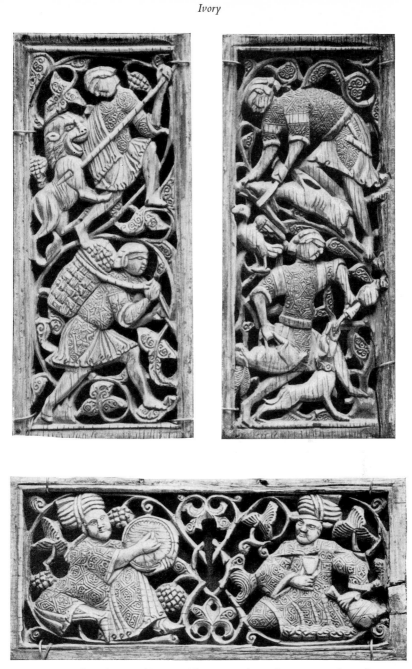

Fig. 194. Inlay plaques of ivory with openwork carving. Egypt, eleventh to
twelfth century.
Museo Nazionale, Florence.

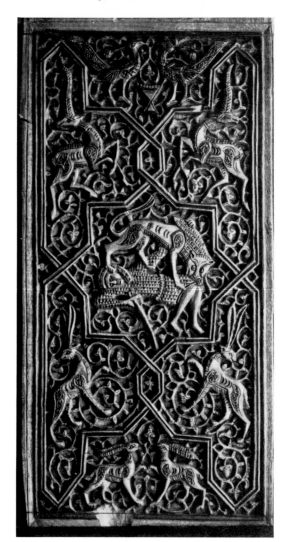

Fig. 195. Inlay plaque of ivory. Spain, thirteenth century.
Hermitage, Leningrad.

carvings of the eleventh and twelfth century (Fig. 194); examples are in
the Museo Nazionale in Florence, the Museum Dahlem in Berlin and the
Louvre, all of high artistic quality. A slightly later type of deeply carved
ivory plaque, which only appears occasionally, generally has opposed
animal motifs with arabesque detail over close scrollery, sometimes
contained in a cross and star scheme (Fig. 195); the figure representations

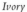

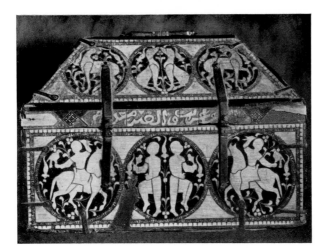

Fig. 196. Jewel casket with ivory inlay. Spain or Sicily, thirteenth century.
Cathedral, Tortosa.

have a decidedly Gothic air and suggest an attribution to the Spanish
mudéjar style of the thirteenth to fourteenth century. The last notable
ivory carvings in the Islamic sphere come from India, some so closely
allied to Hindu decorative carving that they can no longer be regarded
as pure Muslim work.

Ivory Inlays. It is not necessary here to go into all the cases in which
ivory plaques with geometric and sometimes representational ornament
were added to wooden furniture of every kind, together with those of
other materials; but sometimes they had an independent function in this
technique. For instance, the small inlaid jewel caskets with pieces of ivory
cut out into figure, epigraphical and ornamental designs were probably
Palermitan work; a fine example is still there today in the Capella Palatina.
Some others make one wonder if they are not Spanish in origin (Fig. 196).

Painted Ivories. In the thirteenth century the Spanish and Saracenic
Italian carved *coffanetti* were replaced by boxes with painting and
gilding which certainly came from Sicilian workshops; they are preserved
in large numbers in church treasuries and museums in the West. The
motifs here were very varied and the frequent occurrence of Christian
saints – e.g. under a frieze of arcading – suggests that they were largely
intended for the West. Otherwise falconers on horseback, harpists, opposed
peacocks, dogs and self-contained arabesque medallions are special favou-

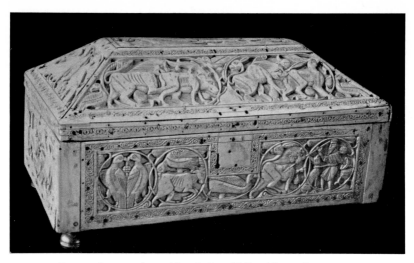

Fig. 197. Ivory casket with painting. Sicily, thirteenth century.
Museum Dahlem, Berlin.

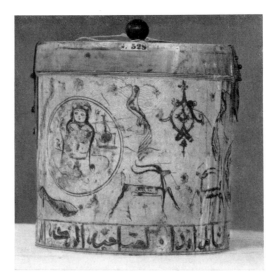

Fig. 198. Ivory pyx with painting. Sicily, thirteenth century.
Germanisches Museum, Nuremberg.

rites among motifs (Fig. 197). The epigraphy is still mostly in correct Arabic, angular or round. Besides gold and the always dominant sepia, red, blue and green tones are used with discretion; here too there are round boxes – sometimes used as pyxes (Fig. 198) – as well as the usual chests with sloping lids, both forms always with metal clasps.

In many cases the gold and colours are entirely or partially worn away. Fourteenth century descendants of this type have unattached motifs in heavier gilding, curious tree forms, serpents and so on, roughly drawn and arranged without discipline in a style that cannot be called wholly Islamic; they are perhaps Spanish in origin.

The opportunity for artistic work in wood was mainly that offered by doors, cupboard and window shutters, balcony lattices, private boxes and pulpits, all of which belong in a larger architectural setting and thus lie outside the scope of this book. Nonetheless they deserve mention because the carved panels, complete in themselves, of which the decoration of the doors, shutters and *minbars* (pulpits) was usually composed, have often

Fig. 199. Decorative panels with carving. Egypt, ninth to tenth century.
Islamic Museum, Cairo.

come on the market as separate pieces removed from the whole, and are popular among collectors. Egypt was always in the lead in this panelling technique, and it is with work from this country that we are primarily concerned. Of the smaller separate furniture chests to hold the Koran and folding desks (*rahle*) for spreading it out were used in various countries, while the inlaid furniture for profane use, produced mainly in the Turkish empire and in India, belong entirely to the nineteenth century and later; the latter already owe much to the European interest in orientalia.

Single wooden panels. The oldest examples of small decorative panels of Egyptian work are based on Coptic models; a further group then shows clear affiliations to the Abbassid bevelled style introduced during the Tulunid period (Fig. 199); but it is under the Fatimids that an individual

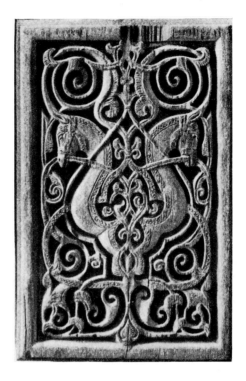

Fig. 200. Door panel with carving. Egypt, eleventh century. Islamic Museum, Cairo.

and extraordinarily rich development took shape in wood carving. A large series of examples shows animals, some still in heraldic form (Fig. 200), some very lively: gazelle, hare, ibex and so on surrounded by tendril scrolls or stepping out in friezes, lions and eagles attacking other beasts, peacocks in decorative opposed pairs, etc. Sometimes human figures are added as well, while on the panels taken from sanctuaries – even prayer niches were executed in wood at that time – only arabesques, palmettes and other stylized plant forms were utilized.

A series of decorative panels from one of the Fatimid palaces (now in the Islamic Museum in Cairo) shows in the figure carving the same sure observation and lively rendering of everyday scenes that we have already seen on ivory plaques. To the same style belong the very delicate open-work door panels (Fig. 201) with single motifs (animals and human figures) in loose medallion arrangement and spiral twists of tendrils.

In the Ayyubid period the inanimate elements were developed into the most extreme of luxuriant and complicated forms, and often every polygon, which is combined with others to form larger patterns, has a different and

235

Fig. 201. Openwork carving in wood.
Egypt, eleventh to twelfth century.
Louvre, Paris.

always unified and complete design. It was above all efforts of the Cairo guild of wood carvers of about 1200 who enabled Islamic ornament, and particularly the arabesque, to celebrate its greatest triumphs in this field.

In the Mamluk period the same style persisted, but was gradually treated in a more and more routine manner, and even in the thirteenth century it was often equalled by Seljuk work (probably influenced by Cairo, of course) both for richness of invention and delicacy of execution. The panel style spread into the world of Moorish art where the famous ninth century *minbar* of Qairawan heralded the future development of wood carving in those parts. The pulpits preserved in Marrakesh and Algiers with their rich ornamental panels testify to the high standard of its production around 1150. Very few single panels survive from the later Alhambra period, and they show much less variety. Persia and West Turkestan, for their part, did not come to the fore in wood carving until the Timurid period, and a noticeable Mongol element was already present.

Mosque Furniture. In the Near East during the Seljuk period the *rahl*, a folding desk for laying out the Koran, became a rich vehicle for the art

Fig. 202. Folding desk for the Koran. Asia Minor, thirteenth century
(Master Abdulwahid).
Islamic Museum, Berlin.

of carving. It was usually made from one piece into two interlocking
leaves, and decorated with writing and arabesques, partly in openwork
(Fig. 202); wooden sarcophagi for holy men, covered with relief inscrip-
tions, were also often set up in mausolea (*turbe*), and the pulpits (*minbar*)
mentioned earlier played an important role. In Cairo, wood mosaic
appeared about this time on Koran chests (with divisions inside for the

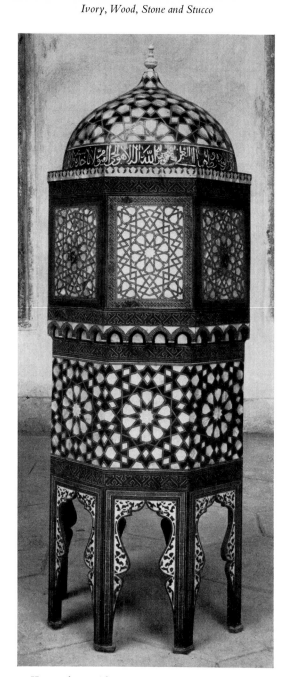

Fig. 203. Koran chest with intarsia. Turkey, seventeenth century.
Museum of Turkish and Islamic Art, Istanbul.

thirty sections of the Holy Book) and lamp tables (*kursi*), the latter modelled on the tall stands that had always been used in private houses for serving food; folding desks were also produced in this technique, which continued into the sixteenth century.

Meanwhile in the Ottoman sphere all mosque furniture had been taken over by intarsia, with inlay of mother of pearl, ebony and ivory; splendid display pieces, particularly of domed boxes and *rahle*, were made in the sixteenth and seventeenth centuries, of which a large number are preserved in the museums of Istanbul (Fig. 203); in the eighteenth century, openwork carving was still used now and again, though the designs were much simplified.

Capitals of the tenth century from Córdoba and Madinat az-Zahra, examples of which are preserved in a few museums, show how the acanthus became freer in the Moorish style, while those from Iraq follow the bevelled style of Samarra.

Vessels of marble have repeatedly played a part in the Islamic world. In Umayyad Spain these appear as large ablution basins, in Fatimid Egypt as vases with variously shaped stands. Turkish museums have a few figured stone reliefs of the twelfth to thirteenth century from Anatolia. These objects hardly ever appear on the market; the collector is more likely to be offered gravestones, often extremely attractively carved with

Fig. 204. Marble tomb stone, dated 1143, Persia.
Art Museum, Seattle.

240

Fig. 205. Fragment of a stucco frieze. Asia Minor (Konya), thirteenth century.
Museum, Konya.

Fig. 206. Stucco relief. Persia, thirteenth century.
Museum Dahlem, Berlin.

241

exquisite calligraphy and close ornament in relief (Fig. 204). Seals are a very frequent article in the bazaars, more often with script than with figure motifs; by far the most interesting of these are the pre-Islamic ones, particularly the quite common Sasanid examples.

Two countries, Persia and Asia Minor, began at about the same time to do work in stucco distinct from the ever-popular plaster architectural decoration for dwellings. The examples known from Konya are to be dated between 1200 and 1300; they are large rectangular or arched panels or small friezes with very fresh and lively battle scenes, animals and many other motifs (Fig. 205). They clearly betray their architectural association, but among the Persian pieces of the same Seljuk period we find large numbers of quite independent straight sided or round reliefs which were obviously never let into a wall but simply hung up as ornaments (Fig. 206); they sometimes have throne scenes and similar compositions containing several figures. There are also occasional examples of human figures in very high relief and with the heads modelled in the round, which doubtless originally came from larger relief groups. Some are now preserved in American museums; they may have been popular as profane wall decoration in the Seljuk palaces.

APPENDIX

The Muslims calculate their calendar according to a shorter lunar year than our solar one. As a result, the 622 years of difference between the beginning of their era and ours has contracted and is now only 580 years. If the *hijra* dates have to be constantly converted to the Christian calendar the *Comparative Tables of Muhammadan and Christian Dates* (Haig, London, 1932) will certainly have to be used; this provides a comparison of calendars accurate to the day. Where this reference is not available or where only a rough result is required the following easy formula is useful to remember:

The number of the Muslim year to be converted is divided by 33, the result to the nearest digit is subtracted from the original number and 622 is added. e.g. H. $1383 : 33 = 42$; $1383 - 42 = 1341$; $1341 + 622 = 1963$ A.D.

To calculate the Islamic year from the Christian subtract 622, divide by 32 and add the quotient to the dividend. e.g. $1963 - 622 = 1341$; $1341 : 32 = 42$; $1341 + 42 = 1383$ H.

The result is either exact or in error by one year, which rarely matters in view of the shifting year end of the lunar in relation to the solar calendar. To be certain of reckoning the solar year exactly, one must know also the month of the event in question.

PUBLIC COLLECTIONS OF ISLAMIC ART

The Islamic Section of the Staatliche Museen in Berlin was of out-standing importance as a systematic specialist collection of the Islamic minor arts. It has however suffered much through the war, especially in the carpets, and through the division into East and West. It is now separated into the Islamic Museum in Berlin C 2 in the Eastern Sector and the Islamic Section in West Berlin (Exhibition collection in the Museum Dahlem, study collection and store in Charlottenburg, Jebensstr. 2).

Important comprehensive collections in all branches are in the Louvre and the Musée des Arts Decoratifs in Paris, the British Museum and Victoria and Albert Museum in London, the Hermitage in Leningrad, the Benaki Museum in Athens, the Metropolitan Museum in New York, the Freer Gallery in Washington. Collections of the different techniques are also in the Osterreichische Museum für angewandte Kunst in Vienna, the Museum für Kunst und Gewerbe in Hamburg, the Walters Art Gallery in Baltimore, the Fine Arts Museum in Boston, and the Art Museums in Cleveland, Philadelphia, Chicago and Cincinnati.

The Islamic art of Egypt and Syria is nowhere so brilliantly represented as in the Museum of Islamic Art in Cairo; finds from excavations in Syria are in the Museum in Damascus, those from Iraq in Baghdad, and important collections of Turkish art, including pieces formerly preserved in religious foundations, in the museums of Istanbul and Ankara. Persian art can now no longer be adequately studied without a visit to the National Museum in Teheran. Hispano-Mauresque objects are best seen in the Archaeological Museum and the Instituto de Valencia de Don Juan in Madrid.

Some techniques of Islamic art can be studied with particular thorough-ness in collections which are less interesting in other ways, and a list of collections under the different headings is therefore added:

Books: In the first rank are the oriental sections of the large libraries in Berlin (at present still in Tübingen), Munich, Vienna, Paris, London,

Leningrad, Cairo (especially many luxury Korans), the Saray Library and University Library in Istanbul; also the Chester Beatty Library in Dublin, and the Bodleian Library in Oxford. Large collections of miniatures are housed in Boston, Metropolitan Museum, Freer Gallery, Walters Art Gallery, Gulistan Museum in Teheran, Turkish-Islamic Museum in Istanbul (calligraphy, bindings, illuminated manuscripts). The Islamic Museum in Berlin and the Victoria and Albert Museum, London are particularly rich in Indian miniatures. There are smaller collections and single fine pieces in various places, especially in the USA; there are examples of bindings in the Leather Museum in Offenbach.

Ceramics. All provenances are covered by the rich collections in the Louvre, Victoria and Albert Museum, Metropolitan Museum, Museum Dahlem, Berlin, Freer Gallery, Washington; other collections of major importance are the British Museum, Musée des Arts Décoratifs in Paris, Moorish faience in the Museo Arqueológico and Instituto de Valencia in Madrid, all types of Fostat ware and other Fatimid lustre pottery, and also Persian faience, in the Museum of Islamic Art in Cairo. Turkish pottery is well represented in the Gulbenkian Foundation in Lisbon. There are some outstanding faiences in the Museums of Arts and Crafts in Leipzig, Hamburg, Frankfurt, Vienna, Budapest, Copenhagen, Stockholm, Brussels, and in the Heetjens Museum in Düsseldorf, the Ethnographical Museum in Munich, the Rijksmuseum in Amsterdam, the Gemeente Museum in the Hague, the Ceramic Museum at Sèvres, the Benaki Museum in Athens, the Museums of Palermo and Barcelona; also in Boston, Baltimore, Cleveland, Detroit, Chicago, Philadelphia, Kansas City and other American collections.

Metalwork. Next to the Islamic Section in Berlin, the Louvre and Musée des Arts Décoratifs Paris, the British Museum and Victoria and Albert Museum, the Museum of Islamic Art in Cairo (Harari Collection), the Metropolitan Museum and Freer Gallery the following should also receive particular mention: Museo Nazionale in Florence, Hermitage in Leningrad. Interesting pieces can be found in a number of other places.

Weapons. So-called "Turkish booty" is preserved in the Landesmuseum in Karlsruhe, the Historical Museum in Dresden, National Museum in Munich, Kunsthistorisches Museum in Vienna and the Museum für Deutsche Geschichte (formerly Zeughaus) in Berlin. There are extensive collections of weapons in the Victoria and Albert Museum and Indian

Museum in London, Leningrad Hermitage and the former Arsenal in Moscow, the Army Museum and Saray Museum in Istanbul. The Moser Charlottenfels Collection in the Historical Museum in Bern has examples of all types, primarily Persian and Indian, mostly of later date. The Armoury in Stockholm, the Louvre, the Musée de la Porte de Hall in Brussels, the Armeria in Madrid, and other weapon collections also contain remarkable oriental examples.

Glass and Crystal. The leading collections are again the Islamic Section in Berlin, the Louvre, the British Museum, the Victoria and Albert Museum, the Metropolitan Museum, Freer Gallery and the Islamic Museum, Cairo (the largest collection of enamelled glass lamps). Some outstanding pieces are in the National Museum at Munich, the Landesmuseum at Kassel, the Kunsthistorisches Museum in Vienna, Czartoryski Museum at Cracow, Treasury of San Marco in Venice, Hermitage and elsewhere.

Ivory. The Louvre, the Victoria and Albert, the Museum Dahlem and the Archaeological Museum at Madrid, also the Metropolitan in New York all have a large number of Islamic ivories; several pieces are in the possession of the British Museum and Museo Nazionale in Florence. There are single objects elsewhere.

Wood. The Museum of Islamic Art in Cairo is superior to all others; the Islamisches Museum, Berlin, the Louvre, the Victoria and Albert Museum, and the Benaki Museum have large collections; Seljuk and Ottoman work is best studied in the museums in Istanbul and Ankara.

Stucco and Stone. There are excavation finds of the Early Islamic period in the museums of Berlin, Damascus, Baghdad, and Cairo; Istanbul is very rich in Seljuk reliefs.

SELECT BIBLIOGRAPHY

(Very outdated works, publications on limited periods or single objects and articles in journals are not quoted here).

G. *Migeon*, Manuel d'art musulman: Arts plastiques et industriels. Second edition, Paris 1927, 2 vols.
(Still indispensable as a single comprehensive handbook on all Islamic decorative arts, with many illustrations in the text.)

M. *Dimond*, A Handbook of Mohammadan Art, 2 ed., New York 1944. A survey of Islamic decorative art on the basis of the collection of the Metropolitan Museum in New York.

Die Ausstellungen von *Meisterwerken Muhammedanischer Kunst* in München 1910, ed. F. Sarre and F. R. Martin, with collaboration of M. Berchem, M. Dreger, E. Kühnel, C. List and S. Schröder. 3 vols. Munich 1912.
(Important exhibition with examples of Islamic decorative art from all regions in excellent, some coloured, plates).

A. V. Pope (ed.) *A Survey of Persian Art*. (Contributions from over sixty authors). 6 vols. London and New York 1938; index, 1958; de luxe edition plates 1939. (Standard reference work on all fields of Iranian art, with 1482 plates, mostly in colour, indispensable as splendid collection of material with informative discussion).

G. *Migeon*, Exposition des Arts musulmans. Paris 1903.
(Illustrations include many pieces not reproduced in the Munich catalogue).

G. *Migeon*, Musée du Louvre: L'Orient Musulman. Paris 1922, 2 vols.
(Small plates, some in colour, showing the most important examples of Muslim art in the Louvre).

E. *Kühnel*, Islamische Kunst aus dem Berliner Museum. Berlin, 1954.
(List of the collection of the Islamic Section exhibited in the Museum Dahlem with seventeen pages of illustrations; with supplement to bring it up to date.)

G. *Wiet*, Album de Musée Arabe du Caire. Cairo 1930.
(Convenient volume of illustrations of all the important objects in the Museum, short notes in French, English and Arabic.)

F. *Sarre*, Seldschukische Kleinkunst. Leipzig 1909.
(Descriptions of the most important examples of wood carvings, stucco reliefs, ceramics, and carpets of the Seljuk period in Asia Minor.)

B. *Moritz*, Arabic Palaeography. Cairo 1905.
(Reproductions of texts from the National Library in Cairo, designed for the study of the various hands; no text.)

C. *Huart*, Les calligraphes et les miniaturistes de l'orient musulman. Paris 1908.
(Review of the Islamic schools of calligraphy and their representatives from oriental sources [some unreliable]).

T. W. *Arnold*, Painting in Islam. Oxford 1928.
(Important for a general orientation on the significance of painting in Islam and this special problems.)

247

F. R. Martin, The miniature painting and painters of Persia, India and Turkey. 2 vols. (text and plates), London 1912.
(Standard work with excellent illustrations. Attributions not always reliable.)

E. Kühnel, Miniaturmalerei im islamischen Orient. (Die Kunst des Ostens, vol. VII). Second edition, Berlin 1923.
(Short selection of the whole subject with historical introduction: out of date but not yet entirely superseded.)

E. Blochet, Les peintures des manuscrits orientaux de la Bibliothèque Nationale. Paris 1920.
(Important text with 82 collotype illustrations.)

R. Ettinghausen, Arabische Malerei. Geneva 1962.
(Outstanding presentation of the Arabic contribution to Islamic painting, with 80 excellent reproductions, many previously unpublished, in text.)

W. P. Schulz, Die persisch-islamische Miniaturmalerei. 2 vols., Leipzig 1914.
(With many useful details, but very involved and out of date.)

G. Marteau and *H. Vever*, Miniatures persanes ... exposées au Musée des Arts Decoratifs ... 1912. Paris 1913. 2 vols.
(An older luxury volume with some colour plates.)

A. Sakisian, La miniature persane du XIIe au XVIIe siècle. Paris, Brussels 1929.
(Review of the various periods of development.)

L. Binyon, J. V. S. Wilkinson, B. Gray, Persian Miniature Painting. London 1933.
(Exhaustive catalogue of the miniatures in the 1931 London exhibition, with introductions to the different periods. An important, richly illustrated reference work.)

B. Gray, Persian Painting. Geneva 1961.
(Excellent presentation of the historical development with about 80 superlative colour reproductions in the text. Skira series, also French and German.)

P. Brown, Indian painting under the Mughals, A. D. 1550 to A. D. 1750. London 1924.
(Important handbook to this special field, with much historical informations.)

E. Kühnel and *H. Goetz*, Indische Buchmalereien aus dem Jahangir-Album der Staatsbibliothek zu Berlin. Berlin 1924.
(Good colour reproductions of single leaves and border paintings.)

E. Kühnel, Indische Miniaturen aus dem Besitz der Staatl. Museen zu Berlin. Berlin 1937.
(19 colour reproductions with explanations and introductory text.)

E. Kühnel, Moghul-Malerei, Berlin n. d.
(Second series of 20 colour reproductions from the Berlin collections, with commentary.)

A. Coomaraswamy, Rajput Painting. 2 vols., Oxford 1916.
(Standard work on the Hindu schools.)

F. Sarre, Islamic Bookbindings. London 1923.
(Bindings from the Islamic Sections of the Berlin Museums and from the author's own collection – now in the Leather Museum in Offenbach. Many in excellent colour reproduction.)

E. Gratzl, Islamische Bucheinbände. Leipzig 1924.
(Examples from the Bavarian Staatsbibliothek, with detailed descriptions.)

M. Weisweiler, Der islamische Bucheinband des Mittelalters. Wiesbaden 1962.
(With important facts on technique and 42 plates.)

248

P. Kahle, Islamische Schattenspielfiguren aus Ägypten.
(Der „Islam" 1910/11.) (With illustrations of shadow play figures and references to other literature.)

A. Lane, Early Islamic Pottery. London (1947).
(Excellent handbook on Islamic pottery vessels before the Mongol period, with 96 plates of illustrations.)

A. Lane, Later Islamic Pottery: Persia, Syria, Egypt, Turkey. London (1957).
(Continuation of the previous volume with 104 plates. The best presentation of the subject.)

H. Rivière, La céramique dans l'art musulman. Paris 1913.
(One hundred splendid colour reproductions of faiences of various types.)

R. Koechlin and *G. Migeon*, Oriental Art. Ceramics, Fabrics, Carpets. London 1928.
(One hundred colour plates, twenty pages of text.)

F. Sarre, Die Keramik von Samarra. (Die Ausgrabungen von Samarra, vol. II; Forschungen zur islamischen Kunst, Abt. 2). Berlin 1925.
(Systematic catalogue of the ceramic finds at Samarra excavations, with 36 plates, some in colour.)

M. Pézard, La céramique archaïque de l'Islam et ses origines. Paris 1920.
(Important plates, with some in colour; reproductions of Samarkand, Samarra and Gabri ware; dating often a century too early.)

R. Meyer-Riefstahl, The Parish-Watson Collection of Mohammadan Potteries. New York 1922.
(The plates, some in colour, include mainly outstanding Rayy ware of the thirteenth century.)

H. Wallis, The Godman Collection. London 1891.
(Persian faiences of the thirteenth and fourteenth centuries; the oldest collection of its kind in Europe; text outdated.)

M. Bahrami, Gurgan Faiences. Cairo 1949.
(Discusses the Persian faiences found in Gurgan and allegedly also made there. With 98 plates.)

K. Otto-Dorn, Türkische Keramik. Ankara 1957. (Schriften des Kunsthistorischen Institutes der Universität, 1).
(Comprehensive presentation with 98 plates, some in colour.)

The Burlington Fine Arts Club Exhibition of the Fayence of Persia and the nearer East. London 1908.
(With many illustrations, some in colour, especially of Turkish faiences.)

Musée de l'Art du Caire, La céramique égyptienne de l'époque musulmane. Bâle 1922.
(With excellent reproductions, some in colour, of Fostat fragments in the Arabian Museum in Cairo; no text.)

D. Fouquet, Contribution à l'étude de la céramique orientale. Cairo 1900.
(Deals with the signed Fostat ware; many potter's marks.)

A. van de Put, Hispano-Moresque Ware of the XV century. London 1904; supplementary studies, London 1911.
(Important for th eclassification of the Valencia majolica; much historical information.)

A. Frothingham, Catalogue of Hispano-Moresque Pottery, New York 1936.
(Comprises the collection preserved in the Hispanic Society of America of Hispano-Mauresque faience.)

A. Frothingham, Lustreware of Spain, New York 1951.
(Excellent presentation of the history of lustre wares in Spain, with 220 illustrations in text.)

M. Olivar Daydí, La cerámica trecentista en los países de la Corona de Aragón. Barcelona (1952).
(Standard work on the faiences of Teruel, Paterna, Manises and elsewhere, with important documents and 124 excellent collotypes.)

R. L. Hobson, A guide to the Islamic Pottery of the Near East. London 1932.
(Guide to the British Museum Collection, with 118 illustrations in text.)

F. Sarre and *E. Mittwoch*, Sammlung von F. Sarre: Metall. Leipzig 1906.
(Illustrated catalogue of the Sarre Collection of metalwork now in the Islamic Section of the Staatl. Museum.)

G. Wiet, Objets en Cuivre (Catalogue général du Musée Arabe). Cairo 1952.
(Exhaustive catalogue of the inscribed pieces in the Museum, with 86 plates. Appended is a list of the inscribed bronzes preserved in other museums.)

D. E. Barrett, Islamic Metalwork in the British Museum, London 1949.
(Introduction and short descriptions, with 40 plates.)

G. Schmoranz, Altorientalische Glasgefäße. Vienna 1898.
(On the enamelled Syrian glass, with magnificent colour reproductions of mostly hitherto unknown pieces.)

C. J. Lamm, Mittelalterliche Gläser und Steinschnittarbeiten aus dem Nahen Osten. Berlin 1929/30, 2 vols. (Forschungen zur Islamischen Kunst, 5).
(Standard work on all Islamic glass techniques, including rock crystal. All pieces discussed are illustrated in over 200 plates, some in colour or collotype, some only sketches.)

G. Wiet, Lampes et bouteilles en verre emaille (Catalogue général du Musée Arabe). Cairo 1929.
(Catalogue of the large collection in the Museum of enamelled glasses with 92 plates and a list of objects in other collections.)

E. Pauty, Les bois sculptés jusqu'à l'époque ayyoubide.
(Catalogue général du Musée Arabe) Cairo 1929.
(Contains those early Islamic and Fatimid wood carvings in the Museum which are not purely inscriptions.)

J. Ferrandis, Marfiles árabes de Occidente. 2 vols, Madrid 1935 and 1940.
(Standard work on West Islamic ivories, with 137 plates. Vol. I deals with the carved pieces, Vol. II with the painted and other examples.)

P. B. Cott, Siculo-Arabic ivories. Princeton 1939.
(Complete catalogue of all known painted ivory caskets and boxes attributed to Sicily, with 80 large plates.)

INDEX